Mastering Adobe Animate 2021

Explore professional techniques and best practices
to design vivid animations and interactive content

Joseph Labrecque

BIRMINGHAM—MUMBAI

Mastering Adobe Animate 2021

Group Product Manager: Ashwin Nair
Publishing Product Manager: Rohit Rajkumar
Senior Editor: Hayden Edwards
Content Development Editor: Aamir Ahmed
Technical Editor: Shubham Sharma
Copy Editor: Safis Editing
Project Coordinator: Kinjal Bari
Proofreader: Safis Editing
Indexer: Manju Arasan
Production Designer: Aparna Bhagat

First published: February 2021

Production reference: 2050221

Published by Packt Publishing Ltd.
Livery Place
35 Livery Street
Birmingham
B3 2PB, UK.

ISBN 978-1-80107-416-2

www.packt.com

This book is dedicated to those who search for a deeper insight... in all things.

-Joseph Labrecque

`Packt.com`

Subscribe to our online digital library for full access to over 7,000 books and videos, as well as industry leading tools to help you plan your personal development and advance your career. For more information, please visit our website.

Why subscribe?

- Spend less time learning and more time coding with practical eBooks and Videos from over 4,000 industry professionals

- Improve your learning with Skill Plans built especially for you

- Get a free eBook or video every month

- Fully searchable for easy access to vital information

- Copy and paste, print, and bookmark content

Did you know that Packt offers eBook versions of every book published, with PDF and ePub files available? You can upgrade to the eBook version at `packt.com` and as a print book customer, you are entitled to a discount on the eBook copy. Get in touch with us at `customercare@packtpub.com` for more details.

At `www.packt.com`, you can also read a collection of free technical articles, sign up for a range of free newsletters, and receive exclusive discounts and offers on Packt books and eBooks.

Foreword

I have known Joseph Labrecque for about seven years now. He is believed to be one of the leading experts in the field of digital animations. His videos, books and lectures about Adobe Animate have provided immense help to those interested in creating animations with the product.

In this book, Joseph helps you get started with the basics including the types of content you can create including character animations, interactive animations, games, web content and more. He goes over the tips and techniques of creating animations with the product and then the ability to export them to various platforms. It is a book that will help you gain a deeper understanding of the various workflows and platforms that will allow you to express yourself freely and create amazing animations that suit your style on a platform and device of your choice.

Ajay Shukla

Group Product Manager, Adobe Animate

Contributors

About the author

Joseph Labrecque is a creative developer, designer, and educator with nearly two decades of experience creating expressive web, desktop, and mobile solutions. He joined the *University of Colorado Boulder College of Media, Communication and Information* as Instructor of Technology for the *Department of Advertising, Public Relations and Media Design* in Autumn 2019. His teaching focuses on creative software, digital workflows, user interaction, and design principles. Before joining the faculty at CU Boulder, he was associated with the University of Denver as adjunct faculty and as a senior interactive software engineer, user interface developer, and digital media designer.

Joseph has authored a number of books and video course publications on design and development technologies, tools, and concepts through publishers which include Packt, LinkedIn Learning (Lynda.com), Peachpit Press, and Apress. He has spoken at large design and technology conferences such as Adobe MAX and for a variety of smaller creative communities. He is also the founder of Fractured Vision Media, LLC; a digital media production studio and distribution vehicle for a variety of creative works.

Joseph is an Adobe Education Leader, Adobe Community Professional, and member of Adobe Partners by Design. He holds a bachelor's degree in communication from Worcester State University and a master's degree in digital media studies from the University of Denver.

I would like to thank my wife, Leslie… and our daughters,
Paige and Lily. It's been a weird couple of years!

About the reviewer

Matthijs Clasener was schooled as a multimedia designer. He now is a well experienced educator at the Grafisch Lyceum Rotterdam, The Netherlands. He teaches media and design subjects and is highly interested in animation. He takes the lead in the animation curriculum at this vocational career school. Matthijs is an Adobe Education Leader and is well known for his contributions to educational (online) events. Through his own company Cutaway, he develops courses on nearly all of the Adobe tools.

Packt is searching for authors like you

If you're interested in becoming an author for Packt, please visit `authors.packtpub.com` and apply today. We have worked with thousands of developers and tech professionals, just like you, to help them share their insight with the global tech community. You can make a general application, apply for a specific hot topic that we are recruiting an author for, or submit your own idea.

Table of Contents

3

Settling into the User Interface

4

Publishing and Exporting Creative Content

Section 2: Animating with Diverse Techniques

5

Creating and Manipulating Media Content

6

Interactive Motion Graphics for the Web

7

Character Design through Layer Parenting

8

Animating Poses with IK Armatures

9

Working with the Camera and Layer Depth

Section 3: Exploring Additional Platforms

10

Developing Web-Based Games

11

Producing Virtual Reality Content for WebGL

12
Building Apps for Desktop and Mobile

13
Extending Adobe Animate

Other Books You May Enjoy

Index

Preface

Adobe Animate is a platform-agnostic asset creation, motion design, animation, and interactivity software packed full of time-tested tools and workflows. Using this software, you can target multiple platforms to produce motion design content, character animations, interactive displays, games, applications, and anything else you might think of. Perhaps the greatest strength of Animate is in the diversity of its toolset, along with the ease at which developers can use it for design and for designers to use it for development. Animate is a true creative powerhouse for hybrid creative work unlike any other.

Given Animate's previous incarnation as Flash Professional, a fair amount of what the software can produce is web-based, but the past few years have really opened things up in order to target all manner of diverse platforms. We can target the native web through the HTML canvas element or via WebGL, generate rich animated content for broadcast television and film, develop games and applications for Apple iOS, Google Android, Microsoft Windows, and Apple macOS, and even generate content for virtual reality. By the end of this book, you'll be able to produce a variety of media assets, motion design materials, animated artifacts, and interactive content pieces—all while targeting a variety of compelling platforms.

This book will not teach you everything there is to know about Animate as no book could possibly do that. It isn't an introductory book either as there are many such works available elsewhere. The intent of this book is to help you gain mastery of Animate through the diversity of its various workflows and platforms built upon a solid foundation of its history and foundations. I hope you enjoy the contents of these pages and use the concepts within to further the creative legacy of this wonderful software!

Who this book is for

This book is perfect for web, graphic, and motion design professionals with elementary experience in animation who want to take their existing skills to the next level. Building upon an initial understanding of fundamental animation concepts will help you to get the most out of this book and produce results that extend beyond the basic expectations.

What this book covers

Chapter 1, A Brief Introduction to Adobe Animate, provides background and context around the history and capabilities of the software. We'll also take a deep dive into all the new features available in Animate 2021!

Chapter 2, Exploring Platform-Specific Considerations, covers the various target platforms that are natively supported by Animate by exploring the underlying aspects of each platform, when to use one over another, and even see how to convert between document types.

Chapter 3, Settling into the User Interface, explores the Animate interface in depth, alongside tips and tricks to get the most out of working with the software. You'll discover how to customize the entire workspace to your liking to achieve a more customized workflow.

Chapter 4, Publishing and Exporting Creative Content, explores ways of getting your content outside of Animate in a form that can be consumed by the user or reused in additional ways within other software and systems.

Chapter 5, Creating and Manipulating Media Content, covers the fundamentals of Animate workflows in both the creation of content with various vector shape tools and also the use of different tweening mechanisms within the software. In addition to shape data, we also examine the use of symbols and instances within Animate – and see how to apply motion to both simple shape and symbol instances along with the application of easing presets.

Chapter 6, Interactive Motion Graphics for the Web, explores traditional motion graphics workflows for the web through the creation of an animated advertisement using both imported bitmap graphics and vector content native to Animate.

Chapter 7, Character Design through Layer Parenting, explores Advanced Layers mode and the ability to rig character animations across layers using Layer Parenting mechanisms. We'll also see how to create automated lip-sync animations through the power of Adobe Sensei!

Chapter 8, Animating Poses with IK Armatures, explores a more refined and controlled way of rigging an armature through the use of the Bone tool and IK Armatures with full joint constraints and the management of Poses across the timeline. We'll also see how to share completed rigs and related assets through the use of Animate Asset files and the new Assets panel.

Chapter 9, Working with the Camera and Layer Depth, dives into the Camera as a means to animate an entire scene that is otherwise fairly static and even taps into Layer Depth manipulation and the use of layer effects and filters.

Chapter 10, Developing Web-Based Games, explores the construction of a playable web-based game targeting HTML5 canvas using CreateJS JavaScript libraries as we build out the logic for our entire game bit by bit across the timeline and through the use of global scripts.

Chapter 11, Producing Virtual Reality Content for WebGL, explores the Virtual Reality and WebGL glTF document types within Animate through the assembly of fully interactive Virtual Reality environments using scenes, textures, and additional imported assets.

Chapter 12, Building Apps for Desktop and Mobile, focuses on the AIR document type, through which we will build a small utility application for browsing photographs using ActionScript 3.0 as a programming language and the Adobe AIR SDK as a development platform for desktop and mobile platforms.

Chapter 13, Extending Adobe Animate, examines a set of options available to extend Animate through the creation and execution of custom in-app tutorials, the use of the JavaScript API to automate actions, and an overview of the Custom Platform Support Development Kit.

To get the most out of this book

You will need Adobe Animate 2021 or a later version installed on a compatible macOS or Windows computer in order to most effectively follow along with this book. A full Adobe Creative Cloud subscription is the most beneficial way of doing this, as you'll get access to the Adobe Fonts service we use in certain projects and will have additional access to useful software such as Photoshop, Fresco, and Dimension to create content for use within your Animate projects. For the web-based projects in this book, an up-to-date web browser is highly recommended as well.

Software covered in the book	OS requirements
Adobe Animate 2021	Windows or macOS
Web Browser	Windows or macOS

Also refer to the Animate System Requirements page for specific hardware and software specifications: `https://helpx.adobe.com/animate/system-requirements.html`.

If you are using the digital version of this book, we advise you to type the code yourself or access the code via the GitHub repository (link available in the next section). Doing so will help you avoid any potential errors related to the copying and pasting of code.

Download the example projects, media assets, and code files

You can download the example files for this book from GitHub at `https://github.com/PacktPublishing/Mastering-Adobe-Animate-2021`. In case there's an update to these assets, it will be updated on the existing GitHub repository.

We also have other code bundles from our rich catalog of books and videos available at `https://github.com/PacktPublishing/`. Check them out!

Code in Action

Code in Action videos for this book can be viewed at `http://bit.ly/39nvbQD`.

Download the color images

We also provide a PDF file that has color images of the screenshots/diagrams used in this book. You can download it here: `https://static.packt-cdn.com/downloads/9781801074162_ColorImages.pdf`.

Conventions used

There are a number of text conventions used throughout this book.

`Code in text`: Indicates code words in text, database table names, folder names, filenames, file extensions, pathnames, dummy URLs, user input, and Twitter handles. Here is an example: "Locate the `PondSign.png` image files within your filesystem and drag each into the appropriate scene."

A block of code is set as follows:

```
private function photoSelected(e:Event):void {
    var selectedPhoto:File = photos[e.target.selectedIndex];
    PhotoViewer.source = selectedPhoto.url;
}
```

Bold: Indicates a new term, an important word, or words that you see onscreen. For example, words in menus or dialog boxes appear in the text like this. Here is an example: "Select **More Settings** from the **Properties** panel."

> **Tips or important notes**
> Appear like this.

Get in touch

Feedback from our readers is always welcome.

General feedback: If you have questions about any aspect of this book, mention the book title in the subject of your message and email us at customercare@packtpub.com.

Errata: Although we have taken every care to ensure the accuracy of our content, mistakes do happen. If you have found a mistake in this book, we would be grateful if you would report this to us. Please visit www.packtpub.com/support/errata, selecting your book, clicking on the Errata Submission Form link, and entering the details.

Piracy: If you come across any illegal copies of our works in any form on the Internet, we would be grateful if you would provide us with the location address or website name. Please contact us at copyright@packt.com with a link to the material.

If you are interested in becoming an author: If there is a topic that you have expertise in and you are interested in either writing or contributing to a book, please visit authors.packtpub.com.

Reviews

Please leave a review. Once you have read and used this book, why not leave a review on the site that you purchased it from? Potential readers can then see and use your unbiased opinion to make purchase decisions, we at Packt can understand what you think about our products, and our authors can see your feedback on their book. Thank you!

For more information about Packt, please visit packt.com.

Section 1: Getting Up-To-Speed

Welcome to *Mastering Adobe Animate 2021*! This book is divided into three sections, each containing a set of chapters that focuses on a variety of fundamental topics. This first section of the book includes all the foundational and background content you must understand before tackling the more advanced chapters. You'll be introduced to a number of must-know foundational concepts and background information here that will be built upon as we proceed through the remainder of the book.

This section comprises the following chapters:

- *Chapter 1, A Brief Introduction to Adobe Animate*
- *Chapter 2, Exploring Platform-Specific Considerations*
- *Chapter 3, Settling into the User Interface*
- *Chapter 4, Publishing and Exporting Creative Content*

1
A Brief Introduction to Adobe Animate

This chapter provides background information on Animate, what it is used for in the industry, and specifics around the new features in Adobe Animate 2021 and how to put them to use. When new features are released, the software release notes usually just aren't enough, so we'll explore each of the new features in depth so that you can start using them right away, including the new Assets panel, rig management, quick publish options, timeline and symbol features, and even the new capabilities around creating your own in-app tutorials. We'll also cover some resources around keeping up to date with all things Animate. You'll come away from this chapter with a refreshed understanding of Animate as a creative platform for designers, animators, and developers.

After reading this chapter, you'll come away with the following skills:

- Understand the history of Animate and what the software can be used for.
- Learn which features have been added to the software, what their purpose is, and how to put them to use.
- Know where to look for new releases and stay abreast of new resources around Animate, related software, and the industry.

Technical Requirements

You will need the following software and hardware to complete this chapter:

- Adobe Animate 2021 (version 21.0 or above).

- Refer to the Animate System Requirements page for hardware specifications: `https://helpx.adobe.com/animate/system-requirements.html`.

Understanding Adobe Animate

Adobe Animate has a lengthy history that is full of growth, accolades, disappointments, crushing defeats, pivots, and at least one notable resurrection. To cover the entire history of this software would take a book in itself, so we'll only touch upon certain, relevant points here. It is important to know, however, that beginning a new project in Adobe Animate is now a unique experience that, without certain decisions by Adobe and obvious passion from the community of users, might not be possible today.

A Bit of History

Animate began its journey as a simple vector graphics drawing program called **SmartSketch** for use on stylus-based devices developed by a company called *FutureWave*. It soon gained such popularity that it was made available on both Windows and macOS with added motion capabilities and given the name **FutureSplash Animator**. The blossoming popularity of the **World Wide Web** at this time led to the software pivoting to target this young medium through the use of a browser-based runtime.

This was the beginnings of both the authoring software that we still use today and what eventually became the **Flash Player** browser runtime. The idea was that you could author your content using FutureSplash Animator and play back the content through the web browser using an installed extension, often referred to as a **plugin**. The capabilities of web browsers at the time were such that **HTML** was a simple markup language for sematic text declaration and hyperlinks. Technologies such as the current iterations of **CSS** and **JavaScript** didn't even exist yet; even image files were barely supported! If you wanted a rich media experience on the web, you had to rely on such browser plugins.

Macromedia acquired FutureWave (and FutureSplash Animator) in 1996 and rebranded the software as **Flash** – sort of a combination of the two names! They made huge investments in the authoring software and web browser plugin, renaming it to **Flash Player**. Macromedia was also responsible for the **ActionScript** programming language and the expansion of the **Flash Platform** across a number of areas, including web, server, and even small steps into mobile.

From FutureWave to Macromedia and now to Adobe, Animate has changed a lot over the years!

Figure 1.1 – 25 years of Adobe Animate

In 2005, **Adobe Systems** acquired Macromedia and all their properties (including Flash!) and have been holders of this technology ever since. Under Adobe, we've seen both great strides and seriously missed opportunities over the years.

On the one hand, the Flash Platform was greatly expanded upon under a number of proprietary and open source initiatives, ActionScript 3.0 was released, and **MXML/ Flex** was made much more accessible to many developers. We even had Flash Platform technologies integrated into nearly every piece of creative software Adobe distributes directly within the workspace panels of software such as **Photoshop** and **Illustrator**. On the other hand, the push for Flash Player on mobile was so bungled that the platform could never recover from the fallout.

While Adobe did release a number of versions of Flash Player for Android and **RIM/ Blackberry** devices, they were never able to get the runtime on **Apple** devices such as the iPhone and iPad. Adobe eventually gave up on Flash Player on mobile altogether and decided to refocus their efforts on the **Adobe Integrated Runtime** (**AIR**), which allowed **iOS**, **Android**, and desktop applications and games to be developed with Flash technologies, and Flash Player on desktop browsers with a renewed interest in 3D and gaming technologies in the form of **Stage3D**.

Adobe made huge efforts with Flash Player at one point, touting Stage3D, concurrency, and more options that appealed to game developers in order to create a blazing-fast experience for the user.

> **Important Note**
> If you'd like to learn more about mobile Flash Player and AIR for Android, have a look at the book *Flash Development for Android Cookbook* by Joseph Labrecque, also from Packt: `https://www.packtpub.com/product/flash-development-for-android-cookbook/9781849691420`.

During this time, **Flash Professional**, the authoring software, was neglected quite a bit. The focus on mobile and developers left creative software such as Flash Professional with fewer resources and, once Adobe lost the war for mobile, the association of Flash Player with Flash Professional was one that even they had trouble justifying. Many expected Adobe to abandon the software entirely, but while Adobe was focused on developers during these years, animators were actually using Flash Professional heavily to produce content for television, web, and film projects.

> **Tip**
>
> If you are curious about what television series make use of Adobe Animate, have a look at the following resource: `https://en.wikipedia.org/wiki/List_of_Flash_animated_television_series`.

In late 2015, following a year or two of a visible increase in both the creative feature set of the software and the inclusion of new target platforms such as **HTML5 Canvas**, Adobe announced that the next version of Flash Professional would be rebranded as Adobe Animate:

CREATIVE CLOUD

Welcome Adobe Animate CC, a new era for Flash Professional

 Rich Lee
November 30, 2015

For nearly two decades, Flash Professional has been the standard for producing rich animations on the web. Because of the emergence of HTML5 and demand for animations that leverage web standards, we completely rewrote the tool over the past few years to incorporate native HTML5 Canvas and WebGL support. To more accurately represent its position as the premier animation tool for the web and beyond, Flash Professional will be renamed **Adobe Animate CC**, starting with the next release in early 2016. *[Update 2/8: Animate CC is now here!]*

Figure 1.2 – Adobe Animate is announced

The name change was primarily a way to let the world know that the software was no longer bound to a single platform (Flash) and that creative motion was going to be a big focus moving forward. Since that time, Animate has only gotten better and continues to be used by creatives and developers alike to target multiple platforms without restriction:

> **Note**
>
> The year 2021 marks 25 years of Adobe Animate through all its various identities over the years, from FutureSplash Animator to Macromedia Flash and Adobe Flash Professional, all the way to the present with Adobe Animate. A well-deserved milestone!

© 1993-2020 Adobe. All Rights Reserved.

Artwork by Charlie Davis. For more details and legal notices, go to the About Adobe Animate screen.

Initializing JavaScript API...

Figure 1.3 – Adobe Animate 2021

Animate 2021 is the latest release and the major features that have shipped over the past year will be detailed within this chapter.

Familiar uses of Adobe Animate

With 25 years of history behind it, Adobe Animate has been used in all sorts of projects. In recent years, as the focus of the application has moved from a purely Flash-based experience to one that is much more platform-agnostic and increasingly expansive, the possibilities have expanded as well. This is a great time for new users to learn the software and for those who may have used older versions of the software to revisit it and see what is now possible.

Animation and motion design remain two of the biggest uses of the software. People all across the world are exposed to content created in Animate every day and likely do not even realize it! This content is hosted on the web, streamed through subscription services, and can be viewed on a wide assortment of television channels.

Of course, many digital advertisements across the web and mobile are also created with Animate. The software even has a number of presets that conform to such ad standards, making it easy to get going with this platform.

One of the things that makes Animate unique, however, is its dynamic and interactive capabilities. Non-interactive animated features such as *Star Wars: Galaxy of Adventures* and *My Little Pony: Friendship is Magic* are all great, but Animate can produce rich, interactive content as well.

Dumb Ways to Die and *Angry Birds* are two well-known examples of interactive content created with the software. Animate, and Flash before it, has a long history of games and interactive applications hosted on the web with Flash Player and HTML5 Canvas, but also on Android and iOS, as packaged natively for those platforms using AIR. In fact, **YouTube** got its start and saw such immense popularity thanks to Flash Player and what was made possible through these technologies.

Again, Animate is unique and powerful with its ability to combine both design and development capabilities seamlessly within the same environment.

In this section, we explored the history of Adobe Animate and gained an understanding of the many reasons it has changed identities over the decades. We also had a look at some common uses of the software. Coming up, we'll take a comprehensive look at the new features that were introduced between Animate 2020 and Animate 2021.

Exploring New Features of Animate

With nearly every new Animate release, users receive access to new features and improved workflows. Since the release of Animate 2020 in November 2019, there have been a large number of features added to the software that users should know about. We'll go over each of these features now, and will work with some more thoroughly in subsequent chapters of this book!

Assets Panel

While Animate has had a Library panel for most of its existence, it is just used on a per-document basis to contain assets such as bitmap images, sound files, and internal symbols, and once that document is closed, you'd need to open it back up again to transfer any assets between documents for reuse.

> **Tip**
>
> If the Assets panel is not visible within your chosen workspace, you can enable it by selecting **Windows | Assets** from the app menu.

The new Assets panel works differently from the Library panel in that it contains a persistent set of assets that exist apart from any single document. When you first use the panel, it is prepopulated with a library of material from Adobe, but the real power of this panel comes into play once you create your own custom collection of assets and include them in the panel. Managing important assets in this way allows quick access to them, no matter what document you might be working in at any one time.

Assets are organized into main categories that include **Animated**, **Static**, and **Sound clips**:

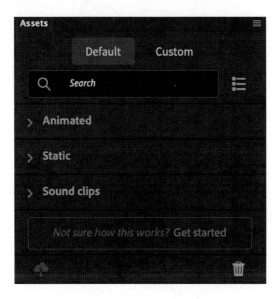

Figure 1.4 – Assets Panel

You can search the panel for keywords and tags or expand a number of subcategories to find what you need.

Managing Animate Assets

Assets are managed externally from the Animate program itself by exporting them as .ana (Animate asset) files. You can generate and export .ana files from any project library and even export a full scene as a single .ana file.

> **Note**
>
> You might expect an Animate authoring file to hold the `.ana` extension, but the extension for an authoring file is actually `.fla`! The reason for this is due to Animate formerly being known as Flash Professional.

To export content as an Animate asset file from the library, select the asset you want to export and open the right-click menu:

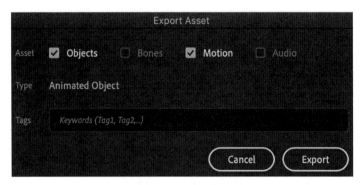

Figure 1.5 – Asset generation

Choose the **Export Asset** option and follow the prompts to specify what to include and how to tag your asset for organizational purposes:

> **Tip**
>
> You can also generate assets for use immediately within the Assets panel and avoid the intermediate `.ana` file format by simply choosing **Save as Asset** instead of **Export Asset** from the Library panel.

Upon initial installation, Animate includes a small number of default assets within the Assets panel. Adobe makes additional assets available through a download mechanism available at the bottom of the panel. It appears as a small cloud with a downward-facing arrow. If additional assets are available for download, this icon becomes brightly colored and you can then click on it to download additional assets from Adobe's servers.

> **Tip**
>
> It is also possible to delete assets from the Assets panel that you no longer need. Right-click on the asset you want to remove and choose **Delete** for the right-click menu that appears. Note that you can also rename assets in this way!

Anyone with a recent copy of Animate can then use the Assets panel to import prepared assets into the **Custom** area of the Assets panel.

Social Share and Quick Publish

Traditionally, there have been two primary methods for generating distributable content from an Animate document.

The first way would be to publish your content, and what form the published content takes would be tied directly to the document target type. Examples of this would include the following:

- **HTML5 Canvas** publishes to HTML and JavaScript.
- **ActionScript 3.0** publishes to Flash Player.
- **WebGL glTF** publishes to JavaScript.
- **AIR for iOS** publishes to an iOS app.

These are just a small set of examples to show a direct relationship between the chosen target platform and the resulting published file types.

The second way would be to export files derived from your Animate document through various export mechanisms found under the **File | Export** menu. These file types vary quite a bit from one another and are completely independent of the chosen document type. For instance, any document type in Animate can export content as a video file or animated GIF.

The new social share and quick publish options help to get around that confusion and publish directly to some of the most common formats, regardless of the traditional differences between exporting and sharing your Animate content. Both are accessed from the **Quick Share and Publish** menu at the upper right of the Animate UI, left of both the workspace switcher and the **Play Movie** button:

Figure 1.6 – Quick Share and Publish appears as a box with an upward arrow emerging from it

When you click this button, you gain access to the **Social share (One click social media share)** and **Publish (Export in multiple formats)** options:

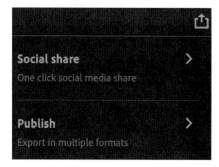

Figure 1.7 – Social share

Choosing either option will open a secondary menu of choices. Let's take a look at these options.

Social share

Choosing **Social share** will bring you to the next step in that process, which presents the choice of sharing directly to **Twitter** or **YouTube**, with more social channels coming soon:

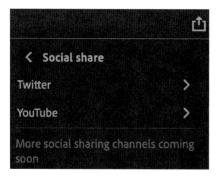

Figure 1.8 – Social share

Selecting either of these two options will necessitate an authentication task that allows Animate to publish directly on your behalf.

Once authenticated, Animate generates the media in a format suitable for either channel and allows the inclusion of a small message (with hashtags, of course!) before posting. After the content is successfully posted to the chosen social channel, Animate lets you know through a small confirmation dialog and the media is, at that point, live.

Quick Publish

Choosing **Publish** provides an alternative set of choices that depends somewhat on your document target platform.

For instance, if you're using HTML5 Canvas, you'll get the option to publish an MP4 video file, an animated GIF file, or a set of files compatible with HTML/JavaScript:

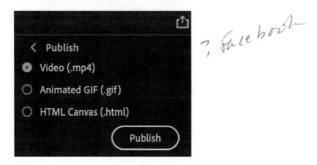

Figure 1.9 – Quick publish

However, if working from an ActionScript 3.0 document type, you'll be presented with only options for video and animated GIF, since a .swf file is no longer appropriate for public distribution.

> **Note**
> SWF files can be used in many different ways as part of an authoring workflow across applications such as Animate and After Effects, but are no longer able to be used in public channels due to web browsers no longer supporting Flash Player since December 31, 2020. Adobe no longer supports Flash Player in the web browser, but the format is thankfully still useful for advanced workflows.

Just as with the channel selection for social sharing, the quick publish options will likely change over time, especially as more targets are added to Animate.

Timeline and Symbol Enhancements

Almost every new release of Animate contains not just entirely new features but also quality-of-life improvements, which expand upon existing functionality in meaningful ways. This new version of Animate does an excellent job in this area, expanding and improving workflows across the timeline and symbols.

Converting Layers to a Symbol

Oftentimes when working in Animate, you'll find yourself having created some really engaging content in the main timeline that you then decide should have really been created within a symbol instead. At that point, you'll need to create a new symbol, then manually cut the layers you need as part of that symbol from the main timeline, and finally, paste these layers into the empty symbol itself. It can be a lot of work!

Thankfully, with this new version of Animate, converting layers to a symbol no longer has to be such a manual process.

We now have the ability to select the layers we want to convert to a symbol, open the right-click context menu from the selected layers, and choose the new **Convert Layers to Symbol** option:

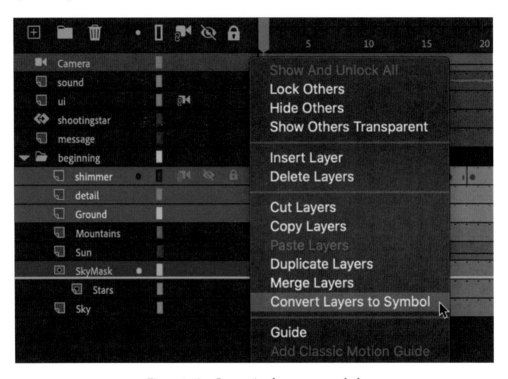

Figure 1.10 – Converting layers to a symbol

The **Convert Layers to Symbol** dialog will then appear. It looks exactly like the dialog to either create an empty symbol or convert existing assets to a symbol:

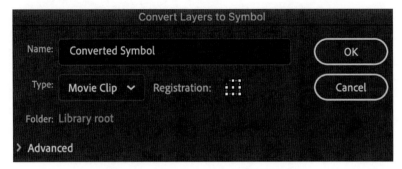

Figure 1.11 – Convert Layers to Symbol Dialog

You can provide a symbol name, choose the symbol type, and even set the registration point for your new symbol.

Once you hit **OK**, the selected layers will be automatically transferred to the symbol's internal timeline and the original layers are replaced with a new layer containing an instance of the new symbol.

Converting Symbols to Layers

In a similar way, you can perform the inverse action on an existing symbol. Simply right-click on a symbol instance and choose **Break Apart Symbol to Layers** from the menu that appears:

Figure 1.12 – Breaking Apart a Symbol to Layers

New layers will be created, and the contents of the selected symbol will be placed in each layer with all properties intact.

Additional Looping Options for Graphic Symbol Instances

We also have additional looping options when working with graphic symbols. These small options will make long-time users of Animate very happy!

With a graphic symbol instance selected on the Stage, have a look at the **Properties** panel for **Object** properties and locate the **Looping** section:

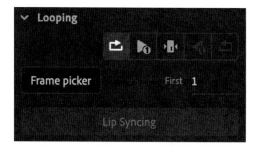

Figure 1.13 – Graphic Symbol Looping Options

Now, this will only exist for graphic symbols, so any other type of object selected will not include this special section.

Notice the set of five buttons at the top of this section. Previous versions of Animate only included three options here:

- **Play Graphic in Loop**
- **Play Graphic Once**
- **Play Single Frame for the Graphic**

There are now two additional options that will make things so much easier whenever you want to reverse the playback of a graphic symbol instance:

- **Play Graphic Reverse Once**
- **Play Graphic in Reverse Loop**

To reverse playback before these options, you'd need to enter the symbol, copy and paste keyframes and associated tweens, and finally, reverse the order of the keyframes to create reverse motion. The same effect can now be accomplished with the click of a button!

Copy and Paste Tween Settings

Animate has also improved the tween management controls in this new version (we will discuss tweening in more detail in *Chapter 5, Creating and Manipulating Media Content*). You now have the ability to copy and paste tween settings from one tween to another.

With a tween selected in the timeline, look at the **Properties** panel for **Frame** properties and locate the **Tweening** section:

Figure 1.14 – Copy and Paste Tween Settings

At the upper right of that section is now a small gear icon and clicking it gives you access to additional tween options, which allow you to choose **Copy settings**, **Paste settings**, or even **Reset settings** for the selected tween.

Advanced Rigging

Animate includes a variety of ways in which various structures can be bound together in some form of hierarchy to create a rig. The most common of these involve **layer parenting** through the use of **Advanced Layers mode** and **Inverse Kinematics (IK)** through **armatures** and **poses**. The expanded rigging system in Animate expands upon the use of IK armatures in order to isolate a rig independently from the visual assets for reuse across additional visual forms.

> **Note**
>
> The rigging process described here is in beta form as of the time of writing this book. Adobe intends to continue improving upon the rigging process, and rigs themselves, for subsequent releases of Animate.

Rig Mapping

The new **Rig Mapping** panel can be opened from the application menu by choosing **Window | Rig Mapping**.

This panel will also open automatically when selecting a rig for use within the Assets panel, as you must identify individual movie clip symbol instances to apply to specific bones of the rig armature:

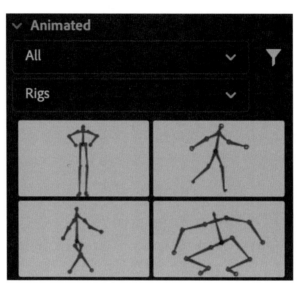

Figure 1.15 – Locating Rigs within the Assets panel

Rig Mapping is, at this point, bound directly to Rigs available through the Assets panel. Of course, you can create and use your own rigs as assets as well!

To apply a rig from the Assets panel to a symbol instance, you must first double-click the instance to enter the symbol itself. Dragging and dropping a rig onto the Stage will then open the **Rig Mapping** panel and allow you to map certain visual elements, such as torso, arms, and legs, to the rig itself.

You simply click each bone in the **Rig Mapping** panel and then choose individual movie clip symbol instances within the containing symbol to associate each bone with a symbol instance in order for the system to recreate the armature:

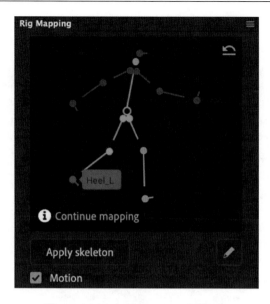

Figure 1.16 – Applying a pre-built rig

Be sure to start with the root node and then branch off from there. Rigged bones will appear green, while unrigged bones are gray in color.

Once you've mapped all the necessary visuals to the rig, choosing **ApplySkeleton** will create an armature, with full animation if the **Motion** checkbox is selected, to your symbol instance.

When a skeleton has been completely applied to a set of objects, the rig will appear pink.

Tip

There is also a way to automatically map a rig to your symbol instance and avoid the manual mapping process. For this to work, be sure that each of the movie clip symbol instances that make up your visuals include **instance names** that are identical to those from the rig itself. This method bypasses the visual **Rig Mapping** panel workflow altogether but is very specific.

Bone Tool Enhancements

Since the current rigging model is based upon IK armatures, and in an effort to improve how this model functions, improvements have been made to the IK engine itself.

With this particular improvement, we have the ability to further refine our rigs and control constraints at the end of leaf nodes for our armatures. While constraints were available across other node types as part of an armature in the past, this extends that model all the way to the end of each branch.

Auto KeyFrame

Traditionally, when using a Shape Tween or Classic Tween, you had to manually create keyframes before making a change in the object properties on the Stage. This is normally done by selecting a frame location where you'd like to create a keyframe and choosing to insert a new keyframe from the buttons above the timeline, from the right-click menu, from the application menu by selecting **Insert | Timeline | Keyframe**, or by using the *F6* keyboard shortcut. You then select that keyframe and modify the properties of your object on the Stage to create a change between the preceding keyframe and the one just created.

The new Auto KeyFrame option makes Shape and Classic Tweens behave closer to how Motion Tweens work, in that keyframes are created automatically as you adjust object properties across the timeline.

The **Auto KeyFrame** option can be turned on and off as desired from the **Insert Frames Group** drop-down menu:

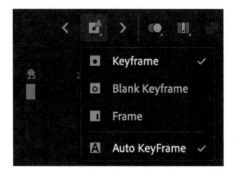

Figure 1.17 – Auto KeyFrame

When enabled, you get a small, circular indicator that appears above any selected frame. This indicates that a keyframe will be created there if any object properties are changed.

Hands-on Tutorial Creator

Beginning with Animate 2020, Adobe began to ship a number of in-app tutorials within Animate. While this began with a set of 2 introductory tutorials, the selection has now grown considerably larger and includes 15 tutorials of varying complexity. These tutorials appear within the application directly, in the form of little card overlays on the application UI.

They can include text instructions, motion previews of the step in action, and the ability to navigate across the various steps of a tutorial:

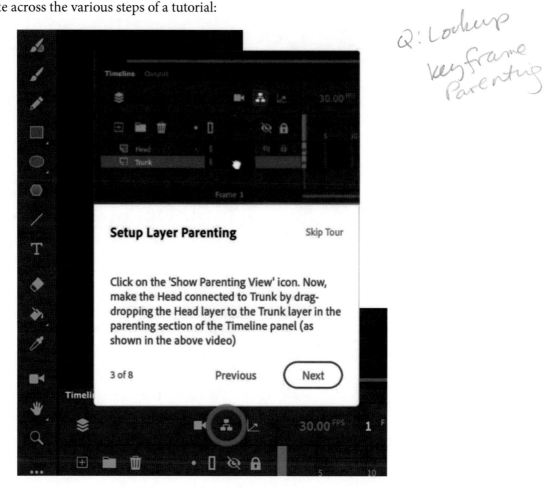

Q: Lookup keyframe Parenting

Figure 1.18 – Steps appear as contextual cards within Animate

Each tutorial will contain a curated set of steps prompting the user to perform certain actions in order to provide a step-by-step walkthrough directly within the application.

Adobe-supplied tutorials can be activated under the **Help** menu by selecting a specific tutorial from the **Hands-on Tutorial** submenu:

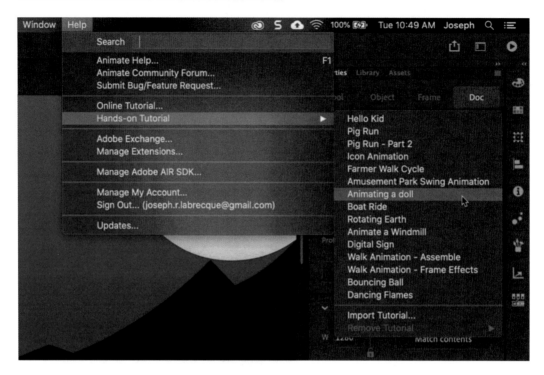

Figure 1.19 – In-app tutorial selection

These tutorials are meant to showcase certain techniques within the application in a way that is visual, engaging, and reliant upon the wilful action of the user. The tools to build these same types of tutorials are now available to any Animate user through a built-in extension.

All you need to do to get started is open **Window | Extension | Hands-on Tutorial Creator** to access this feature:

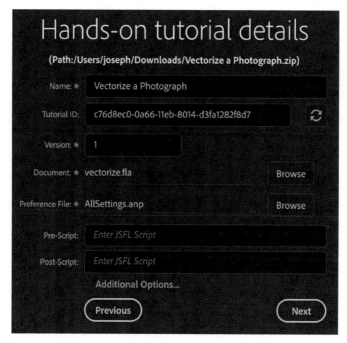

Figure 1.20 – Hands-on Tutorial Creator Panel

With the panel open and ready, you'll then proceed step by step through the process, building out various cards that contain explanatory steps, preview images or animation, and contextual prompts anchored to the application interface.

We'll explore this feature in depth in *Chapter 13, Extending Adobe Animate*.

Selective Texture Publishing

When using an HTML5 Canvas document, if you select **Texture** from the **Export as** dropdown within the **Image Settings** tab under the publishing options, Animate will process your textures using new optimizations that aim to reduce the file size by only converting complex vectors to bitmap textures, while retaining simpler shapes as vector data.

While there are additional export options for images when publishing HTML5 Canvas documents, in order to make use of this feature, you must be sure to choose **Texture** as the others will not support the new optimizations:

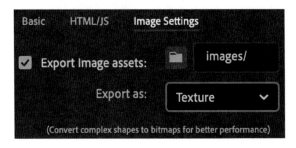

Figure 1.21 – Selective Texture Publishing

Adobe claims that even with such optimizations, runtime performance remains stable.

New Canvas Blend Modes

ActionScript 3.0 remains the most powerful and flexible document type you can choose to work with in Animate. It is a format that grew alongside the software and, for a long time, was the only platform available! Adobe owned the format and could add to or make adjustments however they pleased, making it all very powerful.

HTML5 Canvas is based upon web standards and, as such, does not have a close relationship with Animate, nor the flexibility and power that comes with a proprietary format such as ActionScript 3.0 and Flash. Because of this, things move much more slowly, and HTML5 Canvas still has a long way to go before it gets even close to what a Flash-based SWF can do in many areas. A good example of this is blend mode support. For a long time, there were only a few blend modes that were available to use when authoring content for HTML5 Canvas.

In newer versions of Animate, this has opened up a bit and many more blend modes are now accessible to content authors:

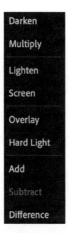

Figure 1.22 – Blend mode selection

The list of blend modes when using HTML5 Canvas is now much closer to what we can use when targeting ActionScript 3.0.

Previously supported blend modes in HTML5 Canvas included **Add** and **Normal**; that was it! In the current version of Animate, we have access to **Darken**, **Multiply**, **Lighten**, **Screen**, **Overlay**, **Hard Light**, and **Difference**, in addition to the two that were previously supported. Even with these additions though, there are a few that will still be disabled when using HTML5 Canvas.

> **Note**
> Blend modes in HTML5 Canvas are still quite limited as they cannot be animated across keyframes. Once set, that is what you are stuck with at runtime!

Stream Audio Sync in Canvas

One of the best reasons for choosing the ActionScript 3.0 target platform in Animate is that it provides not one but four sound sync types. Audio is hugely important in many mixed-media projects, and massively important in animation, especially when synchronizing sound with visual motion, event sounds, characters speaking, incidental noises, and so forth. If audio sync is off, the viewer will notice!

The best way to ensure that your audio is perfectly synchronized to the animated content is through the use of the **Stream** sync type. However, until now, the **Event** sync type was all that was available when targeting HTML5 Canvas. This meant that the use of audio inside an HTML5 Canvas project was quite limited, as **Event** sounds simply began playing and only stopped when they were over, making it really common for the audio and video to get out of sync.

When using HTML5 Canvas documents in Animate 2021, you can choose between both sync models!

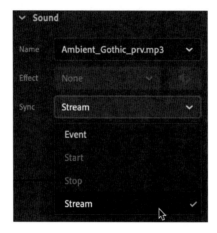

Figure 1.23 – Audio Stream Sync

Stream sounds are actually bound frame by frame to the timeline along with any visual content, ensuring that the sound and visuals always stay perfectly in sync with one another.

> **Tip**
> With the Stream sync type enabled in HTML5 Canvas, this means that you can now actually use the new Auto Lip-Sync feature of Animate in these documents as well.

The audio sync type can be chosen from the **Frame** tab of the **Properties** panel when an audio file from the project library has been assigned to a frame.

> **Note**
> Related to the sync type, you can now split the stream audio embedded on the timeline by choosing **Split Audio** in the right-click menu. Split Audio enables you to pause the audio when necessary and resume the audio from where it was stopped at a later frame on the timeline.

Enhanced Video Export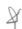

The amount of control you now have when exporting your Animate project as a video file has been greatly enhanced. Animate leverages **Adobe Media Encoder** to process video exports in a similar fashion to **Premiere Pro** and **After Effects**.

Many of the options that you once had to choose in Media Encoder are now present directly within the **Export Media** dialog within Animate. These include **Format** and **Preset**. These options are gathered directly from Media Encoder, so are the same across both applications.

There is also the option of specifying a specific start time and duration for your exported video, and you can even export specific scenes, so long as your working publishing targets support them.

Choose **File | Export | Export Video/Media** from the application menu to view all these new options as part of the **Export Media** dialog:

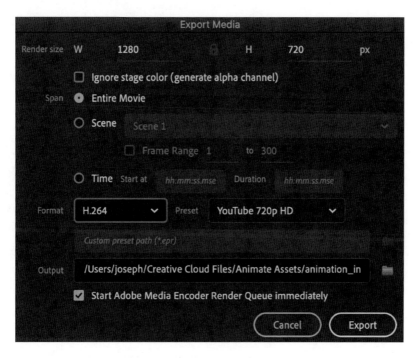

Figure 1.24 – Export Media Dialog

Once you click **Export**, Media Encoder will open and process the file, but you don't have to interact with that program directly at all any longer.

In this section, we had a comprehensive look at all the new features introduced in Adobe Animate over the past year. Coming up, we'll learn how to keep up to date with new versions of the software and related industry activity.

Keeping Up to Date with Animate Releases

As we have seen, Animate receives a significant amount of features between major versions! It's always a good idea to stay on top of changes with any software for the benefits provided through new features, general improvements, and overall compatibility with other software. Aside from the software itself, it's beneficial to understand how others are using the software and general thoughts around intersections with others in the industry.

Adobe Creative Cloud Desktop

Just like any other Adobe Creative Cloud desktop application, Animate is managed through the Creative Cloud desktop application. You can download the desktop application from `https://www.adobe.com/creativecloud/desktop-app.html`, either if you need to install it for the first time or if you need to perform a forced update.

The Creative Cloud desktop app will alert you whenever a new version of Animate has been released:

Figure 1.25 – Creative Cloud Desktop

If you have the application installed, you can easily see whether Animate is up to date by viewing your installed applications.

Any that are up to date will indicate this and those that have an update will display that information as well:

An **Animate** ● Up to date

Figure 1.26 – Animate is up to date!

It's a great mechanism for staying on top of new updates across all Creative Cloud software.

To manually check for updates, click the **Updates** tab along the side and locate the **More Actions** button at the upper right of the screen. Clicking this button allows you to either **Enable Auto Update** or **Check for Updates**. With auto-update disabled, you'll need to manually update Animate when a new version is released.

Adobe Blog

The Adobe Blog at `https://blog.adobe.com/` is a great resource for keeping up to date on all things Adobe. Of course, articles having to do with Animate are included here as well!

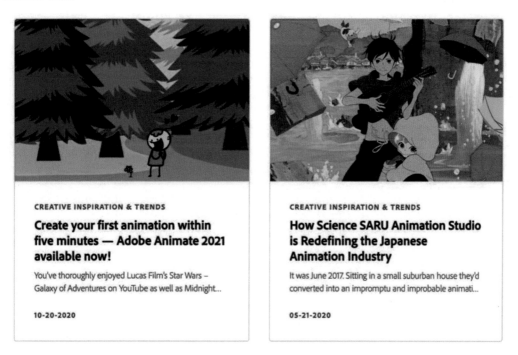

Figure 1.27 – Adobe Animate blog

Subjects range from animator interviews and project showcases to new feature announcements. Many of these are written by Ajay Shukla from the Animate team and can be found under his profile: `https://blog.adobe.com/en/authors/ajay-shukla.html`.

Adobe MAX

Generally, new versions of Animate (and most other Adobe Creative Cloud software) are released at the annual creativity conference: Adobe MAX. You can learn more about Adobe MAX at `http://max.adobe.com/` and even register to attend if it is that time of the year. MAX normally takes place in the autumn and runs for about 3 days.

It is a great opportunity to learn more about Animate and other creative software while being inspired by industry experts:

Figure 1.28 – Adobe MAX Creativity Conference

Adobe Animate 2020 was released at Adobe MAX 2019, and Animate 2021 was released during MAX 2020. You can see how important this conference is to Adobe and their release strategy!

In this section, we examined how to keep Animate updated with the most recent version and explore news and happenings in the wider community.

Summary

We have already gone over a lot of content in this first chapter! You should now have a good understanding of the state of Adobe Animate through the years and can speak of its current capabilities. You also now have an excellent understanding of all the new features that have been released since the previous major version of the software. You know how to use Animate assets, how to manage rigs, and can even create your own custom, in-app tutorials. We also covered some good places to look at so as to ensure that your installation of Adobe Animate remains up to date and that you stay abreast of any changes to the software.

In the next chapter, we'll explore the various target platforms supported by Animate. Get ready to learn about HTML5 Canvas, ActionScript 3.0, AIR for desktop, WebGL glTF, and more!

2

Exploring Platform-Specific Considerations

We will now spend some time exploring the various target platforms that are natively supported by Adobe Animate. To be successful with Animate, you must understand the underlying technologies involved in each platform and when to use one over another, as they each have their strengths and weaknesses. This understanding enables sound decisions when selecting a target document type when starting a new Animate project.

We'll begin with an overview of the major platforms supported natively as publish targets within Animate. Following this, we can then explore the variety of document types that support and target different aspects of these platforms for a greater understanding of why you might use certain document types over others.

Objectives for this chapter include the following:

- Understand the set of platforms native to Adobe Animate.
- Learn the purpose of and best practices around ActionScript 3.0, HTML5 Canvas, and AIR document types.
- Understand recommendations around beta document types, including both Virtual Reality (VR) and WebGL (standard and extended).

Technical Requirements

You will need the following software and hardware to complete this chapter:

- Adobe Animate 2021 (version 21.0 or above).

- Refer to the Animate System Requirements page for hardware specifications: `https://helpx.adobe.com/animate/system-requirements.html`. The CiA video for this chapter can be found at: `https://bit.ly/3cike51`.

Exploring Animate Document Types

While Flash Professional was, for years, focused entirely on the Flash platform, Adobe Animate seeks to define itself as a platform-agnostic software application. This basically means that any target platform is welcome to be part of the publish pipeline – even those not traditionally associated with the software.

Even though Animate seeks to play well with any platform that wants in on the game, it does support a number of important platforms natively:

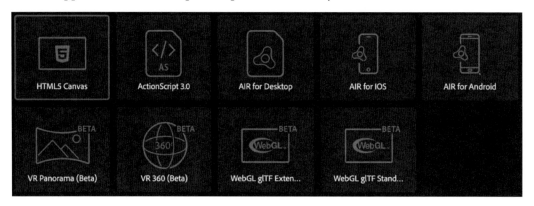

Figure 2.1 – Publish targets native to Animate

Today, Animate comes pre-packaged with a number of target platforms for common usage. These include ActionScript 3.0, AIR for Desktop, AIR for iOS, AIR for Android, HTML5 Canvas, VR 360, VR Panorama, and WebGL glTF (in both standard and extended flavors). Some of these target platforms are still based on Flash Platform technologies, but most newer platforms that have been added target native web technologies such as the HTML canvas element with JavaScript and include specifications such as WebGL and glTF to achieve some pretty neat stuff!

You can see all available document types by choosing **File | New** from the application menu or by choosing **Create New** or **More Presets** from the **Home** screen and then choosing the **Advanced** category of the **New Document** dialog:

Figure 2.2 – New Document dialog – Advanced presets

The **Advanced** category of presets allows you to create a new document based upon a specific publishing platform, while the other category presets tend to only allow the choice of *ActionScript 3.0* or *HTML5 Canvas*.

> **Tip**
> Within the **New Document** dialog, document types are listed under **Platforms** and **Beta Platforms**. You may need to scroll down to see them all. Any third-party platforms that have been enabled will show up even farther down the stack.

We'll next proceed through an overview of the major platforms available in Animate today. These are all based upon the Flash platform runtimes, native web technologies, and a set of beta platforms that extend these technologies.

Flash Platform Runtimes

As we detailed in the previous chapter, Animate was once only able to author **Flash Platform** technologies. You could create content to publish as a `.swf` to be executed using Adobe **Flash Player** in the web browser. For a long time, that was pretty much it! Of course, Flash content was absolutely huge during that time and Flash Platform designers and developers had no problem with this popularity.

The Flash Platform covers two main runtimes: the web-based Flash Player and the **Adobe Integrated Runtime** (**AIR**):

Figure 2.3 – The Adobe Flash runtimes: Flash Player and AIR

Both publish targets are based upon **ActionScript 3.0**, but in Animate terminology, the ActionScript 3.0 document type publishes a `.swf` file for use with Flash Player or other external mechanisms.

With all major web browsers – and even Adobe – no longer supporting Flash Player in the browser, we've come to a very interesting point in time. Even with web browsers no longer supporting Flash Platform content, the `.swf` format and other files published in various forms using the platform are still highly usable for many purposes. These purposes include the format's role as a motion graphics interchange format for other software such as Adobe After Effects, as packaged **projector** content, and most importantly, as an application development platform in Adobe AIR with the ability to target macOS, Windows, iOS, Android, and more!

Branching Out to the Native Web

In 2011, Adobe began an experiment with converting documents created with Flash Professional to **HTML5**. The project was codenamed **Wallaby** and only existed for a few years until other technologies and superior workflows took its place. Wallaby required an existing `.fla` for conversion and only included about 50% of the capabilities of a Flash `.swf` file.

This was followed in 2012 by **Toolkit for CreateJS**, an extension that would allow Flash Professional users to export to HTML5 directly from the software without having to produce an intermediate `.fla` file. The problem with this mechanism was that it was an optional extension that users would need to install, and it was still not tightly coupled with the authoring environment in the way that users would expect, and so was limited when compared to producing Flash content. The Flash Professional Toolkit for CreateJS ran as an extension and appeared as a panel within the interface – very different from the normal publishing process.

Eventually, with the maturity of the **CreateJS** libraries, coupled with a more platform-agnostic approach to publishing within the software, Flash Professional made CreateJS a native document type within the software through the use of the HTML5 Canvas document type.

Since that time, Adobe and the CreateJS team have expanded capabilities and integrations to the point where HTML5 Canvas is one of the primary document types within Animate. For interactive, web-based content, HTML5 Canvas is the go-to document type.

In addition, Animate can publish to the native web beyond the use of CreateJS through the use of the **WebGL** standard alongside the additional WebGL and **Virtual Reality** JavaScript runtime engines. We'll also explore some basic information around these additional native web-based target platforms in a bit!

Open to Custom Platforms

We mentioned previously that Adobe Animate is a **platform-agnostic** software application. This is a pretty major change in the software since, for most of its existence, Flash Professional produced content that ran exclusively within Flash Player.

We've explained a bit about expanding to additional platforms with *CreateJS* and related standards such as *WebGL*, but Animate actually goes even further by opening up the entire publishing **API** for anyone to incorporate their publish target platform of choice into the software:

Animate

The Animate Custom Platform SDK lets you extend Animate to support custom platforms. In addition, the Unity reference import plugin allows you to import animations orchestrated in Animate to...

(View downloads)

Figure 2.4 – Animate custom platform SDK

Leveraging the **Custom Platform Support Development Kit (CPSDK)**, anyone can create an extension that allows Animate users to target the platform of their own choosing. The CPSDK extends the power of Animate to new platforms such as **Google AMP** and **LottieFiles**. We'll look more deeply into different examples of extending Animate in *Chapter 13, Extending Adobe Animate*.

> **Note**
>
> Animate can be extended in three ways. It includes a **JavaScript API (JSAPI)** to automate actions in the user interface and the CPSDK to extend the power of Animate to new platforms.

In this section, we had a brief introduction to the three main target platform types supported by Adobe Animate: Flash/ActionScript-based targets, HTML/JavaScript-based targets, and custom platforms. Coming up, we'll have a look at the particulars around using ActionScript 3.0 documents.

Understanding ActionScript 3.0 Documents

It makes sense to first explore what was at one time the single target platform supported by Animate for most of its existence: Flash Player and the .swf file format. Since Flash Player is a runtime, it exists to execute a packaged set of assets and data in order to run a program. The .swf file format is basically a compressed little bundle of creative assets and code that Animate can publish for this purpose.

> **Note**
>
> ActionScript 3.0 used to be used to produce all sorts of rich, interactive content. With the deprecation of Flash Player in the web browser, however, the role of .swf has become more focused.

There is a bit of confusion around the naming of this document type within Animate, as you won't find a document type that targets "Flash Player" or "SWF" but rather "ActionScript 3.0" instead:

Figure 2.5 – The ActionScript 3.0 document type

Newcomers are often confused by this terminology and expect that, if creating an **ActionScript 3.0** document, they will be writing code. While you can absolutely write full applications using this document type, it isn't necessary to do so.

ActionScript 3.0 documents are ideal for working in Animate when exporting to video or even for integration with *After Effects* and other compositing software. ActionScript 3.0 is the document most often chosen for creative, non-interactive content today, even over any sort of Flash Player. If you want to create interactive content for the web or other platforms, Animate can do those things too! You'll want to use other document types such as HTML5 Canvas or AIR for these purposes.

Okay, let's dig deeper through an overview of the technologies behind ActionScript 3.0 documents in Animate by exploring Adobe Flash Player, the SWF file format, and the ActionScript programming language.

Adobe Flash Player

There are a couple of different versions of *Flash Player* to know about. There is, of course, the once-ubiquitous web browser plugin that was finally deprecated on December 31, 2020 after years of being a staple web technology and even being built into major browsers such as *Google Chrome* and *Microsoft Internet Explorer* due to its status as a de facto standard.

Adobe announced that Flash Player in the web browser would be deprecated way back in 2017 and we should assume from now on that no user will be able to run such content through the browser plugin.

The reasoning behind this decision was stated that native web standards such as **HTML5**, **WebGL**, and **WebAssembly** had reached a point of maturity that they could now be relied upon to serve the same (or similar) needs that Flash Player in the browser had fulfilled in years past, thus making Flash Player redundant.

> **Important note**
>
> For more insight into the thinking behind this, I suggest you have a look at the Adobe Flash Player EOL General Information Page at `https://www.adobe.com/products/flashplayer/end-of-life.html`.

The web browser is only part of the story though. There are also standalone and debug versions of the Flash Player runtime, which can operate outside of the browser environment. A good example of this is the Flash Player that is built into Animate itself. Whenever a **Test Movie** is performed from an ActionScript 3.0 project, Animate opens a `.swf` file produced from your project within this version of Flash Player. It's very convenient to be able to test your animated content directly within the authoring software in this way.

The SWF file format

As mentioned previously, when publishing an ActionScript 3.0 document in Animate, a `.swf` file is produced. The `.swf` file extension is so named due to Macromedia wanting to extend its **Shockwave** branding that was being used by another software product, **Director**, to produce content that would run on the web.

When Macromedia acquired *FutureSplash Animator* and renamed it *Flash*, they also named the files it produced **Shockwave Flash** – SWF!

Figure 2.6 – ActionScript 3.0 produces a SWF file

What made this file format so desirable for use of the web was that it could contain all sorts of media: vectors, bitmaps, sound, video, data, and program code. It did all of this in a very efficient way, as these files were known for being small in size and as such, quite suitable for transfer over the web.

In 2008, Adobe published portions of the `.swf` file format as part of their **Open Screen Project** initiative, but since much of the technology is either licensed or strictly proprietary, anyone wanting to build an open source version of Flash Player to interpret `.swf` files will have a difficult time replicating all functionality.

With the decline of Flash Player and the eventual removal of the runtime from web browsers, it has become increasingly difficult to play `.swf` files as originally intended. Thankfully, the `.swf` file format can also be used as a transport format, and other applications such as **Adobe After Effects** can leverage this as part of an animator's compositing pipeline.

The ActionScript Language

ActionScript is the programming language native to Flash Player and the `.swf` file format. There are three versions of the language: **ActionScript 1.0** and **ActionScript 2.0** are very similar to one another and are executed by the same **VM** (**virtual machine**) within Flash Player and AIR, while **ActionScript 3.0** is a completely new language that runs in its own dedicated VM.

Similar to **JavaScript**, ActionScript is based upon **ECMAScript**, and while both languages do share many features, ActionScript 3.0 is based upon **ECMAScript 4**, which was ultimately abandoned and explains the various differences between ActionScript and JavaScript as they exist today.

A simple example of an ActionScript class is the following:

```
package com.josephlabrecque.example {
    public class Example {
        public function Example() {
            // constructor code
        }
    }
}
```

Even with this small example, you can see how organized the language structure and syntax is. Each *class* exists within a *package* and requires a constructor function. The language also supports object-oriented concepts such as interfaces and instantiation.

Even with Flash Player in the web browser being a thing of the past, ActionScript is still an excellent language, fun to write, and feature-rich. Even in the present day, we can effectively write applications and games for desktop and mobile using ActionScript and target these platforms with AIR technologies. We'll read more about AIR in a little bit.

Additionally, ActionScript is used when writing code for native web platforms through the integrations available in open source frameworks such as **Apache Royale**: `https://royale.apache.org/`. ActionScript is by no means a dead language!

> **Tip**
> ActionScript documentation can be found on Adobe's website: `https://help.adobe.com/en_US/as3/learn/`.

In this section, we explored the technologies involved when using the ActionScript 3.0 document type. Coming up, we'll perform a similar examination of the document type known as HTML5 Canvas.

Understanding HTML5 Canvas Documents

If you want to target the native web using Animate, the most popular option is to use the **HTML5 Canvas** document type. This is a native document type that is deeply integrated within Animate and produces animated and interactive content that will run in any modern web browser on desktop or mobile.

The HTML5 Canvas document type includes nearly all the capabilities and features that are available in older formats such as Flash, without the need for a separate plugin, extension, or runtime:

Figure 2.7 – The HTML5 Canvas document type

This is a native document type that is deeply integrated within Animate and produces animated and interactive content that will run in any modern web browser on desktop or mobile.

In our explorations of the HTML5 Canvas document type, we'll begin with a look at how Animate leverages both **HTML** and **JavaScript** to produce published content, followed by an overview of the canvas element, specifically. We'll round things off with a quick look at what makes all these technologies work together, the **CreateJS** libraries.

HTML and JavaScript

When publishing an HTML5 Canvas document, Animate will produce a bundle of files that includes HTML, JavaScript, and additional assets depending upon the project. The two main files that will always result when publishing this document type include an `.html` file and a `.js` file.

The **HTML** will act as a container document, while the **JavaScript** controls what happens within:

Figure 2.8 – HTML5 Canvas produces HTML and JavaScript

If using bitmap assets or sound files, they will also be included in the output within the folders you specify in the document **Publish Settings**.

Note

CSS can also be used in HTML5 Canvas documents through the use of **HTML5 Components**. To access these components, choose **Window | Components** from the application menu when using a document targeting HTML5 Canvas.

The CreateJS libraries themselves can be loaded via a **Content Delivery Network (CDN)** or can be exported along with your files (it's completely up to you). If you want to view your published files, it is best to transfer them from your local drive to a real web server. Browser security restrictions being what they are, they will likely not allow your canvas-based content to execute properly unless served from a web server.

Tip

When testing your HTML5 Canvas content via the **Test Movie** command within Animate, the software actually spins up a small, local web server to get around any potential browser security restrictions. It's very convenient!

The Canvas Element

The HTML5 Canvas document type is so named because it heavily leverages the `<canvas/>` element of HTML in order to provide a dynamic, interactive canvas for content playback and rendering. It basically defines a rectangular "stage" area in which all of our media resides as part of a larger HTML document.

A canvas element in HTML is established in the following manner using HTML Markup language:

```
<canvas width="1280" height="720"></canvas>
```

Here, we are only specifying a width and height for our element. You may want to also provide an ID in order to target this element specifically.

> **Tip**
>
> To learn more about the HTML canvas element, refer to the documentation on the Mozilla Developer Network: `https://developer.mozilla.org/en-US/docs/Web/HTML/Element/canvas`

To interact with and make adjustments to the canvas element and content rendered within, JavaScript is used. Have a look at the following example:

```
<script>
    const canvas = document.querySelector('canvas');
    const ctx = canvas.getContext('2d');
    ctx.fillStyle = 'darkred';
    ctx.fillRect(440, 160, 400, 400);
</script>
```

Here, we are defining our JavaScript code within an HTML `<script/>` tag. We initially set a constant to act as a reference to our canvas element and then set the context to operate in 2D. Following that, we are able to then draw content within this element through the use of the various canvas functions. In this simple example, we draw a red square and center it within the canvas element.

Animate, of course, does all this heavy lifting for us when working in HTML5 Canvas. There is no reason to manually create and manage HTML elements – we only provide these examples here for context.

> **Note**
> If you use components within an HTML5 Canvas project, they will be published within a special overlay that sits directly over the canvas element. Such projects will make use of both the canvas element and an additional set of elements representing the chosen components.

The CreateJS Libraries

While HTML and JavaScript establish the basic foundation of an HTML5 Canvas project, the real heavy-lifter for this target platform is **CreateJS**. This JavaScript library is actually a suite of libraries that includes the following:

- **EaselJS**: This library makes working with the HTML canvas element a more pleasant experience for those used to developing content using Flash technologies via the abstraction of the underlying APIs.

- **TweenJS**: We make use of this library to allow tweening and motion through the HTML canvas element and underlying native JavaScript APIs.

- **SoundJS**: Again, this library makes working with underlying web-native media APIs a more pleasant experience with a focus on audio management and playback for the web.

- **PreloadJS**: This allows the simplified management of both assets and data when working with other CreateJS libraries.

Together, these individual libraries form the **CreateJS** suite of tools. They can be used outside of Animate as well, but given that these libraries were designed specifically to emulate the Flash display list, they are a perfect match for Adobe Animate.

In this section, we saw how the canvas element of HTML combined with the CreateJS JavaScript library is used to form HTML5 Canvas documents in Animate. Coming up, we'll look at another important document type, Adobe AIR.

Exploring the Adobe Integrated Runtime

Adobe AIR was a major component of what used to be called the **Flash Platform**. It was one of two runtimes for the platform – and while AIR is certainly more powerful than its sister runtime, **Flash Player**, it is perhaps even more misunderstood. People generally understand web browsers and their capabilities and uses, but an installable package that runs similar to a native application on desktop and mobile such as AIR is somehow more difficult for the average person to get a handle on.

There is a lot to cover when it comes to AIR. We'll begin our overview with a look at a general explanation of what AIR is and its relationship to other technologies such as the **ActionScript** language. An explanation of the relationship between the two AIR **SDK** providers will follow as we go over recent partnerships between **Adobe** and **HARMAN**. To wrap things up, we'll explore the supported AIR document types within Animate: **AIR for Desktop**, **AIR for iOS**, and **AIR for Android**.

Adobe AIR

AIR itself is built upon Flash technology and in most cases, an .swf file is even produced that is packaged as part of the bundle:

Figure 2.9 – The AIR for Desktop document type

For platforms such as iOS that do not support .swf, the entire code base is actually translated into a native iOS application.

The main thing about AIR is that it runs entirely divorced from the web browser environment, while Flash Player was tied to it directly. This allows AIR to be much more powerful due to reduced security restrictions and tight integration with the underlying operating system. It uses the same language as Flash Player for writing interaction – ActionScript 3.0, and so was easy to adopt for the millions of Flash developers when it was first introduced.

Adobe AIR and ActionScript 3.0

Just as with ActionScript 3.0 document types within Animate, AIR makes use of ActionScript 3.0 as its primary programming language. Unlike targeting the output format as a limited .swf though, AIR is a natively installable package and because of this can have deep hooks within the operating system itself.

A great example of this is the **Extended Desktop** profile, which can be assigned within the **AIR Settings** dialog:

Figure 2.10 – The AIR publish settings allow deep integrations

When **Extended Desktop** has been chosen, AIR is then able to tap into the native processes of the operating system and communicate with any available process in order to really extend the capabilities of the runtime. This makes AIR far more powerful than anything targeting Flash Player or the web browser as it runs on the operating system itself and not through a security-restricted web browser prison.

> **Note**
>
> Initial versions of AIR actually supported developers in writing applications using either ActionScript or JavaScript. As the runtime developed further, the focus was placed on the ActionScript workflows, and eventually, JavaScript was dropped completely.

Adobe AIR and HARMAN

With Adobe halting all development on Flash Player in preparation for the December 31, 2020 deprecation event, they began looking for a partner to continue work on AIR, since it is still heavily used in the creation of applications and games and is completely unrelated to web browsers and the restrictions around that platform.

In May of 2019, the decision was made to partner more closely with **HARMAN**, a division of **Samsung**, which was heavily experienced in Flash Platform technologies. HARMAN would begin by focusing on an AIR solution targeting Android's upcoming 64-bit requirement and eventually expand to other platforms and systems supported by Adobe's version of the runtime.

Why was this decision made? With the end-of-life announcement of its sister runtime, Flash Player, Adobe had to decide whether they would continue supporting AIR or look to partners in the effort to maintain and grow the technology. In 2019, Adobe transitioned the development and support of AIR over to HARMAN due to their long history as a partner in the development and implementation of this technology for specific, bespoke implementations.

To read the announcement around this transition, have a look at *The Future of Adobe AIR* at https://blog.adobe.com/en/publish/2019/05/30/the-future-of-adobe-air.html.

HARMAN also released a statement about this new partnership on the same day as Adobe, in which they described the partnership and transition from their perspective. They explained, similar to the message from Adobe, their long partnership together on the AIR SDK and runtimes. The agreement between the two entities allows HARMAN to take on the support and maintenance of both the AIR runtime and the SDK. They also restated their commitment to ensuring the future growth and support of the technologies across various platforms.

Read more about the partnership from HARMAN's perspective in their FAQ: `https://airsdk.harman.com/faq`.

Since we are now well into 2021 at the time of writing this book, the partnership between Adobe and HARMAN has solidified and it is recommended that a new version of the AIR **Software Development Kit** (**SDK**) is acquired from HARMAN. In addition, the Animate team has repeatedly stated that Adobe remains committed to supporting AIR within Animate as part of this partnership, though you can also make use of the AIR SDK as a completely standalone SDK as well!

AIR for Desktop

An often-overlooked target for Adobe AIR is major operating systems through AIR for Desktop. Developers were able to target both **Windows** and **macOS** long before AIR became available for mobile systems. Originally, the only way to package and distribute applications built with AIR was through the use of an `.air` file. The `.air` format was special because it was completely cross-platform, but because of this, you needed to have the *AIR runtime* installed separately in order to install and run any AIR program. This was, of course, different from native applications.

As time went on, and the separate *AIR runtime* became more of a hindrance to users, additional packaging and installation options became available:

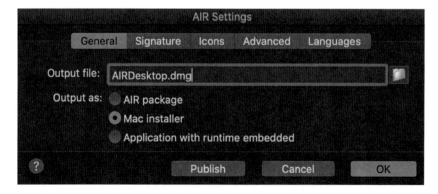

Figure 2.11– AIR for Desktop produces an AIR package or application installer

Today, when developing AIR applications, you can still produce `.air` files that run on both Windows and macOS, but you can also produce operating-system-specific installers that actually have a number of advantages over the `.air` approach. The first of which is that the user does not need to have an AIR runtime installed separately. The second is that a native installer allows even deeper integrations within the host operating system.

AIR for iOS

If you want to target Apple iOS or iPadOS, you can choose the AIR for iOS document type when creating a new project. This will always produce a native iOS package in the form of an `.ipa` file:

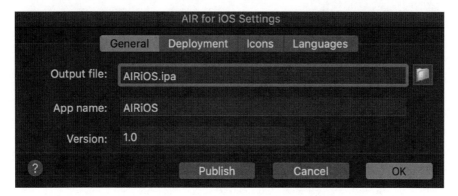

Figure 2.12 – AIR for iOS produces an IPA file

There are also many settings specific to Apple's platforms that can be configured within your **AIR for iOS Settings** dialog, but you cannot produce anything other than an `.ipa` package.

> **Note**
>
> AIR for iOS never had the ability to produce `.air` files as supported by desktop and Android because of Apple's policies against such things within their mobile systems. Adobe got around this by translating all of the assets and code produced in Animate to native iOS code, which is why the package type is so inflexible.

AIR for Android

Choosing the **AIR for Android** document type will allow a developer to target mobile devices and tablets running **Google Android**. The workflow is very similar to working with AIR for iOS, with platform-specific settings available in the **AIR for iOS Settings** dialog.

When targeting Android, you will produce an .apk file – the native format for Android applications:

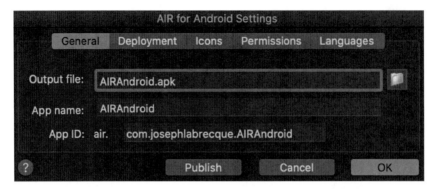

Figure 2.13 – AIR for Android produces an APK file

While we have no choice in the output file produced when targeting Android today, the *AIR runtime* was once also available for this platform in a way similar to how it functions on desktop operating systems. The AIR runtime for Android has since been deprecated and AIR applications must be packaged as .apk, similar to the situation with iOS.

> **Note**
>
> There is now a 64-bit requirement when publishing to Android. Because apps published through **Google Play** will need to support 64-bit architectures, you must use an AIR SDK capable of this. Be sure to use an SDK from HARMAN since the AIR SDKs from Adobe only produce 32-bit apps.

Because AIR can publish for iOS and Android, platforms related to these two core targets are available as well:

Figure 2.14 – Android TV profile selection in the publish settings

AIR for iOS and *AIR for Android* can also publish for **Apple TV** and **Android TV**, respectively.

In this section, we took a deep look at what Adobe AIR is and how it can be used to build installable applications and games for popular platforms such as macOS, Windows, iOS, and Android. Coming up, we'll take a look at the final set of document types available through a fresh install of Animate, the **WebGL glTF** and **Virtual Reality** beta platforms.

Experimenting with Animate Beta Platforms

In recent versions of Animate, Adobe has included a number of new documents that are intended for different use cases. This includes a set of four document types currently marked specifically as **beta**. They include **WebGL glTF (Standard)**, **WebGL glTF (Extended)**, **VR Panorama**, and **VR 360**. These can only be accessed through the **Advanced** category of the **New Document** dialog.

Since these document types are still in beta development, we won't spend as much time on them as we have the previously covered document types in Animate, but they are certainly exciting and worth our attention, so we'll give each a quick overview before moving on.

WebGL glTF – Standard and Extended

The two **WebGL glTF** document types in Animate allow the creation of web-based content as part of a GPU-accelerated experience. *WebGL* is a cross-platform web standard focused on low-level 3D graphics and the term **glTF** (**GL Transmission Format**) is an API-neutral runtime asset delivery format Animate leverages alongside WebGL:

Figure 2.15 – The WebGL glTF Standard document type

The *Standard* document type does not allow any interactivity, as the *WebGL glTF* specification does not allow it. This is an example of why you may want to use the *Extended* document type, though it does break with the established standard to achieve this.

> **Note**
> The **Extended** document type is only meant to run using Adobe's **WebGL glTF** runtime, while the **Standard** document type can be played within any standard WebGL gtTF playback – **BabylonJS** and **three.js** are examples of this.

VR Panorama and VR 360

These document types include a number of features specific to virtual reality, including the ability to use a 360-degree or panoramic photograph as a texture and a special VR View panel that allows more precise placement of interactive and animated assets within the environment.

Figure 2.16 – The VR Panorama document type

You can design your environment by marking certain layers in your timeline as textures, which, upon publication, get wrapped to the inside of either a cylinder or sphere – creating the illusion of being within the virtual space. Both of these target formats are for pretty specific use cases including museum walk-throughs, real estate, or more creative efforts such as experiments, environmental design, or even the creation of simple games.

Like other web-based documents, the VR betas publish to native web technologies and so you would use JavaScript as the coding language.

> **Tip**
>
> No matter what document type you choose, you can always convert from one target platform to another by choosing **File | Convert To** from the application menu. This will convert all assets and animation but any code will need to be rewritten as it is specific to each platform.

In this section, we looked a bit into what makes up the various beta platforms under development at Adobe. We'll read more about these platforms in later chapters, of course!

Summary

With this chapter behind us, you should now have a good overall picture of just how vast and varied the supported native document types within Animate are, and this doesn't even begin to touch upon the array of export formats available! We had a look at some history behind the different major platforms Animate supports and then explored many of the considerations and practices around each specific document type involved in these overall target platforms. We will continue to build upon the foundational knowledge established here in later chapters.

In the next chapter, we'll jump directly into Animate to examine the interface and overall layout of the software with a comprehensive look at how to customize the toolbar, timeline, workspaces, and overall preferences of the application.

3
Settling into the User Interface

We'll now explore Animate with an overview of the general workspace and discover how to get the most out of working with the software through customization. While Animate does come bundled with a number of workspaces targeting common workflows, it's also possible to create your own custom setup. You'll see how to choose which tools appear in the **Tools** panel and which are hidden away, in order to keep your go-to tools immediately present and accessible. We'll also look into customizing the timeline controls for more rapid animating and keyframe management. Finally, we'll have a look at the mechanisms that are in place for managing and preserving your finely tuned preferences. Animate boasts a very customizable experience across all aspects of the program!

After reading this chapter, you will be able to do the following:

- Achieve a working recognition of the general user interface.
- Understand how to manage and customize the workspace to your liking.
- Learn how to manipulate the available tools and timeline options.
- Gain the ability to manage, export, and import Animate preferences.

Technical Requirements

You will need the following software and hardware in order to complete this chapter:

- Adobe Animate 2021 (version 21.0 or above).

- Refer to the Animate system requirements page for hardware specifications: `https://helpx.adobe.com/animate/system-requirements.html`.

Exploring the Animate Interface

While Adobe does perform an interface refresh every 5 years or so on most of their creative software, many of the various panels and tools within Animate should be easily recognizable to those who have only had experience with Adobe Flash Professional or even Macromedia Flash. Animate has long been admired for the general workflows within the application and it would be a shame to break a good experience!

> **Note**
>
> Of course, that is not to say that the Animate UI hasn't changed and improved over the years. In fact, the 2020 version of Animate saw a complete interface refresh that was tweaked and improved upon for Animate 2021.

We'll now look over some of the more persistent interface elements that are part of any Animate workspace, no matter what type of project you are working on.

Important User Interface Elements

While it is absolutely true that the Animate interface can be customized to create hundreds of variants depending upon specific user preferences and workflows, there are certain elements of the general interface that remain so important as to be included in just about any imaginable configuration.

We'll now take some time to identify and provide some helpful information regarding these primary elements.

The Document panel

The largest visual portion of the Animate interface is the **Document** panel, which includes both the **Stage** and **Pasteboard**:

Figure 3.1 – Document panel with Stage and Pasteboard

Each document in Animate opens within the **Document** panel and multiple documents can be open simultaneously, through a system of tabs that display the document name above this panel.

Each document has both a **Stage** and a **Pasteboard** surrounding it. The **Stage** is effectively the container through which any visual elements are displayed as you work on your project, and when published. This is the only portion that will be visible to the viewer.

The **Pasteboard** is simply the area around the **Stage**. While objects on the **Pasteboard** are visible as you author your content, once published, viewers are not able to see anything on the **Pasteboard** until these elements are animated across the **Stage**.

The Timeline Panel

Just as important as the **Document** panel is the **Timeline panel**, which contains your layers, frames, keyframes, tweens, and a full set of tools to manage your frames along with project playback controls:

Figure 3.2 – Timeline

The **Timeline panel** is where you control all of the layers within your project. They behave similarly to other Adobe creative applications, such as Photoshop, in that the content of layers at the top of the layer stack will obscure content within the layers beneath. Layers can be created and managed from tools within this panel.

Each **layer** has a number of frames that span the timeline. These **frames** can be basic frames to extend the content of that layer across time, **keyframes**, which designate some sort of change in properties, and various types of **tweens** to create motion across these frames.

Finally, we have a set of frame management, tween creation, and playback tools available here as well. We'll see later on in this chapter how to customize these tools.

The Tools panel

When it comes to asset creation and manipulation within Animate, the **Tools** panel contains a set of varied selection, drawing, manipulation, and specialized creative tools for you to choose from:

Figure 3.3 – The Tools panel

By default, certain tools are exposed, and certain others are hidden, requiring you to edit your **Tools** panel. Other tools are grouped among one another, requiring a long press to expose the full array. This can all be managed through the included customization dialog, which provides complete control over your entire set of tools.

The various tools are grouped into distinct sections, by default. There exists a visible separator between each section.

Selection tools include the **Selection, Subselection, Free Transform**, and **Lasso** tools:

- The following section includes various brush and shape tools, including the **Fluid Brush, Classic Brush, Eraser, Rectangle, Oval, PolyStar**, and **Line** tools.

- Next, we have a mix of variable tools, including the **Pen, Text, Paint Bucket, Ink Bottle**, and **Asset Warp** tools.

- Below that are the **Hand** and **Zoom** tools, which control the panning and zooming of your **Stage** document.

The **Tools** panel also includes a set of **Fill** and **Stroke** selection tools, followed by an options area that can change to elevate certain tool properties. This area is dependent upon the selected tool and changes depending upon which tool is currently chosen.

> **Note**
>
> Certain tools are only available with certain document types. For instance, the **3D Transform** tool is only available with ActionScript 3.0 document types and is not available in any other. It will appear grayed-out in other document types, letting you know that it is unable to be used.

We'll see how to customize the tools that are visible as part of the **Tools** panel later in this chapter.

The Properties Panel

The **Properties** panel is essentially an ever-changing hub through which you can change the various attributes of anything you could possibly want within your project:

Figure 3.4 – The Properties panel

In older versions of Animate, it was a bit tricky to get to the set of properties you wanted at any given time but no more! In newer versions of Animate, a tabbed interface allows easy switching between the **Tool**, **Object**, **Frame**, and **Document** properties, if available:

- **Tool** properties include options for the currently selected tool in the **Tools** panel.

- **Object** properties appear once you've selected any object on the **Stage**. They often include properties for **position** and **scale**, but otherwise vary depending upon the type of object selected.

- **Frame** properties allow you to adjust both frame- and tween-specific attributes. These can include such things as binding a sound file to a frame span or modifying the specific easing options of a tween.

- Finally, **Document** properties involve everything to do with general document settings, including **width**, **height**, **background color**, and **frames-per-second** (**FPS**). This section will also include all your **Publish settings**.

The **Properties** panel cannot be customized, but will constantly adapt to your current needs in light of the available options.

The Library and Assets panels

Another set of important panels are the **Library** and **Assets** panels. Both of these panels are used to manage various objects within your Animate projects, but their purposes and uses are entirely different.

While the **Library** panel has been around for quite some time, the **Assets** panel is entirely new:

Figure 3.5 – The Library and Assets panels

The **Library** panel is used to manage bitmap images, audio files, symbols, and other complex object types within your Animate document. It is important to note that this panel represents the project library and that each Animate document has its own library distinct from other documents. Therefore, objects in the **Library** panel are only accessible to the document they are associated with.

The **Assets** panel, on the other hand, exists apart from any Animate document in particular. It contains a shared set of assets that can be accessed across any document that you might be using and is in no way tied to a project, but rather is bound to the Animate software itself. Once you select and make use of any objects available in the **Assets** panel, those objects will then appear within that document's **Library** panel as well.

We will now move on to exploring the Animate start settings and how to manage them after your first run.

Choosing Your Start Settings

Apart from the general, persistent interface settings and panels previously outlined, how the Adobe Animate interface appears for you will largely depend upon a single choice made when you first run the application from a fresh install. A dialog appears before anything else and asks a simple question: **New to Animate?**:

Figure 3.6 – The "New to Animate?" decision dialog

Answering **Yes** on this screen will create a default workspace within Animate that is simplified and caters to new users. Answering **No** will present a more traditional experience within the software.

You will either be taken to the **Basic** workspace with **Beginner Preferences** enabled, or to the **Essentials** workspace with **Expert Preferences** enabled, as indicated in the following screenshots:

A **"Yes"** Choice A **"No"** Choice

Figure 3.7 – The result of your choice

There are notable differences in the interface layout and preferences depending upon your choice. For instance, the **Basic** workspace includes far fewer panels and the overall UI elements are given a **Comfortable** appearance, where the various icons, panel sections, and other elements are given a bit more space between them all. In addition, the **Assets** panel is given prominent placement and the **Timeline** view is set to **Preview in Context**, displaying each frame as a visual preview.

The **Essentials** workspace includes many more panels; in fact, it includes an entire column of additional panels along the right-hand side of the interface. The **Properties** panel is given prominence here, and the **Assets** panel is hidden away. The UI elements are given a tighter, more **Compact** feel with the icons and panel sections being given less space between them all. The **Timeline** view is also set to the much more traditional **Standard** setting, displaying keyframes rather than frame preview thumbnails.

Changing your start settings

Okay – so what if your choice of start settings was misguided or you simply want to switch? Don't panic! It's not that difficult to switch between the results you've been given. Again, Animate is highly customizable.

The first course of action will be to change your preferences setting. From the application menu, choose **Animate | Preferences** on macOS and **Edit | Preferences** on Windows. This will reveal a submenu that includes the choices of **Beginner Preferences** or **Expert Preferences**. To follow along with this book more closely, I suggest you switch to **Expert Preferences**:

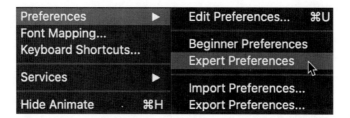

Figure 3.8 – Switching preferences

Once you switch your preferences setting in this way, much of the Animate interface should conform to those settings and you are likely very close to getting Animate in proper shape. There are two additional items to check though, just to be sure.

The first additional item to check is your **Workspace** setting. In the upper right-hand area of the Animate interface is the **Workspace switcher**. The icon looks a bit like an application window:

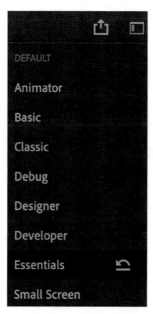

Figure 3.9 – Switching the workspace

Clicking on this icon reveals the available workspaces you can choose. When working alongside this book, I recommend that you choose the **Essentials** workspace if it hasn't already been chosen.

The second additional item to look for is the **Timeline view** setting. In the upper right-hand corner of the **Timeline** panel is a small icon that looks like four lines stacked atop one another:

Figure 3.10 – Fixing the Timeline view

All panels in Animate include this icon and clicking it reveals additional options for that specific panel, along with a number of standard options, such as the ability to close the panel. You will want to make sure that **Standard** is chosen here, not **Preview** or **Preview in Context**. Additional options, such as frame heights of **Short**, **Medium**, or **Tall**, are left to your discretion.

In this section, we had an overview of the set of important, persistent panels in Animate and talked about their specific functions. We then went on to explain the Animate start settings and the differences between the choices you are presented with. We concluded with information regarding how to adjust these settings following your initial choice. Coming up, we'll examine ways in which you can switch workspace settings and even create and manage your own custom workspaces.

Managing Workspaces and Panels

As we've seen, the Animate interface consists of a series of panels, arranged in specific configurations. These configurations are called **workspaces**, and you can easily switch between them by using the workspace switcher. You can even configure and save your own custom workspaces!

We'll now see how to access and switch between workspaces in Animate, and also how to build your own!

Using the Default Workspaces

Animate comes with a number of pre-configured workspaces to choose from. As we saw earlier, depending upon your initial choices when first running Animate with a fresh installation, you will either be using the **Essentials** or the **Basic** workspaces.

You will find these default workspaces and more by activating the workspace switcher in the upper right-hand corner of the interface. Again, the icon looks like a tiny application window.

You initially have a choice between eight different workspaces:

- **Animator**: Emphasizes the **Timeline** panel along with the **Library** panel.
- **Basic**: This is a minimal configuration intended for new users.
- **Classic**: Rearranges the panels so that the **Timeline** panel is above the **Stage**, in the manner of Macromedia Flash.
- **Debug**: A specific configuration used when debugging ActionScript code.
- **Designer**: Focused on an expanded **Tools** panel and various layout panels.
- **Developer**: For those who use the programming features of Animate.
- **Essentials**: This is what was once the default configuration for everyone and is quite balanced and accessible.
- **Small Screen**: Intended for those running Animate on low-resolution displays.

In addition to this set of initial workspaces, we can add as many custom workspace configurations as we want. Let's see how to do this next.

Customizing the Workspace

You can customize any workspace to your exact specifications through two primary methods. The first is to add and remove panels entirely from the interface, and the second is to arrange, place, and group the visible panels in certain ways that are beneficial to your work.

Any open panels can be closed by clicking the **Close** button in the corner of floating panels (looks like a small "x"), or by clicking the panel options button and choosing **Close**.

To open panels that have been closed and add them to the interface, look at the application menu and choose **Window**, as shown in the following screenshot:

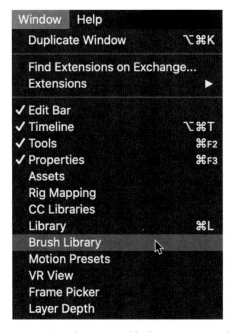

Figure 3.11 – Showing and hiding active panels

This action will display a list of all available panels and clicking upon any panel without a checkmark next to it will open it up, adding it to the interface.

> **Tip**
> Choosing a panel from the **Window** menu with a checkmark next to it will actually close the panel, removing it from the existing interface configuration.

Once you have the panels that you want to include in your workspace open and available, you can then group them with other panels, move them to other areas of the interface, and even change their state from collapsed, to fully open, to floating to docked – it's entirely up to you.

When open, each panel's contents are immediately accessible, but with a collapsed panel you must first click a panel icon to access the contents within, as indicated in the following screenshot:

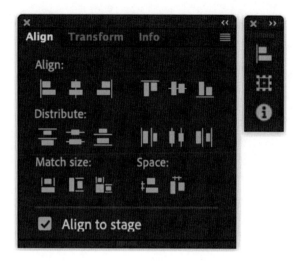

Figure 3.12 – The Customize Timeline editor

All panels can be docked and grouped in various ways:

- To dock panels to other areas of the interface, click and drag the panel name to tear off the panel (or simply reposition a floating panel) to another area until a blue line appears in order to dock the panel at that location when the mouse is released.

- To group panels together, click and drag the panel name to tear off the panel (or simply reposition a floating panel) to another panel or panel group until a blue outline appears in order to group the panels when the mouse is released.

- To collapse a panel or panel group into its icon state, click on the small double-arrow icon at the top right of that panel or panel group.

- To expand a collapsed panel or panel group, click on the small double-arrow icon at the top right of that panel or panel group.

- To temporarily show the contents of a collapsed panel or panel group, simply click on the icon.

How you manage the variety of panels in any workspace is completely up to you. Of course, when you find a configuration you like, you can go ahead and save it for later use.

Saving a Custom Workspace

Saving a custom panel configuration as your own custom workspace couldn't be simpler. Perform the following steps:

1. After your customizations are complete, open the workspace switcher and note that there is a **New Workspace** section at the top of the overlay:

Figure 3.13 – Saving your custom workspace

2. Provide the new workspace with a meaningful name and click the **Save Workspace** button immediately to the right of the name input field.

3. The workspace is now saved! To verify this, open the workspace switcher once more and look at the very bottom of the overlay:

Figure 3.14 – Your saved custom workspace

Your saved workspace will appear under the **SAVED** section and you can now freely switch between that and other workspaces as required.

Managing Workspaces

Depending upon whether you are using one of the default workspaces or one that you created yourself, the management options will differ. No matter which kind of workspace is currently in use, if you've made any changes to the layout of your panels, you will see a small button with an arched arrow pointing backward next to the workspace name.

If you click this button, it will reset both the default and custom workspaces to their original state:

Figure 3.15 – Resetting a workspace

A dialog will appear asking if you are sure that you'd like to reset the workspace. Click **Yes** to reset the workspace.

When it comes to custom workspaces, you also have the option to remove the workspace entirely through the **Delete Workspace** button, which appears as a little trash can icon alongside any custom workspace while that workspace is in use. This cannot be undone, so be certain that this is what you want!

To delete a custom workspace, click the trash can button that appears alongside the reset button:

Figure 3.16 – Deleting a custom workspace

This will cause another confirmation dialog to appear, but this time it asks if you want to delete the custom workspace. Clicking **Yes** will make it so.

In this section, we explored the workspace switcher and saw how to create and manage our own custom workspaces. Coming up, we'll explore the new capabilities of both the **Tools** panel and the **Timeline** panel toolset, and see how to customize each to our individual liking.

Customizing the Tools and Timeline panels

Both the **Tools** and **Timeline** panel customizations are relatively new to Animate, but are absolutely required, with more tools and features being added in these areas. You can now keep your most frequently used tools in both the **Tools** and **Timeline** panels ready for immediate access instead of being hidden or grouped beneath other tools. It's completely under your control!

Customizing the Tools Panel

As of the time of writing, the Animate **Tools** panel consists of 37 individual tools – a lot to fit on one tiny panel! As a result of this, older versions of Animate would have many of these tools grouped together, making them difficult to locate. In newer versions of Animate, we can now hide any tools that we do not often use and can make individual decisions regarding whether to group tools together:

1. To edit your **Tools** panel, look at the bottom area of the panel and locate the **Edit Toolbar…** button. It appears as a small set of three dots:

Figure 3.17 – Activating the tools editor

2. Clicking the **Edit Toolbar…** button will reveal the **Drag and drop tools** editor, allowing you to make changes to the tools available within the **Tools** panel, how they are grouped, their order, and where tool separations occur:

Figure 3.18 – The Drag and drop tools editor

3. To customize your tools, simply drag them from the editor to the **Tools** panel or from the **Tools** panel to the editor. You can change groupings, rearrange locations, and add and remove separators to cluster tools in the way that makes most sense to you.

4. To close the editor when you are finished customizing your tools, hit the *Esc* key on your keyboard, or simply click anywhere outside of it.

> **Note**
>
> Certain tools will not be available for all target documents. Tools that are unavailable in the currently open document will appear disabled in the **Tools** panel and have a small, yellow, warning indicator in the lower-left corner when viewing the **Drag and drop tools** editor.

If you want to create additional, smaller toolbars in your workspace, you can drag a separator from the **Tools** panel and that cluster of tools will now appear as a floating mini toolbar:

Figure 3.19 – Floating toolbar

Hovering over the end of the toolbar will activate its rotation feature, allowing it to be presented either vertically or horizontally.

With these customization options available to us, we can craft the ideal **Tools** panel for our particular needs and preferences, or even create small toolbars for specific use cases.

Exploring the Timeline Tools

The Timeline panel also has a set of tools. These, however, relate directly to the function of the Timeline itself and include tools for managing frames, keyframes, tweens, and viewing options, along with general playback and navigation controls:

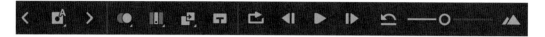

Figure 3.20 – The Timeline tools

Just about all of these tools can be modified and removed through the use of the **Customize Timeline** editor.

Customizing the Timeline

To customize the tools within the **Timeline** panel, you will need to perform the following steps:

1. In the **Timeline** panel, locate the panel options button in the upper-right corner (the three horizontal lines). Clicking this will expose the available options for this panel:

Figure 3.21 – The Customize Timeline Tools option

2. With the option menu exposed, locate and choose the option labeled **Customize Timeline Tools**. This will open the **Customize timeline** editor.

3. Now that the editor is open, you have a number of different actions you can take in order to customize which tools appear in the **Timeline** panel and even how they appear:

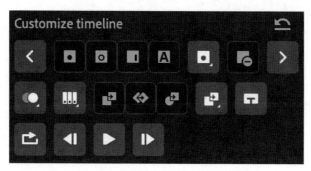

Figure 3.22 – The Customize timeline editor

By default, frame and tween options are grouped together within an **Insert Frames** group and an **Insert Tweens** group. When customizing the tools here, you can separate these groups out into individual buttons and include only those you specifically need. You can also disable any other controls that you do not normally use as well, or add in extra controls such as the **Remove Frames** button, which is not regularly part of the Timeline tools.

Clicking each tool or tool group will csause the Timeline tools to adapt to your choices. Click away from the editor or hit the *Esc* key to dismiss the editor. Clicking the **Reset** button in the upper-right corner of the editor will reset the Timeline tools to their default configuration.

Tip

From this same panel options menu that we accessed during the last task, you can also choose to place the timeline tools along the top or bottom of the **Timeline panel** by selecting the appropriate option.

In this section, we explored the **Tools** panel and the **Timeline** panel, seeing how to customize and manage the tools across both. Coming up, we'll have a look at how to manage our Animate preferences, keyboard shortcuts, and see how to export and save our individual preference settings through the use of an **Animate preferences** file.

Managing Animate Preferences

The preferences in Animate range from general settings, to how your code appears, to various drawing and text options. All of this is under your control through the **Preferences** dialog.

Customizing preferences

To access the Animate **Preferences** dialog, go to the application menu and choose the following options:

- **Animate | Preferences | Edit Preferences…** on macOS
- **Edit | Preferences | Edit Preferences…** on Windows:

Figure 3.23 – Accessing Animate preferences

You'll be taken to the **Preferences** dialog and be able to customize your preferences according to category:

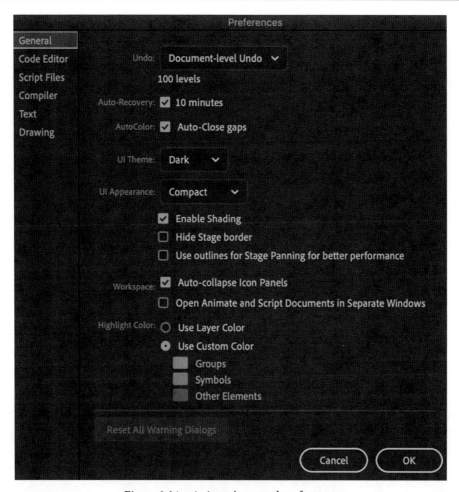

Figure 3.24 – Animate's general preferences

The various tabs along the side allow you to customize preferences for all sorts of things across the application:

- **General**: This is the most important area. Here you can adjust the Animate UI from dark to light, as per your preference, in addition to many other common settings.

- **Code Editor**: This area controls preferences for the **Actions panel** and coding preferences, including font family and font size.

- **Script Files**: You will likely not need to modify this. It is minimal and mostly to do with the encoding of files.

- **Compiler**: Again, no longer very important and you can likely leave this be. It has more to do with the **Flex SDK** and settings pertaining to that.

- **Text**: If you want to change the general font options, this is where you do so.

- **Drawing**: This is actually more useful than most other tabs. It has to do with how strokes are interpreted.

Clicking **OK** will commit your choices.

Keyboard Shortcuts

Keyboard shortcuts are a more advanced way of interacting with any software in a way that is often much quicker than using a mouse or stylus. Many long-time Animate users use these shortcuts to perform common tasks, such as inserting keyframes or converting objects to symbols. You also have access to more common shortcuts, such as copy or paste.

Of course, you can also customize your keyboard shortcuts! To display the **Keyboard Shortcuts** dialog, choose the following options:

- **Animate | Keyboard Shortcuts…** on macOS

- **Edit | Keyboard Shortcuts…** on Windows:

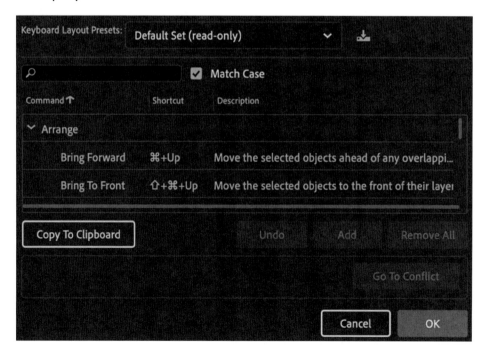

Figure 3.25 – Managing Keyboard Shortcuts

You can customize or add as many shortcuts as you like through this dialog. In fact, not every function in Animate has a keyboard shortcut attributed to it, so if you have a workflow you'd like to speed up, adding a custom keyboard shortcut is a great way to accomplish this.

> **Tip**
> I would recommend keeping commonly used shortcuts in place and not changing them, since many tutorials and references will reference the default shortcuts. If an action does not have a shortcut assigned, however, it is fair game.

Managing Your Preferences

In more recent versions of Animate, you can export and import your preferences. This exported package can optionally include your custom workspaces and keyboard shortcuts.

To export your preferences, go the application menu and choose the following options:

- **Animate | Preferences | Export Preferences…** on macOS
- **Edit | Preferences | Export Preferences…** on Windows:

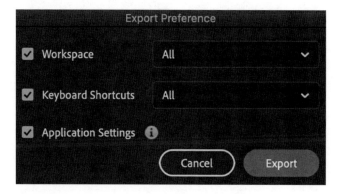

Figure 3.26 – Export Preference

The **Export Preference** dialog will appear, allowing you to choose what you would like bundled into the export file, including your **Workspace**, **Keyboard Shortcuts**, and **Application Settings**. You can even choose specific workspaces and shortcut definitions to include if you do not want to package them all.

Clicking on the **Export** button will prompt you for a filename and location to save your preferences:

Figure 3.27 – Preferences are stored within an Animate preferences (.anp) file

The resulting file is of the .anp type – an **Animate Preferences** file. You can use this file as a backup or for distribution to others.

To import a .anp file, open the **Preferences** menu once more and this time choose **Import Preferences…** from the submenu. You can browse for an .anp file and even choose what aspects of it to import, as indicated in the following screenshot:

Figure 3.28 – Import preferences

Clicking **Import** will result in your choices being imported from the chosen .anp file.

> **Note**
>
> An .anp file is also necessary when creating an **In-App Tutorial** for Animate. Now you know how to generate one! We'll see how to create such a tutorial in *Chapter 13, Extending Adobe Animate*.

In this section, we looked at Animate preferences and discovered how to manage these preferences alongside keyboard shortcuts, as well how to export these same preferences for backup or distribution.

Summary

With this chapter concluded, you now have a good, general understanding of the Animate interface and which portions of that interface are most essential to working with the software. We also took some time to understand how to customize the workspace itself, along with the various tools and timeline controls that are available. Finally, we had a look at the various preferences available to us and how to preserve them for later use.

In the next chapter, we'll explore the various methods of getting content out of Animate for use across different platforms through both the publish and export processes.

4
Publishing and Exporting Creative Content

In the previous chapter, we had a look at some of the more important features of the overall Animate interface. We'll now look specifically at creating content within Animate in a form that can be accessed or reused in additional ways. We will explain the differences between publishing to a specific target platform and exporting to various file types and see why you'd want to choose one workflow over the other in certain cases. We'll also have a look at the new Assets panel and how to package assets for distribution and reuse through this mechanism.

After reading this chapter, you'll come away with the following skills:

- Understand the differences between publishing and exporting content from your projects.
- Gain awareness as to which platforms you should target for various use cases and the differences in publishing settings between them.

- Understand the options available through various export formats and settings.

- Become familiar with the Assets panel and mechanisms for sharing assets with others using this workflow.

Technical Requirements

You will need the following software and hardware to complete this chapter:

- Adobe Animate 2021 (version 21.0 or above).

- Refer to the Animate system requirements page for hardware specifications: `https://helpx.adobe.com/animate/system-requirements.html`.

Publishing versus Exporting

In this section, we are going to compare what it means to publish a document versus what it means to export a document. When dealing with any Animate document, there are going to be a number of choices you can make depending on what type of files you want to generate from your project.

Let's consider what it means to publish your document first. Often, new users to Animate think that by choosing a certain document type, this choice will lock them into producing only a specific type of content. This is actually only the case when considering the publish workflow.

Every document in Animate publishes to a specific target platform, such as the following:

- **ActionScript 3.0** publishes to **Adobe Flash Player**.

- **HTML5 Canvas** publishes to **HTML** and **JavaScript** for the native web.

- **WebGL glTF (Standard)** publishes a set of files that can be played back in any standard **glTF** player.

However, we are not restricted to the publish format as the only way of generating content from Animate.

We'll now consider what it means to export your content. Consider an **ActionScript 3.0** document. Yes, it publishes for **Flash Player** and that may initially seem useless. If you consider the choices for exporting in place of publishing, though, the possibilities really open up. For example, you can export the following from a single ActionScript 3.0 project:

- **HD video** files in just about any format you wish

- Animated **GIF** files

- Still images and image sequences in the form of **PNG**, **JPG**, and even **SVG**

- **SWF** files to be imported into other applications that read the format, such as Adobe After Effects

- **Sprite sheets** and **texture atlases**

Exporting your content allows you all the power and flexibility of your chosen document type without being locked into a specific platform!

In addition, the publish workflow will allow the generation of even more asset types, such as **SWC** files, **Projector** files, **SWF Archive** files, **OAM** bundles, and more! All of this from a simple ActionScript 3.0 document! It is vitally important to understand both the publish and export workflows for every document type.

In this chapter, we'll be working off of a simple set of example project files that make use of various major document types available to Animate. You can find them as part of the chapter files available from `https://github.com/PacktPublishing/ Mastering-Adobe-Animate-2021`.

Locate the file named `ActionScript3.fla` and open it to view the project:

Figure 4.1 – A simple Animate project

It is a simple animation displaying the Adobe Animate logo scaling up across a color-shifting background. Of course, you can design your own projects as well if you prefer to use your own creations.

We'll next learn specifically about the publish and export workflows and how they differ from one another.

Publishing your Projects

The full **Publish Settings** dialog can be accessed from two different methods. In the **Properties** panel, when working with the **Doc** tab selected, you will find a **Publish Settings** section and clicking the **More settings** button here will open the dialog:

Figure 4.2 – Document Publish Settings

You can also open the **Publish Settings** dialog by choosing **File | Publish Settings...** from the application menu.

Note

The **Publish Settings** dialog itself will differ in appearance and options depending on the document type you are working with.

In either case, the dialog will appear. From within this dialog, you can tweak a great variety of settings that determine how your project will publish. We'll learn more about these platform-specific settings later in this chapter.

Clicking the **Publish** button from within the dialog will publish your project in accordance with these settings.

Tip

You can also publish directly, bypassing the dialog altogether, by choosing **File | Publish** from the application menu.

In addition to the publish workflow, we can also choose to export our content to a variety of different formats. We'll have a look at that next.

Exporting your Content

While publishing your content is intrinsically bound to your chosen document type, exporting content is completely different. These differences are not well understood and are often overlooked.

There are actually a number of places in Animate through which you can invoke various export options. We'll cover them all in this chapter, but the most direct way to export content is from the Animate application menu.

Look to the application menu and choose **File | Export** and a submenu will appear, containing a variety of export options:

Figure 4.3 – Export options

These export options are available to us regardless of the document type. They are not bound in any way to the publish options or restrictions inherent to a certain platform:

- **Export Image…:** Brings up a dialog with many different options for exporting PNG, JPG, and GIF file types in order to export a single image file based on the current **playhead** position in the **timeline**.

- **Export Image (Legacy)…:** This is an older – and much simpler – image export mechanism. You have minimal options when exporting to various image formats but this dialog allows SVG export as well as PNG, JPG, and GIF.

- **Export Movie…:** Using this option, you can export full image sequences (PNG, JPG, GIF, or SVG) that can then be brought into other applications. You can also export an SWF directly from this dialog, even when not using an ActionScript 3.0 document type!

- **Export Video/Media…:** This option will render your project into any video format supported by **Adobe Media Encoder**. We'll look at this option more closely in a bit.

- **Export Animated GIF…**: This option will open the same dialog as the **Export Image…** option; however, the settings will all be configured to produce an animated GIF file and not a still image.

- **Export Scene as asset**: This option allows you to export your entire project scene as an **Animate asset** (`.ana`) file for backup or distribution to others.

We'll explore many of these options in the latter part of this chapter.

In this section, we had an overview of what it means to publish from Animate versus what it means to export content. Coming up, we'll look specifically at the publish workflow and how the various settings differ across target platforms as specified by the Animate document type.

Publish Settings Differences between Document Types

In *Chapter 2, Exploring Platform-Specific Considerations*, we had a look at the variety of platforms that are tied to each document type in Animate. We'll now explore the various publish settings for these document types as well. The settings available for each document type vary quite a bit, with the ActionScript-based documents having the most settings due to their age and the beta documents having the least for the same reason.

We'll now look at the various native document types within Animate and their particular associated settings when publishing your content.

Publishing ActionScript 3.0 Documents

By default, ActionScript 3.0 documents will publish both a `.swf` file and an `.html` file to act as a container document. Of course, due to Flash Player being completely banned from web browsers, this isn't all that useful!

With the **Publish Settings** dialog open, you'll immediately be struck with just how many settings there are for this publish workflow. You can view these settings in the following screenshot:

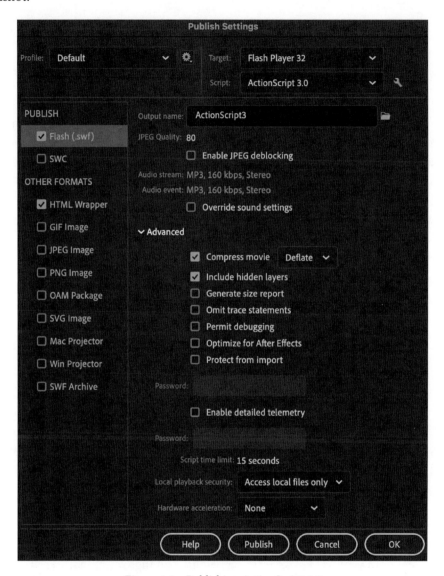

Figure 4.4 – Publishing ActionScript 3.0

Along the side are the **PUBLISH** settings for publishing your Flash content along with **SWC** and also **OTHER FORMATS**.

> **Note**
>
> **Shockwave Component (SWC)** is a format that was popular during the heyday of Flash Player as it could be used to bundle assets and code together in a way that more code-based applications such as Flex Builder could interpret and make use of. It isn't so useful anymore.

These **OTHER FORMATS** include the aforementioned HTML wrapper along with a number of image export types. There are two formats here that are especially noteworthy: **Projector** and **SWF Archive**.

Projector files can be published for either macOS or Windows and basically are a compiled executable program that contains your project alongside a special version of Flash Player that can be used to run your content on the desktop. The neat thing about this format is that there is no need to perform any sort of installation – it just runs!

SWF Archive is a mechanism that renders each individual layer of your project as a separate .swf file, then bundles the entire set as a .zip archive. This is a good mechanism for getting your project into additional applications such as **After Effects** for per-layer compositing workflows.

Those are the overall settings to keep in mind when publishing ActionScript 3.0 document types. Let's turn our attention to **HTML5 Canvas** next.

Publishing HTML5 Canvas Documents

While **HTML5 Canvas** is a much more recent document type than ActionScript 3.0, it includes a major array of publish settings due to its importance within the software, especially since .swf files can no longer be used within web browsers. Since HTML5 Canvas is a completely native web technology, it can step in and take over for Flash Player in many circumstances.

Just as with ActionScript 3.0, you'll find a variety of choices along the side that specify settings under **PUBLISH** and **OTHER FORMATS**. **PUBLISH**, in this case, includes only a single target – **JavaScript/HTML**. Here, you will find all the major publish settings for HTML5 Canvas documents.

These **JavaScript/HTML** settings are divided into three tabs, the first of which is the **Basic** tab:

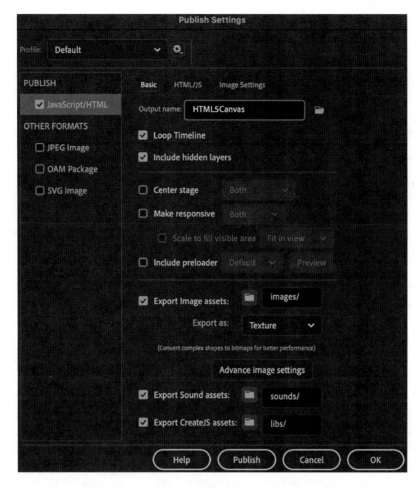

Figure 4.5 – Publishing HTML5 Canvas Basic settings

Here, we find the most general settings to do with publishing HTML5 Canvas documents. Notable settings include the following:

- **Output name**: This is where you can name your published files and specify an output folder through the file browser.

- **Loop Timeline**: Checking this box allows the timeline playback to loop continually. Uncheck this box to have the playhead stop once playback ends.

- **Include hidden layers**: Determines whether to publish layers that have been hidden in the timeline or not.

- **Center stage**: By default, the published content appears at the upper left of the browser viewport. You can override this presentation and center your published content horizontally, vertically, or both.

- **Make responsive**: Enabling this option will scale your content down if it doesn't completely fit within the containing element. Additionally, you can also allow it to scale up to fill the containing element.

- **Asset locations**: Here is where you name each of the subfolders to which Animate will publish any audio files and the local CreateJS library files.

The second tab is centered around more advanced settings concerning how HTML and JavaScript are handled as part of the publishing process:

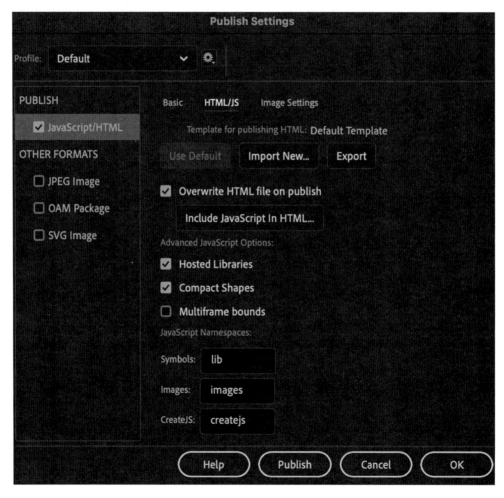

Figure 4.6 – Publishing HTML5 Canvas HTML/JS settings

The **HTML/JS** tab includes a number of more advanced settings when considering how your content is published. Settings of the greatest importance in this area include the following:

- HTML template: There is a default HTML template that includes a number of tokens to represent properties such as stage color, width, height, and so on. You can export this template, modify it to include additional elements, or perform more advanced actions through the code present in the template, and bring it back into Animate so that it is used when publishing your content. This is often used when creating digital ads that require specific structures and attributes. A small example of how these tokens appear in .html is shown here:

```
<canvas id="$CANVAS_ID" width="$WT" height="$HT"
style="position: absolute; display: $CANVAS_DISP;
background-color:$BG;"></canvas>
```

- **Overwrite HTML file on publish**: By default, Animate will overwrite the generated .html file each time you publish. Unchecking this option allows you to manipulate the .html that is exported without worrying that it will be overwritten with subsequent publish activity.

- JavaScript inclusion: Here you can choose to include your JavaScript directly within the published .html file instead of in a separate .js file.

- **Hosted Libraries**: This checkbox determines whether the CreateJS JavaScript libraries are hosted on CreateJS servers or whether they are outputted to local files.

- **Compact Shapes**: This option will attempt to optimize shape data on publish.

- **Mutiframe bounds**: When obtaining measurements and calculations against the width and height of certain objects, you must include data for multiframe bounds. This is especially useful for game development.

- **JavaScript Namespaces**: There are default namespaces already applied here to avoid code collision, but you can redefine these namespaces here if you need to.

The third and final tab has to do entirely with how images are published as part of the HTML5 Canvas publish pipeline:

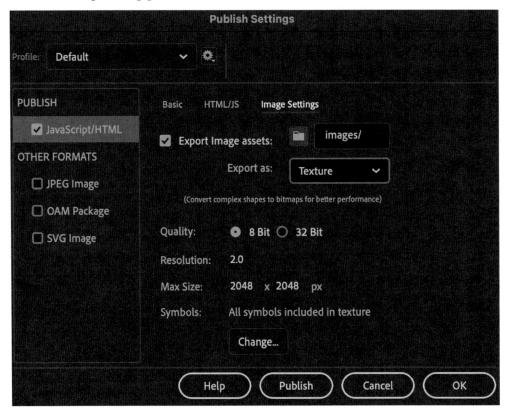

Figure 4.7 – Publishing HTML5 Canvas Image Settings

These settings have everything to do with the handling of image files, including how they are exported, which image file type to use, along with specific encoding settings, and which portions of your content to render as part of this output:

- Image export folder: Similar to the audio folder location setting in the **Basic** tab, this allows you to determine the folder where published image files are located.

- **Export as**: You can choose from **Texture**, **Spritesheet**, or **Image Assets** from the dropdown. Your choice will determine which setting regarding image data can be further specified:

 Texture will convert all of your shape assets into bitmap textures for better performance. When this option is selected, you will be able to choose the image quality, resolution, and maximum size. These options determine how the image is encoded. You can even specify which symbols to include in this process.

Spritesheet will combine all bitmap images into a sprite sheet, the settings of which you can define once selected. These settings include the file format itself and then associated settings such as quality, maximum size, and even the background color.

Image Assets will simply publish all assets individually, with the choice to have Animate optimize image dimensions or not.

When publishing HTML5 Canvas documents, it is obvious with so many settings available that this is considered one of the major publishing options available as part of Adobe Animate.

Publishing AIR Document Types

Whether dealing with AIR for desktop, AIR for iOS, or AIR for Android, there are a great number of publish settings to consider, and they differ a bit between each platform you are targeting. Additionally, whenever you're exploring the publish settings for any AIR document, you'll actually have two sets of publish settings to deal with.

The first group of settings is accessed and handled in exactly the same way as with an ActionScript 3.0 document:

Figure 4.8 – Publishing AIR

There are only two differences here as opposed to an ActionScript 3.0 document. The first is that your only options under **PUBLISH** are **Flash (.swf)** and **SWC**. This is due to the fact that AIR requires an SWF in order to compile and package the AIR bundle. The second difference is that we are targeting AIR and not Flash Player, which leads directly into the second group of settings in a completely different dialog.

The second and perhaps most important group of AIR settings is accessed by clicking the small wrench icon directly to the right of the **Target** dropdown in **Publish Settings**. This reveals the **AIR Settings** dialog with an additional set of settings specifically to do with your AIR project:

Figure 4.9 – AIR Settings

There are a lot of settings here, and they are grouped within the following tabs:

- **General**: These settings determine things such as what type of bundle is produced upon publication, the name and ID of the app produced, and various settings around window styles, profiles, and extra files you can define and package within the application.

- **Signature**: This includes settings around your code-signing certificates. The requirements for this vary by target platform.

- **Icons**: This is where you define the application icons that show up once the app has been installed. The icon requirements vary by platform.

- **Advanced**: Here, you can define a varied set of options, which include file associations, initial window settings, installation location, and more.

- **Languages**: The various languages your app can support are defined here.

We will have a deeper look at other aspects of the AIR settings when we build a small application in *Chapter 12, Building Apps for Desktop and Mobile*.

With the AIR settings out of the way, we'll finally have a peek at the various settings available in the **WebGL glTF** and **VR** document types.

Publishing Beta Document Types

Since the various beta document types are still under development, these settings could change rather quickly. At this time, though, they are all nearly identical.

Choosing **Publish Settings** for the **VR** document types reveals a **Publish Settings** dialog similar to what we've seen for other platforms, while the **WebGL glTF** settings dialog appears a bit differently, as shown in the following figure:

Virtual Reality (VR) **WebGL glTF**

Figure 4.10 – Publishing beta VR and WebGL documents

Regardless of which document type you are working with, all four employ **WebGL** within the HTML `<canvas>` element and so they all have the same settings, aside from differences in the appearance of the dialog itself.

The particular settings are as follows:

- **Output name**: This is where you can name your published files and specify an output folder through the file browser.

- **Loop timeline**: Checking this box allows the timeline playback to loop continually. Uncheck this box to have the playhead stop once playback ends.

- **Include hidden layers**: Determines whether to publish layers that been hidden in the timeline or not.

- **Use JavaScript hosted libraries**: This checkbox determines whether the JavaScript engine that makes these beta document types possible is hosted on Adobe's servers or whether they are output to local files.

Again, these settings are quite minimal when compared to ActionScript 3.0, HTML5 Canvas, or AIR, but that is to be expected with document types still in development.

In this section, we had a look at the **Publish Settings** dialogs across the various document types that ship native to Adobe Animate. Coming up, we'll see how to export our content, bypassing the publish mechanisms in various ways.

Options for Exporting your Content

While publishing is completely dependent upon the Animate document type that's been chosen for a project, exporting is completely free from such restraints and can be undertaken regardless of document type and publish platform. For instance, whether you're using ActionScript 3.0 or HTML5 Canvas documents, you can always export to an image sequence, animated GIF file, or HD video file through **Adobe Media Encoder**.

Let's have a look at some of these export options and see how they differ from the more restricted publish workflows.

Exporting Video Files

If your project is non-interactive, a video file is often the best format for producing it in a distributable format. Video, of course, is an incredibly popular format for sharing creative content and can be generated from any document type, making it quite versatile as well.

From the application menu, choose **File | Export | Export Video/Media...** and the **Export Media** dialog will appear, as shown in the following screenshot:

Figure 4.11 – Exporting video files

The **Export Media** dialog is dense with options. One of the nicer additions over the past few versions of Animate is the inclusion of the ability to define what portion of your timeline you'd like to render to video, in addition to being able to select the video format and preset directly within the dialog itself.

> **Tip**
> As detailed in *Chapter 1, A Brief Introduction to Adobe Animate*, .mp4 video files can also be exported through the **Quick Share and Publish** option.

The options presented here include the following:

- **Render size**: This will default to the width and height defined in your document settings but can be increased or decreased here to modify the overall resolution of the output video.

- **Span**: Your entire project timeline will be used by default, but you can override this to only include certain scenes, frame ranges, or time selections.

- **Format/Preset**: These settings are drawn directly from Adobe Media Encoder and allow the selection of video format and a format preset without even messing with Media Encoder at all.

- **Output**: This is where you can name your rendered video file and specify an output folder through the file browser.

You can also select whether you want to start the render queue immediately or not through a checkbox. Once you hit **Export**, Adobe Media Encoder will appear and process your video if that option has been selected, in accordance with the settings you have chosen.

Again, video is a tremendously popular option for producing content from Adobe Animate.

Exporting Animated GIFs

Perhaps just as popular as video among certain networks is the animated `.gif` file. The GIF file format is one of the oldest available for internet playback and was supported in web browsers even before the existence of Flash Player. Traditionally, these files have been used as small, animated elements as part of a web page design, but in recent years, they've been used purely as content for use in certain social networks.

From the application menu, choose **File | Export | Export Animated GIF...** and the **Export Image** dialog will appear:

Figure 4.12 – Exporting animated GIFs

Unlike when exporting still images, this dialog will be tuned specifically for the export of animated `.gif` files. You will be presented with a preview of your resulting animation, underneath which are statistics such as file size and format properties. Along the opposite side are the settings you can tune to modify aspects of the resulting file.

> **Tip**
>
> As detailed in *Chapter 1, A Brief Introduction to Adobe Animate*, animated GIF files can also be exported through the **Quick Share and Publish** option.

The various settings are grouped into four categories:

- **Preset**: You'll want to leave the preset selection dropdown alone, but feel free to tweak other aspects of your GIF, including the number of colors and dither settings.

- **Image Size**: Allows you to adjust aspects of the width and height of your output. Depending upon the estimated file size, you may need to scale the resolution down somewhat.

- **Color Table**: A `.gif` file can have, at most, 256 colors. This table allows you to selectively add and remove colors.

- **Animation**: Here is something you'll want to check. You can set the output to loop forever or just once and stop. You also have access to a set of playback controls here to help preview the animation.

Clicking the **Preview...** button will generate a preview of your resulting GIF and display it within a web browser.

Here is an example of what is shown during an animated GIF preview:

- **Format**: GIF

- **Dimensions**: 1280w x 720h

- **Size**: 392.7K

- **Settings**: Selective, 128 Colors, 100% Diffusion Dither, 60 frames, Transparency off, No Transparency Dither, Non-Interlaced, 0% Web Snap

Directly below that in the preview, you will find some example HTML tags that demonstrate how to incorporate the file into your documents:

```
<html>
<head>
<title>HTML5Canvas</title>
<meta http-equiv="Content-Type" content="text/html;
charset=iso-8859-1">
</head>
<body bgcolor="#FFFFFF" leftmargin="0" topmargin="0"
marginwidth="0" marginheight="0">
<img src="HTML5Canvas.gif" width="1280" height="720" alt="">
</body>
</html>
```

The entire preview process generates a single web view that includes an output of image file encoding information, followed by an example of how to utilize the exported animated `.gif` file within an `.html` document. It couldn't get any easier.

> **Note**
>
> Be very careful to keep an eye on the file size of your exported `.gif` files. It is very easy to produce a GIF that is far larger than an equivalent video file!

To actually save your animated GIF, choose **Save** and you will be prompted for a name and location with which to save the exported file.

Now that we've covered the process and settings to generate an animated GIF, let's have a look at additional image-based output choices.

Exporting Image File sequences

Image file sequences are a series of `.png`, `.jpg`, or `.svg` files, which are generated frame by frame from your animation.

Choose **Export | Export Movie...** from the application menu and then choose an image sequence format and click **Save** to make an export dialog appear:

Figure 4.13 – Exporting image sequences

The dialog settings will vary depending upon the selected image sequence format.

> **Note**
>
> You can also export single image files instead of full sequences through the export menu as well by choosing **Export | Export Image...** or **Export | Export Image (Legacy)...** for `.png`, `.jpg`, `.gif`, or `.svg` file generation with the "legacy" choice.

An image sequence is a useful way of getting your content into software that may not support formats such as **SWF**, as just about anything can handle a sequence of images. However, we can actually export a `.swf` file through this same export menu!

Export Options from the Library Panel

There is one more spot within Animate that allows the export of your content into a variety of formats, though this option works with individual assets and not the entire document.

If you open the **Library** panel and right-click upon any symbol, a menu will appear:

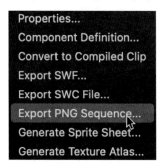

Figure 4.14 – Exporting from the library

This menu will include a set of additional export options that will export the selected object. You'll find a number of export options here that we've covered elsewhere, in addition to the additional options of exporting a symbol to a sprite sheet or texture atlas. Both of these options will open a dialog where you can tweak the settings to your needs.

In this section, we had a look at the variety of export options available across Animate document types. Coming up, we'll look specifically at how to export Animate content for use within Animate!

Sharing Content as Animate Asset Packages

A new method of getting content out of Animate is the ability to export **Animate Asset** (.ana) files. These files can contain packaged objects, motions, bones, and audio for personal backup or distribution to other Animate users. This differs a bit from the other export options we've seen since the intended platform of use is Animate itself!

The most direct way of exporting **Animate Asset** files is from the **Library** panel:

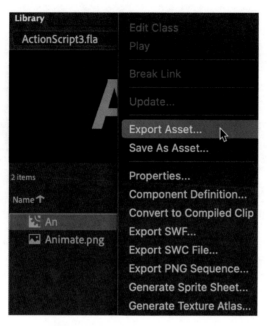

Figure 4.15 – Sharing a single asset

If you right-click on a symbol in the **Library** panel, you are given two menu options regarding **Animate Asset** files. Choosing **Export Asset…** will create a .ana file on your filesystem. Selecting **Save As Asset…** will not produce a .ana file but rather add the asset directly into your **Assets** panel without an intermediary import process.

Another mechanism for exporting assets can be found in the application menu by choosing **File | Export | Export Scene as asset**, as shown in the following screenshot:

Figure 4.16 – Sharing a scene as an asset

This option allows you to export a full scene from the main timeline as a single Animate asset. This method produces the exact same type of assets as the library method since the main timeline is basically a giant **movie clip** symbol anyway – it is only accessed differently.

When choosing to export an Animate asset file from either the Library panel or through the **File | Export | Export Scene as asset** menu, you are presented with the **Export Asset** dialog, as shown in the following screenshot:

Figure 4.17 – Export Asset dialog options

From here, you can choose from available assets to include in your file, depending on whether these types of assets exist in the selected symbol. A system of checkboxes allows you to include the following:

- **Objects**: Visual assets within your chosen symbol
- **Bones**: Any IK rigging you've designed within the symbol
- **Motion**: Any animation created with your provided assets
- **Audio**: Sound files that have been included in your symbol

You are also provided the opportunity to tag the asset with keywords, which can then be searched through when using the Assets panel.

Once you click **Export**, your assets will be bundled into an .ana file on your local machine, ready to be imported or distributed:

Figure 4.18 – Animate asset file

There are a handful of uses for these Animate asset files. They can be preserved as a backup, distributed to other members of your team or even strangers on the internet, or can be immediately imported back into Animate for use through the Assets panel:

1. To perform an import using a generated .ana file, open the **Assets** panel. If it isn't already open, you can access it from the application menu by choosing **Window |
 Assets**.

2. With the **Assets** panel open, look to the bottom left within the panel and click the **Import Assets** button (looks like a big plus sign). Alternatively, open the panel options menu at the upper right and choose **Import** from the choices that appear.

 You will then be taken to a file browser to locate your .ana file.

3. Select the file to include and click **Open** to complete the import process.

Once the .ana file has been imported, you can locate it with the **Custom** tab of the **Assets** panel:

Figure 4.19 – An imported Animate asset

You can filter and search custom assets just as is possible with the default assets.

In this section, we explored a new mechanism for exporting useful assets from Animate using the new Animate asset export and import features.

Summary

In this chapter, we explored a wide variety of publish options depending on the chosen document type, and also the export options available to us regardless of document type and target platform. It is so important to understand the differences between these two ways of getting content outside of Animate! When executing the publish workflow across different document types, we now have a better familiarity with the options available to each, and also how these settings can differ drastically between target platforms. Regarding export workflows, we've seen how varied these can be and the wide array of file formats that can be chosen – regardless of the initial document type. We also had a look into the various export options when generating Animate asset files.

In the next chapter, we'll explore how to create and manipulate assets within the software to design engaging animated content.

Section 2: Animating with Diverse Techniques

With the foundational content out of the way, we will now begin to really explore some of the techniques used to animate content within the software. We'll start out fairly traditional but soon move into more advanced topics, such as animating a figure with forward and inverse kinematics, the use of the camera to animate entire scenes, and how to enrich our animated camera movements with layer depth settings.

This section comprises the following chapters:

- *Chapter 5, Creating and Manipulating Media Content*
- *Chapter 6, Interactive Motion Graphics for the Web*
- *Chapter 7, Character Design through Layer Parenting*
- *Chapter 8, Animating Poses with IK Armatures*
- *Chapter 9, Working with the Camera and Layer Depth*

5
Creating and Manipulating Media Content

In the previous chapter, we had a look at the many ways of getting content outside of Animate for distribution or further work, but what about actually creating content?

This chapter covers many of the creative capabilities of the software, starting with a refresher regarding how to create shapes and add motion to them. We then follow up with the use of symbols and explore the various types of symbols available to us in Animate. We will learn why and when to use certain symbol types in different circumstances, and how to create motion with them. Importantly, we will also explore the various easing profiles available within the software that allow further refinement of our motion in a natural way.

After reading this chapter, you'll be able to perform the following functions in Animate:

- Design and animate vector content using shape tweens.
- Create symbols and animate them using classic tweens.
- Apply natural easing profiles to your animated content.
- Explore the properties of symbol instances and various applied tweens.

Technical Requirements

You will need the following software and hardware in order to complete this chapter:

- Adobe Animate 2021 (version 21.0 or above)
- Refer to the Animate system requirements page for hardware specifications: `https://helpx.adobe.com/animate/system-requirements.html`.

Working with Shapes

In this section, we are going to begin by looking at some of the shape creation tools within Animate and see how to establish vector-based shape objects in order to apply motion to them in upcoming sections.

While Animate can certainly make use of imported content, such as bitmap images, sound files, and other types of external media files, the creation and manipulation of native vector shape objects is a workflow that Animate excels at. With a full range of tools that support the creation of vector shapes and a dedicated tweening engine to consider, there is no doubt that shapes are key to the Animate experience.

We'll now have a look at some of the important topics associated with the creation and manipulation of shapes within an Animate project. We'll examine the set of tools that allow creation of shape objects and see how to set different tool property values that directly influence the properties of the resulting shapes.

Understanding the Shape Tools

There may be more shape tools than any other type of tool within the Animate toolbar. Since the software is used by artists and creators of all types, there has to be a set of tools for both freeform drawing and precise form generation.

You can view the full set of shape tools available in the following screenshot:

Figure 5.1 – Animate shape tools

These tools are arranged and listed in no particular order, and will differ depending upon the current workspace that has been chosen:

- **Fluid Brush**: This is a GPU-accelerated brush that is built on the same technology as **Adobe Fresco** brushes. It allows for smooth lines with a more fluid approach to painting and drawing. This brush produces a fill.

- **Classic Brush**: An older brush within Animate, this brush will produce a fill when used and contains a limited number of controls.

- **Paint Brush**: This tool produces strokes by default but can be toggled to produce fills instead. It works by mapping vector art across the paths that are generated.

- **Pencil**: Another older tool with a limited number of options, this one produces a stroke in the same way that the Classic Brush produces a fill.

- **Rectangle**: This tool allows the creation of rectangles and square shapes consisting of both fill and stroke.

- **Rectangle Primitive**: This works similar to the Rectangle tool, with the distinction of being able to manipulate the corner radius following creation of the object.

- **Oval**: This tool allows the creation of ovals and circular shapes consisting of both fill and stroke.

- **Oval Primitive**: This works similar to the Oval tool, with the distinction of being able to manipulate the start angle, end angle, and inner radius following creation of the object.

- **PolyStar**: A unique tool that creates a polygonal or star shape where you can determine the number of sides or points, accordingly. It creates a shape with both fill and stroke.

- **Line**: This draws a straight line consisting only of stroke.

- **Pen**: This tool works in a similar manner to the **Pen tool** in **Adobe Illustrator** or **Photoshop**. It allows the creation of custom shapes through the use of anchor points and related curve handles. It creates a shape consisting of stroke alone, but that can be filled with the **Paint Bucket tool** if the path is closed properly.

Generally, some of these tools will be grouped together with one another, and some may not even be visible unless you specifically add them to the toolbar, depending upon your chosen workspace.

> **Tip**
> Remember that you can edit the tools that appear in your toolbar or even create smaller tear-off toolbars. Have a look back at *Chapter 3, Settling into the User Interface* for a refresher!

When a tool is selected, you will be able to adjust the properties of that tool from the **Properties** panel. It is a good idea to set tool properties before creating content with your chosen tool, since oftentimes there will be properties set that cannot be easily changed with objects once they've been created.

Just make sure to choose the **Tool** tab at the top of the **Properties** panel before you begin using any tool:

Figure 5.2 – Common Tool properties

Shapes in Animate can consist of **Fill**, **Stroke**, or a combination of both. Some of the tools will have special options that you will find lower down within the **Properties** panel, as the more common options are generally located toward the top. Once you've settled on a set of properties that make sense to your task, you can go ahead and start creating!

> **Note**
>
> Fill and stroke can be added or removed from any shape so long as the requirements for each are met. Look at both the Paint Bucket and Ink Bottle tools to add each aspect to your shape.

Using these various tools, we can create shapes and apply animation to them.

In this section, we saw how to create shapes using the variety of shape tools available to us in the software. Coming up, we'll apply motion to these basic shapes through the use of shape tweens.

Animating with Shape Tweens

Before we perform any sort of animation, we'll need to actually create a visual shape to manipulate. After the shape is established, we'll perform a specific type of tween that only works with shapes. It will likely come as no surprise to anyone that this type of tween is called a **Shape Tween**.

> **Note**
>
> The term "tween" is actually shorthand for "in-between" and is a traditional animator's term describing the frames that exist in between the main "key" frames drawn by a senior animator that would be filled in by less-skilled junior animators using the "key" frames as a guide. Tweens in Animate work in much the same way!

Let's now create a shape object with which to perform a bit of animation:

1. First, create a new ActionScript 3.0 document and set the width to 1280 and the height to 720 with an **FPS** setting of 30. You can verify that you've done this correctly from the **Properties** panel, as shown in the following screenshot:

Figure 5.3 – Document Settings

2. You'll then choose a tool with which to create your shape object. I suggest keeping it simple for now and using the **Rectangle** tool.

3. Look at the **Tool** tab of the **Properties** panel, set the fill to a medium blue (#0066CC), and disable the stroke by selecting the swatch that looks like a white square with a red line passing from corner to corner:

Figure 5.4 – Rectangle tool properties

4. Click on the left side of the **Stage** and hold down the *Shift* key and drag to create a square that measures about 200 pixels in both **Width** and **Height**.

5. Choose the **Selection** tool and select the object that was just created. Look at the **Object** tab in the **Properties** panel to ensure that your properties match with what has been described. The **X** position value should be 220 and the **Y** position value should be 260:

Figure 5.5 – Our newly created square shape

We now have a shape on the Stage ready to animate. At the most basic level, animation is performed within the timeline through the use of keyframes. Keyframes hold data values for certain properties, such as position, scale, rotation, and opacity. The creation of multiple keyframes across time gives the appearance of motion, even though nothing is actually moving, but your eyes are tricked into processing the change in data between frames as motion.

We'll now establish an additional keyframe, change certain properties of our shape in that keyframe, and apply a **Shape tween** to animate our object across the **Stage**:

1. Before doing anything else, we'll want to rename **Layer_1** to something more descriptive. Double-click on the layer name and type in **Square** as a new layer name. It's important to stay organized!

Figure 5.6 – Renaming your layer

2. Now, click the rectangle beneath the **1s** mark at *frame 30* in order to select it. It will appear highlighted in blue:

Figure 5.7 – Selecting the 1s mark at frame 30

3. Click the **Insert Keyframe** button, or press *F6*, to insert a keyframe at *frame 30*. A duplicate keyframe is created with the exact properties of the previous keyframe at *frame 1*:

Figure 5.8 – Inserting a keyframe at frame 30

4. Using the **Selection** tool with the *Shift* key held down, move the square shape to the opposite side of the **Stage**. Holding *Shift* will constrain the movement along the *x* and *y* axes. The **X** position should now be 860, and the **Y** position should remain at 260.

5. The keyframes at *frame 1* and *frame 30* now have different position values. To create a **Shape Tween** in order to fill in the changes between these keyframes across time, click the **Create Shape Tween** button from the **Insert Tweens** group above the timeline, or choose **Insert | Create Shape Tween** from the application menu:

Figure 5.9 – Creating a shape tween between keyframes

The **Insert Shape Tween** option can be located within the **Insert Tweens** group.

6. The **Shape Tween** is established between the two keyframes and an arrow appears between them across the frame span. The frames that make up the **Shape Tween** take on an orange color. This all indicates that the tween was created successfully. Go ahead and drag the blue playhead across the frame span to preview the animation on the stage:

Figure 5.10 – Completed shape tween

The **Shape Tween** works by having Animate fill in the data values between each of the keyframes we have established. It does so in a completely linear way unless instructed otherwise.

> **Tip**
>
> If the arrow between keyframes appears as a broken or dashed line, this indicates a problem with the tween. Ensure that you have at least two keyframes and that both keyframes contain shape data and no other object types.

Test your movie by choosing **Control | Test Movie** or by clicking the **Test Movie** button in the upper-right corner of the Animate interface. The animation of our little square will play back in a small window. Go ahead and close this window when you are finished.

We now know how to perform animation with a basic **Shape Tween** in our projects. Next, we'll look more deeply into the properties of the tween that can be modified.

Exploring Shape Tween Properties

There are a number of additional properties of a **Shape Tween** that can be modified once it has been created. To access these settings, select any frame or keyframe that is part of the tween and look at the **Properties** panel. Ensure that the **Frame** tab is selected and look down toward the **Tweening** section of the panel:

Figure 5.11 – Shape tween properties

Within the **Tweening** section of the **Properties** panel, you fill find the following settings:

- **Ease**: There are two easing choices here: **Properties together** and **Properties separately**. When using shape tweens, you can only choose **Properties together**. Other tween types are more flexible in this regard.

- **Effect**: This setting allows the application of different easing effects to your tween. Unless you want completely linear movement, it is recommended that you apply some sort of ease to your tween; the difference is immense! You can apply **Ease Effect** presets or even edit your own custom ease through these controls. If using a **Classic Ease**, you can tweak the intensity by changing its value from the default of 0.

- **Blend**: This setting determines how the tween frames are calculated by Animate. You have two choices here: **Distributive** or **Angular**.

Each individual **Shape Tween** can have its own properties adjusted. A new feature in Animate is the ability to copy, paste, or reset a tween's properties through the **Tween Options** button in the upper-right corner of the panel. You can also remove the tween entirely by clicking the **Remove Tween** button.

Here is an example of our square's movement with a linear default effect applied to the motion, versus one of the many easing effects available to us:

Figure 5.12 – Cubic-Ease-Out versus Classic Ease

The bottom square has the default **Classic Ease** applied and moves across the stage at the same linear rate of speed for each of the 15 frames represented in the image. The top square has a **Cubic-Ease-Out** effect applied to it and, because of this, the rate of speed varies across different frames, starting out slow and then speeding up.

It is important to know that both of these squares start and end in the same position on the stage and share the exact same first 15 frames of movement captured by this image. These effects can be used to establish much more natural, physical movements.

All right, that's all there is for tween properties. Next, we'll have a deeper look at keyframes and additional shape properties that can be modified over time using the tweening engine.

Manipulating Shape Properties across Tweens

When we established our **Shape Tween**, the only value that differed between each of our keyframes with the shape's **x** position in order to create movement from one side of the screen to the next. Using a **Shape Tween**, there are many additional properties that can be tweened!

Let's go ahead and modify the animation to incorporate some of these changes in properties:

1. First, we'll have the square change shape along with position. Move the playhead to frame 30 and select the square shape on the stage.

2. Hit the *Delete* key on your keyboard to remove it. Note that in the timeline, there is still a keyframe present, but it is an empty keyframe since there is no longer any content. The tween also appears broken for this same reason:

Figure 5.13 – Keyframe contents removed

3. Now, select the **PolyStar** tool and use it to draw a star shape on the stage in roughly the same position that the square shape used to occupy. Set your **Tool** options in the **Properties** panel to use a star **Style** with 5 sides and a point size of 0.5 within the **Tool** tab. Note that we are still at frame 30 in the timeline:

Figure 5.14 – Drawing a five-pointed star

4. Let's have the square change color as it morphs into the star shape. With the star shape selected, change its fill color to a vivid violet (#9900FF).

5. We can even change the scale of our elements if desired through the use of the **Free Transform** tool. With this tool selected, clicking on the star shape will display a transform box around it, allowing us to scale from any corner, and also perform additional transforms and rotations. Remember to hold down the *Shift* key in order to constrain proportions as you scale. Note the small white circle in the center of the transform box? This is the **Transform Point**, and any rotation or scale will be done in relation to this point:

Figure 5.15 – Using the Free Transform tool to change scale and rotation

With these changes in place, either click the **Play** button at the top of the timeline or the **Test Movie** button in the upper-right corner of the Animate interface. Whichever choice you've made, you will see how the animation is now very different, with all the various properties being tweened together between the two keyframes.

You may also note that as the square morphs into the star, it does so in a strange way. There are two things we can try in order to correct this: one is to switch the **Blend** setting in the *Tweening* section of the **Frame** properties between **Angular** and **Distributive**. That may help, but a surer solution is to employ **Shape Hints** to guide the tweening engine into morphing our content in a more reliable way.

Let's now fix our shape morph by adding some **Shape Hints**:

1. Move the playhead back to frame 1. **Shape Hints** work across two keyframes and should be set at the initial frame of any tween.

2. Add a **Shape Hint** by choosing **Modify | Shape | Add Shape Hint** from the application menu. A small red circle with the letter **a** is added to the center of the square at frame 1:

Figure 5.16 – A shape hint appears as a red circle

3. Move the **a** hint to the top center of the square. We will be placing each hint on the square where each point of the star would be if the two shapes were overlaid, one on top of the other. This will direct Animate to morph the shape in a more controlled manner.

4. Continue to add four additional **Shape Hints** and place them along the square in a sequence representing our five-sided star:

Figure 5.17 – Shape hints properly positioned

5. Now, move the playhead to frame 30. We need to place the **Shape Hints** at the proper spots on this shape as well so as to correspond with their placement on the square. Notice that we do not have to add any **Shape Hints** at frame 30, as they carry over from frame 1 but are all grouped together at the center of our star shape:

Figure 5.18 – The shape hints appear at the center

6. Move each of the **Shape Hints** to their corresponding place on the star shape. Note that they must be placed in the same order to be most effective and that once they are correctly positioned, their color will change from red to green:

Figure 5.19 – Properly positioned shape hints

7. If you now move the playhead back to frame 1, you will see that the Shape Hints on the square have also changed color, from red to yellow. This indicates that placement is complete on both keyframes:

Figure 5.20 – Verifying that shape hint placement is correct

With that, we can once again preview the animation using the same mechanisms as before. The square will now morph into the star in a much less erratic way. **Shape Hints** are very powerful, but they can be easily broken as well. Always apply **Shape Hints** in an organized and structured way as we've done here to avoid any problems.

In this section, we had a comprehensive look at creating and animating shape objects within Animate. Coming up, we'll look beyond basic shapes to see how to create and manipulate symbols.

Working with Symbols

As we saw in the last section, **Shape Tweens** are only applicable to shape objects. They cannot be used on imported bitmap images, compound shape groups, or complex text objects. If you want to bring motion to these additional object types, you'll have to convert them into **symbols** and tween them using a **Classic Tween** or a **Motion Tween**.

We'll now have a look at some of the important topics having to do with the various symbol types, including the differences between each type and the methods for creating motion through the use of symbols.

Creating symbols

A symbol in Animate is a special object that can be one of three types: **Movie Clip**, **Button**, or **Graphic**. Symbols exist within the **Library** panel project once created and are used by creating **instances**, which exist on the stage to be manipulated in various ways.

Symbols can be created through the **Library** panel by clicking the **New Symbol** button in the lower-left corner of the **Library** panel or by choosing **Insert | New Symbol** from the application menu.

In either case, the **Create New Symbol** dialog will appear:

Figure 5.21 – The Create New Symbol dialog

Once you give the symbol a name and select its type, you will be brought directly within the symbol timeline to begin creating visual or motion content within the symbol, since a new symbol will be completely empty and void of content until you create it.

When you are taken inside a symbol upon its creation, the user interface will reflect this in a number of ways:

Figure 5.22 – An empty symbol timeline

Note in the previous screenshot how the symbol stage and timeline are completely empty. The only visible mark on the stage is a small + symbol, indicating the **Registration Point** of the empty symbol. We can tell we are within a symbol and no longer within the document root by viewing the **Edit Bar** above the stage. The symbol name appears with a small arrow pointing to the left. Clicking this arrow returns us to the project root outside the symbol.

While creating symbols from nothing is definitely a useful workflow in certain circumstances, the more common way of creating symbols is done through a conversion process.

To convert existing content on your project stage to a symbol, you'll first need to select the content to convert:

1. I suggest drawing another square similar to what we created in the last section with the **Rectangle** tool.

2. Switch to the **Selection** tool and select the square shape that was just created.

3. With the shape selected, look at the **Object** tab in the **Properties** panel and locate the **Convert to symbol** button:

Figure 5.23 – The Convert to symbol button

4. Click the **Convert to symbol** button and the **Convert to Symbol** dialog will appear. You can also choose **Modify | Convert to Symbol...** from the application menu:

Figure 5.24 – The Convert to Symbol dialog

The **Convert to Symbol** dialog is very similar to the **Create New Symbol** dialog, but since it is converting existing content, it includes the additional option to set the registration point of the converted content. This can be set to the center, any corner, or any side, based upon the content being converted.

> **Note**
>
> The registration point of a symbol determines its point of origin when using an x/y system of measurement. Initially, the transform point of a symbol instance on the stage will match up with the registration point.

There are a number of additional settings that are shared between the two dialogs:

- **Name**: This is an identifier given to a symbol in order to locate it within the **Library** panel. No spaces are allowed, and it must begin with a letter.

- **Type**: Choose **Movie Clip**, **Button**, or **Graphic**. You can actually switch type afterward if you make a mistake.

- **Folder**: This specifies the location of your symbol within the **Library** panel for organization purposes. Not specifying a folder will save your symbol to the Library root.

- **Advanced**: A set of options that vary according to the chosen symbol type. Most of the time, you can ignore these options as they largely have to do with ActionScript development.

If you would like to explore some of the options in the **Advanced** section of this panel, you will want to be using an ActionScript 3.0-based document type, otherwise most will be entirely disabled. We'll explore these options in *Chapter 12, Building Apps for Desktop and Mobile.*

> **Note**
>
> If you ever want to adjust these settings, you can do so from the project's **Library** panel. Just right-click on a symbol and choose **Properties...** from the menu that appears.

Now that we understand how symbols are created, let's look more deeply into the three types of symbols that Animate supports.

Exploring Symbol Types

When we created our symbols, we took note that symbols had to be classified as one of three types: **Movie Clip**, **Button**, or **Graphic**. We'll now have a look at how each of these types differs from one another and when you would want to use one over another:

- **Movie Clip** symbols have their own internal timeline that is similar to the main timeline and runs completely independent of it. This symbol type is ideal for small animations, such as flames, that should run continually in a loop. Even if an instance of this symbol is included in a single frame on the main timeline, its internal timeline will continue to animate so long as the playhead is on that frame. When previewing your main timeline within Animate, any instance's internal timelines will not play back, and you must perform a test movie to see them in action. Instances of this symbol type can be made interactive and their timeline can be controlled through code.

- **Button** symbols share some characteristics with movie clip symbols, but their internal timeline is completely fixed to four distinct frames. These frames emulate the states of a traditional button and include up, over, down, and hit. You can change the appearance of each of the first three button states through the use of the drawing tools and the hit state determines the pixels that will automatically trigger interactions and state switching when with the mouse cursor. Instances of this symbol type can be made interactive.

- **Graphic** symbols have their own unique behavior in that their internal timeline is locked to the main timeline. There are also robust looping and frame selection mechanisms available through the manipulation of instance properties. Since their internal timelines are bound to the main timeline, previewing the main timeline within Animate will display their internal animation just the same as when a test movie is performed. Traditional animators tend to prefer this symbol type. Instances of this symbol type cannot be interactive.

Whichever symbol type you choose for a specific task, you will work within each symbol to establish its assets and timeline structures and also make use of individual instances of these symbols within your main timeline.

To create an instance of any symbol, simply drag the symbol from the **Library** panel and onto the stage. This will create an instance by means of which you can then change properties such as the position, rotation, scale, and even more depending upon the symbol type. When you adjust the properties of any symbol instance, these changes only apply to that property, whereas changing anything within the symbol itself will apply to the symbol and all of its instances.

To view the available properties of any symbol instance, select it on the stage and look at the **Object** tab of the **Properties** panel, as shown in the following screenshot:

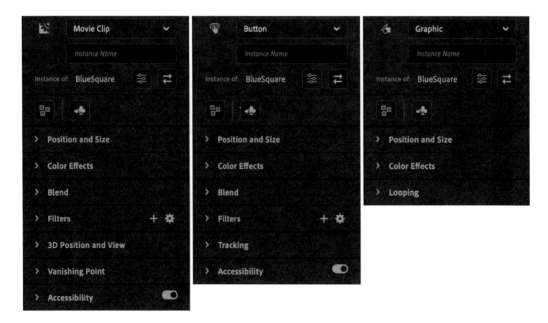

Figure 5.25 – Symbol instance properties

As alluded to previously, instance properties will differ depending upon the symbol type selected.

> **Tip**
> You can actually override the behavior of any symbol instance by choosing a new behavior from the **Instance Behavior** dropdown. This will not change the symbol type, but will change the behavior of that particular instance.

There are a standard set of property sections that are shared across all three types of symbol instances. This can be seen in the following screenshot:

Figure 5.26 – Shared properties

They include the following:

- **Position and Size**: This includes the **X** and **Y** position of your instance on the stage, according to the registration point symbol, as measured from the top-left corner of the stage itself. The width and height of your instance can also be adjusted here.

- **Color Effects**: This property takes the form of a **Color Styles** drop-down selection from where you can choose **None, Brightness, Tint, Advanced**, and **Alpha**. Each selection will present a number of sliders and other controls that allow you to control the color properties of an individual instance.

Movie Clip and **Button** symbol instances also include properties that pertain specifically to **Accessibility** and are only ever available within ActionScript 3.0 document types:

Figure 5.27 – Accessibility options

These options allow you to include information for screen readers such as a name and description, while also allowing you to define keyboard shortcuts and the **TAB** order.

The **Movie Clip** and **Button** symbol instances also include **Filters** and **Blend** property selections:

Figure 5.28 – The Filters and Blend modes

These property sets allow a choice from a number of **Blend Mode** options, including **Normal, Multiply, Screen, Overlay, Hard Light**, and more. You can make choices regarding how your instances are rendered when published within this section. A variety of filters can also be added, including **Drop Shadow, Blur**, and **Glow**, among others. The available filters and blend modes depend upon your chosen document type.

Button symbol instances have a special **Tracking** property set that includes two options: **Track as Button** or **Track as Menu Item**. The difference here is that when you track as a button, the trigger stops at the button click, and when you track as a menu item, the trigger event bubbles up to additional containing items and can be caught to perform additional actions. It is a subtle difference, but one that can be important within certain contexts where you require a secondary action to occur. This feature is only available in ActionScript 3.0 document types.

When using **Movie Clip** symbol instances within an ActionScript 3.0 document, you have access to both the **3D Position and View** and **Vanishing Point** property sections:

Figure 5.29 – 3D Position, View, and Vanishing Point properties

The 3D tools within Animate are only ever functional with ActionScript 3.0-based document types and even then, are of limited use since they only provide the appearance of a third dimension. For true 3D content in Animate, it is suggested to explore **WebGL glTF** documents.

Finally, **Graphic** symbol instances have a **Looping** section containing properties and tools that pertain directly to animation. We'll explore this section in *Chapter 7, Character Design through Layer Parenting.*

With a solid understanding of the three types of symbols, how they are instantiated for use in a project, and the differences in capabilities across them all, it's now time to start animating!

In this section, we saw how to create symbols and explored the three distinct symbol types in Animate. Coming up, we'll see how to add motion to these symbol instances using **Classic Tweens**.

Animating with Classic Tweens

When animating with symbol instances, you have two tween options available to you: **Classic Tweens** and **Motion Tweens**. Both of these tweening types work differently from one another, but a **Classic Tween** is handled more similarly to what we saw when using a **Shape Tween** earlier in this chapter, so we'll examine that first. Motion guides will be explored as part of *Chapter 6, Interactive Motion Graphics for the Web*.

We'll now step through the process of animating a symbol instance with a **Classic Tween**:

1. The first thing you need to do is start a new document. I'm going create a new ActionScript 3.0 document and set the width to 1280 and the height to 720 with an **FPS** setting of 30.

2. Be sure and rename your default **Layer_1** layer to something appropriate to the content you intend to create. I've renamed mine to Square.

3. The contents of our symbol should be pretty simple for this exercise. I'm going to use a square shape, similar in appearance to the shape we used when performing a **Shape Tween**. Using the **Rectangle** tool, draw a square shape on the stage.

4. Next, you must create a symbol to animate. I'm going to create a **Graphic** symbol. Using the **Selection** tool, select the shape you created and choose **Modify | Convert to Symbol** from the application menu. The **Convert to Symbol** dialog appears:

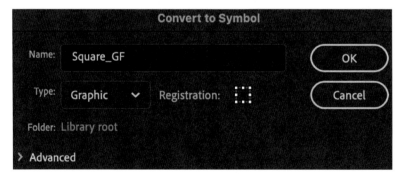

Figure 5.30 – Creating a new symbol

5. If you do not have an instance of your symbol on the stage yet, be sure to drag one from the **Library** panel onto the stage. I'm placing mine to the left side of the stage in this case:

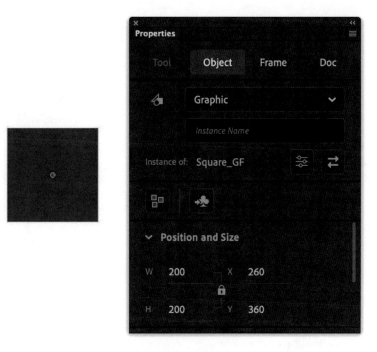

Figure 5.31 – Positioning your symbol instance

6. Since the timeline only contains a single keyframe at frame 1 right now, select frame 30 and insert a new keyframe either from the **Insert Keyframe** button at the top of the timeline, or by choosing **Insert | Timeline | Keyframe** from the application menu:

Figure 5.32 – Creating a new keyframe

7. You now have two keyframes. With the playhead positioned at the second keyframe (at frame 30), use the **Selection** tool to move the symbol instance to the opposite side of the stage. This creates a change in position values between the two keyframes:

Figure 5.33 – Modifying the symbol instance position

8. To create a **Classic Tween** in order to fill in the changes between these keyframes over time, click the **Create Classic Tween** button from the top of the timeline or choose **Insert | Create Classic Tween** from the application menu:

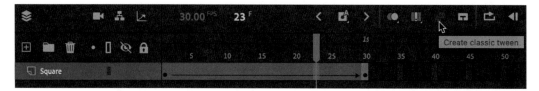

Figure 5.34 – A completed classic tween

Once these steps have been completed and the **Classic Tween** is in place, test your animation with the **Test Movie** button. The symbol instance moves across the stage from left to right.

> **Note**
> Classic tweens cannot do much of what shape tweens are used for, including morphing between shapes and using shape hints, changing fill or stroke colors, and similar property changes. Symbol instances are more limited in this respect since their contents are enclosed within the symbol itself.

As you can see, animating with **Classic Tweens** is very similar to doing so with **Shape Tweens**. Once you have a handle on one tween type, the other is easy to pick up and use.

Using Classic Motion Guides

Motion guides within Animate allow you to direct the change in position during a tween through the use of a dedicated path. It is almost like placing a mining cart on a rail and just letting it go; the cart will follow any twists and turns present.

Say you want your symbol instance to travel in an arc. This is difficult with simple keyframes, but a **Classic Motion Guide** makes it a breeze:

1. The first thing you need is a properly tweened object. We'll use the simple exercise that we completed previous to this task.

2. Right-click on the layer that contains the tween and choose **Add Classic Motion Guide**:

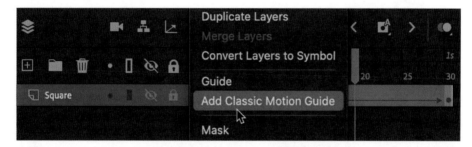

Figure 5.35 – Add Classic Motion Guide

3. A new layer is added above the selected layer and that layer is then nested beneath it with a slight indent:

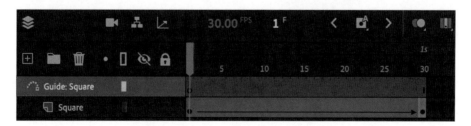

Figure 5.36 – Classic motion guide added

4. Using basically any tool that will create a stroke, such as the **Line** tool, draw a stroke across the stage:

Figure 5.37 – Motion guide created

5. Now, with nothing selected whatsoever, hover the **Selection** tool over the line you just created and drag it upward to create an arc:

Figure 5.38 – Arcing the motion guide

6. You will need to reposition the symbol instance on both frame 1 and frame 30 to be sure that the **Transform Point** of each asset is overlaying the newly created **Classic Motion Guide** arced line asset.

7. Scrubbing the timeline should ensure that the instance follows along the arc of your guide instead of simply moving straight to the other side of the stage:

Figure 5.39 – Completed Classic Motion Guide

If your symbol instance does not follow the arc you've created, be sure that the transform points on all keyframes align with the visible guide you've drawn! Do not worry about the visible nature of the **Classic Motion Guide** within Animate, since when testing or publishing, the line is a guide and will not be visible to the user.

> **Note**
>
> Although they are "classic" motion guides, they are not only to be used in **Classic Tweens**. **Shape Tweens** can also make use of **Classic Motion Guides** in the same way!

Classic Motion Guides are a really useful feature when you want to direct the motion of your animated content across a certain path.

Exploring Classic Tween Properties

Just as we saw earlier with **Shape Tweens**, **Classic Tweens** have a set of properties all their own. Even given the similarities between both tween types, there are a few major differences when it comes to available properties and even how shared properties function.

To view the properties of a **Classic Tween**, select any of the frames that make up the tween span and look at the **Frame** tab in the **Properties** panel:

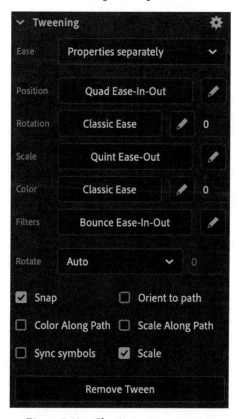

Figure 5.40 – Classic tween properties

Locate the **Tweening** section to view the various properties associated with **Classic Tweens**. Let's explore some of the main properties and functions here:

- **Ease**: One of the major differences between **Shape Tween** and **Classic Tween** easing effects is that a **Classic Tween** can have individual properties, such as position, rotation, and scale, eased in different ways. **Shape Tweens** can only have a single easing effect applied to all properties. Otherwise, this feature has the same behavior across both tween types.

- **Rotate**: You can choose between **None, Auto, Clockwise**, and **Counter-clockwise** as well as the number of rotations between keyframes.

- **Snap**: This option will assist in snapping to any guide that might be in use, helping to align the transform point of the instance being guided along a **Classic Motion Guide**.

- **Orient to path**: This option will preserve the orientation of your object as it moves along a **Classic Motion Guide** by adjusting its rotation. This is a really useful option.

- **Color Along Path**: This option can apply the color of the **Classic Motion Guide** shape to your object as a tint.

- **Scale Along Path**: This option can adjust the size of your object interpreted as scale via the **Classic Motion Guide** being used.

- **Sync Symbols**: This option will force the internal timeline of the symbol to sync frames with the main timeline.

- **Scale**: When selected, the instance will scale across time if the scale has been adjusted within a keyframe. If deselected, scaling will not occur across the tween itself.

- **Remove Tween**: Choosing this button will remove the tween entirely.

There are definitely some differences between the various properties available to us when using different tween types. It's important to know what properties you want to control in order to choose the right type of tween.

In this section, we had a deep look into the various symbol types available in Animate and how to create motion with them through **Classic Tweens**.

Summary

We covered a lot in this chapter! Beginning with an introduction to the various drawing tools in Animate, we then quickly moved along to apply motion to our content using **Shape Tweens** and explored many of the properties associated with this tween type. We then saw how to create symbols from our content and explored the different symbol types that are available to us. Following up, we had a look at how to create instances of our symbols and add motion to them using **Classic Tweens**. Finally, we dove into the use of **Classic Motion Guides** and the variety of properties available to us through **Classic Tween** properties.

In the next chapter, we will expand upon what we've learned here and make use of a third type of tween, the **Motion Tween**, as we build interactive motion graphics specifically for the web.

6
Interactive Motion Graphics for the Web

In the previous chapter, we explored content creation using the various tools within Animate and focused on animating that content through the use of both **Shape Tweens** and **Classic Tweens**.

In this chapter, we are going to design animated content for publication to the native web using the HTML5 Canvas target platform. As we build out a digital advertisement, we will include externally created content such as photographic bitmap images, design text objects within the project using Adobe Fonts, and animate both by focusing on the third tweening type available to us in Animate, the Motion Tween. We'll close out the chapter by examining various properties unique to Motion Tweens and then explore a few ways of writing code to make our project interactive.

After reading this chapter, you'll be able to perform the following functions in Animate:

- Import photographic content to combine with additional object types such as text and shape within Animate.
- Create and animate symbol instances using Motion Tweens, Motion Guides, and the Motion Editor.
- Effectively animate with Motion Tweens and modify associated tweening properties.
- Develop interactive elements for use on the web through the use of the **Actions** panel and the Actions Wizard.

Technical Requirements

You will need the following software and hardware to complete this chapter:

- Adobe Animate 2021 (version 21.0 or above)
- Refer to the Animate System Requirements page for hardware specifications: `https://helpx.adobe.com/animate/system-requirements.html`. The CiA video for this chapter can be found at: `https://bit.ly/3iSDvuQ`.

Designing a Document for the Native Web

While we spoke in some detail about different document types and publishing platforms in *Chapter 2*, *Exploring Platform-Specific Considerations*, and *Chapter 4*, *Publishing and Exporting Creative Content*, we haven't really focused on any particular platform when creating and animating content. This chapter changes that as we will be entirely focused on the native web in everything we do.

The first step in designing content for the web such as digital advertisements or interactive infographics is to create a document that targets these technologies and get our assets together.

Creating a New Document for Digital Advertising

We'll first create a new document that targets native web technologies from the various presets available to us in Adobe Animate. The **New Document** dialog includes a series of categories containing focused sets of presets to be used. You can access this dialog by choosing **File | New** or through the **Create New** button on the welcome screen.

Whichever method you choose, the **New Document** dialog will appear:

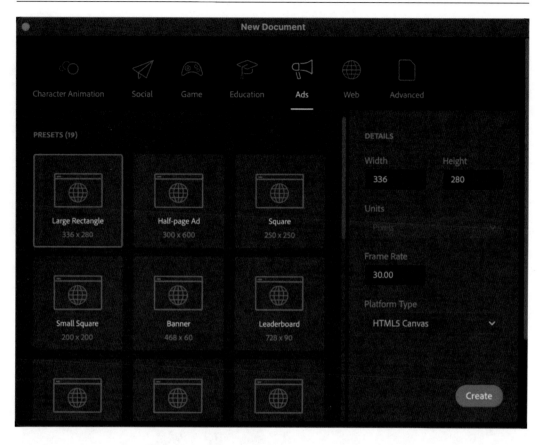

Figure 6.1 – New Document Ads Category Presets

With the **New Document** dialog open, we are ready to choose a preset. Along the top, you'll find six categories: **Character Animation**, **Social**, **Game**, **Education**, **Ads**, **Web**, and **Advanced**. We've already had a look at the **Advanced** category earlier in this book and will now turn our attention to the others.

We are designing a motion advertisement that will be supported on the web:

1. Choose the **Ads** category and view the many ad presets that are present there. These presets are useful for both mobile displays and web browsers and are all built to conform to commonly accepted ad sizes.

2. Locate the preset named **Large Rectangle** and select it. It will then appear highlighted with a blue border.

3. The sidebar will change to display the details of our chosen preset. You'll note the size of our document will be 336x280 with an FPS value of 30. It's fine to adjust the **Frame Rate** if you find the playback requires a smoother frame rate or that you have too many frames for your needs, but since we are targeting commonly accepted ad sizes through these presets, there is no need to make any adjustments to the width and height.

4. Look below the **Frame Rate** and notice that there is a **Platform Type** selection box. If you interact with this control, you will see two choices: the default of **HTML5 Canvas** and **ActionScript 3.0**. Again, since we are targeting the native web, we want to be sure that **HTML5 Canvas** is the one selected.

5. When you are ready to create your document, click the **Create** button and a new document will open up within Animate.

6. Be sure to save your new document as a `.fla` file by choosing **File | Save** from the application menu before moving on.

Our new document is configured, saved, and ready to be worked on.

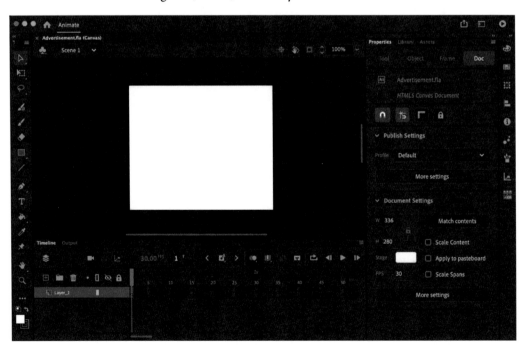

Figure 6.2 – Our newly created document

7. A quick look at the **Properties** panel should confirm that all of the choices made in regard to width, height, FPS, and the target platform have been preserved.

Before moving on, we should note a couple of important things about digital advertising on the web and the standard presets we have based our new document upon. If you are new to the field of digital advertising, you may not know there actually are a set of common ad sizes that almost all ad delivery networks accept.

These range from elongated banners to tall skyscrapers, and a set of sizes that are squarer in aspect. They can be seen in the following figure:

Figure 6.3 – Common display ad sizes

Some of these sizes should be instantly recognizable by shape alone, as they appear all over the internet; on news websites, social networks, personal blogs – everywhere. The presets within the **Ads** category in Animate are all based upon these standard sizes.

> **Tip**
> An extensive list of digital advertising sizes is maintained by Google and can be found at https://support.google.com/google-ads/answer/7031480.

With our new document created and saved, we will now turn our attention to the content to be included in our advertisement.

Importing External Content

Up to this point, we've only worked with assets created within Animate itself and haven't used anything external to the software. Many advertisements contain bitmap images such as .jpg and .png files for a photorealistic approach. Animate has no problem using bitmap images within any project, but you must first import the files to be used into the project library.

We've prepared a set of photographic images that have been prepared using **Adobe Photoshop** that will be used in different ways within this project. Our example advertisement is going to be for a unique brand of coffee that can only be purchased online.

> **Note**
>
> You can find the images we use here, within the exercise files at `https://github.com/PacktPublishing/Mastering-Adobe-Animate-2021`.

Let's go ahead and import some bitmap images into our document:

1. Using the application menu, choose **File | Import | Import to Library...** to summon a file browse dialog:

Figure 6.4 – Choose Import to Library...

2. Navigate to the location of your bitmap image files. If your `Bean.png` and `CoffeeBeans.jpg` files are not visible, within the browse dialog, be sure and choose **All Files (*.*)** from the **Enable** drop-down menu:

Fig. 6.5 – Import image files dialog

3. Select the two files and click the **Open** button.

4. The files will be imported into your project library. You can verify this by opening the **Library** panel. The images will be the only items within, and you will be able to preview them from here as well:

Fig. 6.6 – Imported bitmaps are stored in the library

We could have alternatively chosen to import our images directly onto the stage. When choosing **Import to Stage...** from the **Import** menu, your files will be imported to the project library just as we've done here but instances of these bitmaps will also be placed upon the stage. We are going to handle that part ourselves.

We only want to bring an instance of `CoffeeBeans.jpg` onto the stage at this point, so we can ignore `Bean.png` for now:

1. Be sure your **Library** panel is open and that the stage is in view within the interface as well. Select `CoffeeBeans.jpg` and drag it onto the stage:

Fig. 6.7 – The image is huge

The image is much too large for the stage at its native size of 1,000 pixels in width!

2. Look at the **Object** tab in the **Properties** panel and ensure the small lock icon between the width and height boxes is active. This will retain the native aspect ratio when the image is resized. Set the image width value to `425`:

Fig. 6.8 – Set image width

3. Open the **Align** panel if not already open by choosing **Window | Align** from the application menu. Ensure the **Align to stage** checkbox is active and choose both **Align horizontal center** and **Align vertical center**:

Fig. 6.9 – Align to stage vertical and horizontal center

This will center the bitmap instance across the stage. The image will overlap the stage onto the pasteboard a bit on all sides as well, but that is what we want.

4. We should always aim to be as organized as possible within our projects. Rename **Layer_1** to CoffeeBeans before moving on.

5. If desired, you can hide the parts of the bitmap image that overlay the pasteboard by clicking the **Clip content outside the stage** button right next to the zoom percentage above the stage:

Fig. 6.10 – Our background and timeline are ready

We now have an instance of the `CoffeeBeans.jpg` bitmap file on the stage, resized to allow just a bit to bleed over onto the pasteboard. All of this is contained in a single layer named **CoffeeBeans**, which consists of a single frame.

Next, we'll go ahead and create more objects that will make up the rest of our digital advertisement.

Creating Text Objects

This chapter marks our first time using imported bitmap files in a project, but that won't be the only first. We need some text to include within the coffee advertisement as well and for that, we will put the **Text** tool to work.

Once the text is in place, we will add additional elements to complete the layout portion of this project:

1. We want to keep our text in a different layer from the background image so that we'll be able to animate each separately. Click the **New Layer** button above the layer stack to add a new layer:

Fig. 6.11 – Adding a new layer

2. With a new layer added above the **CoffeeBeans** layer, rename the newly added layer to `TextMsg`. It is always important to name your layers using terms that make sense to the overall project.

3. Select the **Text** tool from the **Tools** panel. Remember, if a tool is not initially present, you can always edit the **Tools** panel to include it:

Fig. 6.12 – Text tool

4. With the **Text** tool selected, look at the **Tool** tab or the **Properties** panel. This allows us to set some properties of our text before even creating it:

Fig. 6.13 – Text tool properties

We will want to use **Static Text** for this task so be sure the text **Instance Behavior** dropdown is set to this. **Static Text** is rendered to shape data upon publishing, ensuring that even viewers who do not have a specific font installed can see the text using the intended font. We'll look at **Dynamic Text** as part of *Chapter 10, Developing Web-Based Games*.

I've selected an **Adobe Font** for this project called *Neue Haas Grotesk Display Pro* and this can be used by anyone with an **Adobe Creative Cloud** subscription – just visit `https://fonts.adobe.com` and search for it!

I'm going to use a `48pt` value for **Size** and `#FF9900` for my **Fill** color.

To add text to the stage, you can click and begin typing to create an expanding width **Point Text** object or click and drag a textbox with a specific width to create **Paragraph Text**. We want to control the width of our text objects so will create **Paragraph Text**:

1. At the top of the stage, click and drag from one side to the other to create a textbox measuring the width of the stage and type `DARK ROAST` using the previously chosen size and fill values.

2. Modify the **Text** tool properties to use a `15pt` value for **Size** and `#FFD495` for the **Fill** color before adding a secondary piece of text.

3. Once again, click and drag from one side of the stage to the other to create a textbox the width of the stage and type `THE ULTIMATE COFFEE EXPERIENCE` directly beneath the original text object.

4. Using the **Selection** tool, click on the first text block and look at the **Object** tab of the **Properties** panel. The object width should be `336` with an **x** position of `0` and a **y** position of `5`. Look to the **Paragraph** section and choose to **Center** align the text.

5. Click the secondary text and look at its properties. The width should be `336` and the **y** position should be `63`. The **x** position remains aligned to the left at `0` just like the previous text object. You should be sure and **Center** align this text as well:

Fig. 6.14 – Text added to our advertisement

The advertisement layout is beginning to take shape! One of the biggest concerns right now is the legibility of the text across the background image. We can increase the readability of the text message by adding a shape between the text and background.

6. Choose the **Rectangle** tool, set its fill color to pure black (`#000000`), and disable the stroke. Enable **Object Drawing Mode** so that the resulting shape is easier to handle:

Fig. 6.15 – Object Drawing Mode activated

7. Adjust the **Fill** opacity to a value of 80% and draw a rectangle at the top of the stage so that it covers the text completely. Your shape should have a width of 336, a height of 90, and be positioned at an **x** and **y** of 0.

8. The last step is to send the shape behind your text, as it is obscuring it right now. Select the shape and choose **Modify | Arrange | Send to Back** from the application menu. The shape will be sent to the back of the stacking order within this specific layer. If you did not activate **Object Drawing Mode** in the last step, you will not need to do this as simple shapes will appear beneath text objects:

Fig. 6.16 – Shape added for clarity

That looks pretty good! The initial layout for our advertisement is now complete.

With our text objects and the background bitmap image on their own layers, this gives us a good starting point to create some animation.

In this section, we assembled imported external bitmap images and created text objects within a new document targeting the native web. Next, we'll begin animating this content through the use of a tween type called the **Motion Tween** – a tween we haven't encountered yet in this book.

Animating with Motion Tweens

We'll now add motion to the various components of our advertisement. In the previous chapter, we used both Shape Tweens and Classic Tweens to create motion, depending upon whether our object was a shape or a more complex symbol instance. In this project, we have a bitmap image instance to animate along with a group of text and shape objects.

We could convert these various objects to symbols and employ a classic tween – that would work just fine! However, this is the perfect opportunity to introduce the third type of tween that you can use within Animate – the Motion Tween.

Motion Tweens work very similarly to Classic Tweens in that they are both used to animate symbol instances and not shapes. A lot differs between the two as well – both in how they are created and the various properties available to us.

> **Note**
>
> Classic Tweens actually used to be called Motion Tweens before Motion Tweens were introduced to Flash Professional. When that happened, they were given the "classic" moniker and are now known as Classic Tweens.

We'll have a look at all of this, but the first task in preparation to use a Motion Tween is to ensure anything we want to animate is encapsulated within a symbol.

Building Symbols for use in Motion Tweens

Before animating with **Motion Tweens**, we will transform the contents of both our existing layers into symbols in order to tween their instances:

1. Using the **Selection** tool, select the instance of our `CoffeeBeans.jpg` bitmap file within the **CoffeeBeans** layer.

2. Choose **Modify | Convert to Symbol…** from the application menu or choose the **Convert to Symbol** button within **Object** properties. The **Convert to Symbol** dialog appears. We must convert any bitmap image to a symbol in order to animate it with a tween as bitmap instances cannot be tweened.

3. Name the new symbol `CoffeeBeans` and choose the symbol type of **Movie Clip**. This symbol type will give us a good amount of flexibility when animating the background and we can also add interactivity to it if the need arises. Click **OK**:

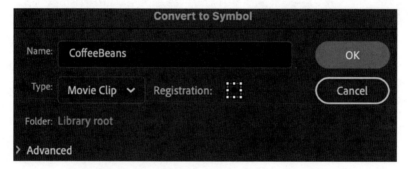

Fig. 6.17 – Create the CoffeeBeans Movie Clip symbol

Have a look in the **Library** panel and note that the newly created symbol appears there – right alongside the images that have been imported. Both imported files and symbols created in Animate will become part of the project library and you can use as many instances of each as you like.

4. Now, we will focus our attention on the **TextMsg** layer. Clicking the keyframe at frame 1 of this layer will select both text objects along with the underlying shape object as they all exist on this single layer. We are going to convert all three to a single symbol in order to animate them as one object.

5. In the **Properties** panel, the **Frame** tab is currently selected since we clicked upon a keyframe. Click the **Object** tab and notice the object type reads as **Mixed**, indicating that objects of multiple types have been selected:

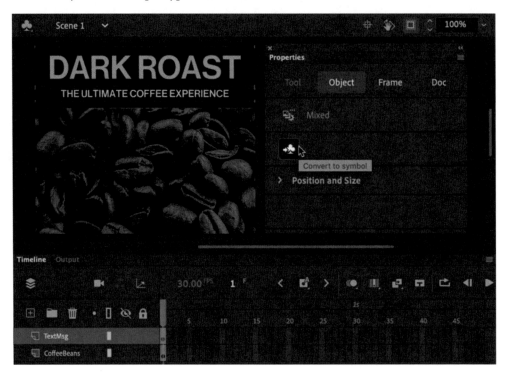

Fig. 6.18 – Object Properties showing a mixed selection

6. With this information verified, click **Convert to Symbol** to summon the **Convert to Symbol** dialog.

7. Name the new symbol `TextMessage` and choose the symbol type of **Movie Clip** just as before. Click **OK**:

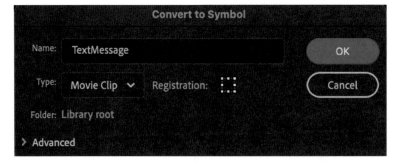

Fig. 6.19 – Create the TextMessage Movie Clip symbol

We now have a single **Movie Clip** symbol instance within each of our layers and they can each be effectively tweened in this state. The **CoffeeBeans** symbol contains a single bitmap image and the **TextMessage** symbol contains multiple objects within it, but we can manipulate them all together since they are now part of a single **Movie Clip** symbol.

We will now create a **Motion Tween** within each layer in order to add animation across both symbol instances:

1. Select the keyframe at frame 1 of the **CoffeeBeans** layer and choose **Create Motion Tween** from the **Insert Tweens** button above the timeline:

Fig. 6.20 – Create Motion Tween creates a Motion layer

The **Create Motion Tween** command establishes a **Motion Tween** with only a single manual keyframe created. This is very different from Shape Tweens and Classic Tweens, which both require at least two keyframes to create a tween. This action converts the chosen layer into a special **Motion Layer** and 1 second worth of frames is added.

2. Do likewise in regard to the **TextMsg** layer so that both become Motion Layers with active **Motion Tweens**. Once the conversions are complete, we can begin animating the contents of each layer.

3. Select frame 30 in the **CoffeeBeans** layer. Right-click and choose **Insert Keyframe | All** from the menu that appears. This will insert a keyframe that holds data values for the **Position**, **Scale**, **Skew**, **Rotation**, **Color**, and **Filter** properties:

Fig. 6.21 – Manual keyframe insertion for Motion Tweens

Note that these keyframes in Motion Tweens appear as small diamonds and not the circular keyframes we are used to:

Fig. 6.22 – A diamond-shaped keyframe is inserted

In addition, you do not even have to set a keyframe manually as we have done here. All that is needed is to change any of the supported properties with the playhead at a specific frame and a keyframe representing the change in data will appear automatically. Again, quite different from other tween types.

4. The only property we'll be adjusting is the scale of the background image. Move the playhead to frame 1 and use the **Free Transform** tool to scale down the image so that it is closer to the height of our stage:

Fig. 6.23 – Scaling the symbol instance

The original scale is preserved in the previously inserted keyframe at frame 30.

5. We'll now move on to the **TextMsg** layer. Insert a new keyframe with all properties as before at frame 25 and frame 15. All three keyframes hold the same values at this point:

Fig. 6.24 – Keyframes inserted along the motion layer

6. At both frame 1 and frame 15, shift the symbol instance upwards, off the stage so that the **y** position value is -55. You will notice a **Motion Guide** appears automatically, which displays the path of motion for our object. The instance will animate in from the top of the stage between frame 15 and frame 25:

Fig. 6.25 – Instance shifted off the stage

7. Our initial animation is rough but complete. Perform a **Test Movie** to view it in the web browser.

Notice the animation loops endlessly and there is no pause at the beginning or end. We will remedy these aspects of our animation before closing out the project.

With the animation of two pieces of content in place, we have seen that changing position when using a **Motion Tween** results in a **Motion Guide** on the stage. We'll next give this a better look and put it into play with another animated object.

Including Additional Library Items

To include additional library items, follow these steps:

1. To complete the layout of our advertisement, we'll also bring in an instance of the `Bean.png` bitmap we imported to the **Library** earlier and animate that as well.

2. The first thing to do is create a new layer to hold our single coffee bean image. This image is a **PNG** file with a transparent background, so all you see is the coffee bean. Name the layer `Bean` once you create it.

3. Drag an instance of the `Bean.png` bitmap image onto the stage. Place it toward the bottom left. Feel free to use the **Free Transform** tool to scale and rotate the image instance as appropriate:

Fig 6.26 – Scaling the Bean.png bitmap instance

4. We will now convert this image instance into a symbol. With the image selected, choose **Modify | Convert to Symbol** from the application menu. Give the **Movie Clip** symbol the name `Bean` and click **OK**:

Fig. 6.27 – Create the Bean Movie Clip symbol

5. Now, create a new **Motion Tween** within the **Bean** layer just as we have done with the previous two. The **Bean** layer becomes a **Motion Layer** with an active **Motion Tween** stretching to frame 30 at the 1-second marker.

6. Click upon the initial circular keyframe at frame 1 to select it. We are going to shift this over a bit.

7. Hover to the left of the keyframe at frame 1 with your mouse cursor and a small double-headed arrow cursor appears, indicating you can move the beginning keyframe along the timeline by dragging it:

Fig. 6.28 – A double-headed arrow appears

8. Go ahead and drag the selected keyframe to frame 30. When the mouse is released, the initial keyframe is relocated and now begins at frame 30. The frame span before frame 30 contains only empty frames.

With the new asset in place on its own layer, we'll next make some adjustments to the previously included animated content.

Adjusting the Timeline

At this point, we are going to want to adjust the previous animations a bit to allow some padding both before and after the animations. A common practice in character animation, it's always a good idea to include a bit of anticipation this way, even with motion graphics in advertising.

Okay, let's fill out our timeline a bit more and perform some additional keyframe arrangements:

1. Insert frames for all layers up to and including the 2-second mark at frame 60 using either the **Insert Frame** button above the timeline or **Insert | Timeline | Frame** from the application menu.

2. Let's ensure that the background scaling animation also extends to the entire 2 seconds. Click the diamond keyframe at frame 30 on the **CoffeeBeans** layer so that it becomes selected and highlighted in blue.

3. If you now hover over this selected keyframe, you will see the cursor change to include a white box with a dashed line around it next to the cursor. This indicates you can now click and drag the keyframe to relocate it. Drag the keyframe to frame 60 and release the mouse to relocate it:

Fig. 6.30 – Dragging the keyframe to relocate

The previous scaling animation is preserved but takes up double the time now.

4. We will now shift our keyframes in the **TextMsg** layer a bit so that the animation we created previously has a bit more room to breathe at the beginning. Select the block of frames that make up the entire set of keyframes in the **TextMsg** layer:

Fig. 6.31 – Block of frames selected

5. Just as before, if we hover over the selection and then drag it across the timeline, we can relocate the entire set of frames. To include a pause at the start of the timeline, drag the keyframe at frame 1 over to frame 10:

Fig. 6.32 – Block of frames shifted to frame 10

Play the animation using the controls above the timeline to view the effect of anticipation.

With these adjustments in place, we can better animate the **Bean** symbol instance in the proper context.

Animating with Motion Guides

Time to add motion to the **Bean** symbol instance! Right now, it exists at frame 30 and just sits there. We will have the bean drop in from the upper right and settle to its present location in the lower left:

1. Select the frame at frame 50 of the *Bean* layer and right-click on the selection to open the menu. Choose **Insert keyframe | All** from the menu that appears. This duplicates the keyframe information from the previous keyframe.

2. Move the playhead back to the initial keyframe at frame 30 and reposition the **Bean** symbol instance to the upper right – completely off the stage. This is where the instance will animate in from:

Fig. 6.33 – Motion Guide created

Notice that, since the position of our object differs between the two keyframes, a **Motion Guide** automatically appears between the two positions. This is very different than working with **Classic Motion Guides** since we don't have to do anything special to make it appear.

3. Using the **Selection** tool, we can make all sorts of adjustments to the curve and ease the motion by hovering over the **Motion Guide** until a small arc appears next to the cursor. Pull this down and to the right to give the motion a slight curve and to space the frames in a more variable way.

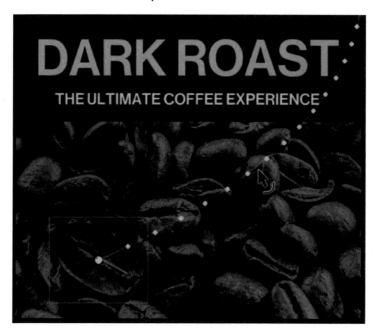

Fig. 6.34 – The curved motion guide

4. Each frame in our tween is represented by a small dot along the **Motion Guide** path. This is a great way to visualize easing for position in our **Motion Tweens**.

5. Go ahead and click the **Play** button above the timeline to preview the animation.

Certain aspects of a **Motion Tween** are very different from the two other tween types in Animate, but in execution perform mostly the same function.

We'll next examine the properties associated with a **Motion Tween**.

Exploring Motion Tween properties

Just as with **Shape Tweens** and **Classic Tweens**, **Motion Tween** properties can be accessed through the **Tweening** section of the **Properties** panel:

1. Go ahead and click on any **Motion Tween** frame and look at the **Frame** tab of the **Properties** panel to access this section and the properties within:

Fig 6.35 – Motion Tween properties

There isn't a lot here by comparison. That is due to the fact that additional properties are located elsewhere. We'll look into that next, but first, the obvious properties:

- **Ease** – Accepts a value between -100 and 100 with a default of 0, adjusting the intensity of either an ease-in or an ease-out.

- **Orient to path** – This option will preserve the orientation of your object as it moves along the **Motion Guide** by adjusting its rotation.

- **Rotate** – You can choose between **None**, **Auto**, **Clockwise**, and **Counter-clockwise** as well as the number of rotations between keyframes and a specific angle.

- **Sync symbols** – Will force the internal timeline of the symbol to sync frames with the main timeline.

- **Remove Tween** – Choosing this button will remove the tween entirely.

 You may have noticed from our initial exploration of **Motion Tween** properties that there are no **Ease Effect** presets like there are in **Shape Tween** and **Classic Tween** properties. With a **Motion Tween**, you access similar functionality through the **Motion Editor**.

2. To access the Motion Editor, simply double-click on any existing **Motion Tween**:

Fig. 6.36 – The Motion Editor

3. The **Motion Editor** will appear as part of the timeline. On the left side, you will see a list of the various properties that can be tweened. Note that each property of a **Motion Tween** can be tweened individually in this way!

4. You'll also see a graph displayed to the right of this, within the timeline proper. Each property has a path here with a set of anchor points and handles that can be manipulated in much the same way as when you edit any path when designing visual content with the **Pen** tool or **Subselection** tool.

5. Below this is the location of the ease presets that were missing from the **Tweening** section we previously examined. If you don't want to manipulate each easing curve by hand, clicking the **Add Ease** button will allow you to choose from a list of presets.

Fig. 6.37 – Motion Ease presets

The **Motion Tween** ease presets are somewhat similar to what can be found in other tween types, but they differ in some ways as well. Double-click on a preset to apply it to any selected property. In addition, certain presets also have the ability to have the intensity value adjusted.

Once you apply an ease preset, the apparent ease will be reflected in the easing graph by way of a dashed easing curve right alongside the original curve.

To hide the **Motion Editor,** simply double-click on the associated **Motion Tween** in the same way that you opened it.

As we saw in our examination of **Shape Tween** and **Classic Tween** properties, **Motion Tweens** have their own set to be aware of. In the next section, we'll see how to make our advertisement interactive using JavaScript code.

Adding Interactivity with JavaScript

Generally, a digital advertisement like the one we've designed here will need to be interactive as well. Most ads of this kind will respond to user interaction by opening a web page where the user can get more information about, or even purchase, the advertised product or service.

Since we are publishing to the native web using an HTML5 Canvas document type, we will be coding our interactions with the JavaScript language.

Writing code with the Actions panel

Animate is a unique piece of software in that it allows both design and development within the same application. This hybrid approach has always been a strong part of the tool and continues to be so, no matter which platform you might be targeting.

Let's go ahead and add some code to our motion advertisement:

1. By convention, and for the purpose of organization, we should keep our code completely separate from any visible assets. Go ahead and create a new layer and name it Actions. All code will go in this layer to keep things clean.

2. All of our code will be on the final frame of the animation, so we must insert a new keyframe at frame 60 in the **Actions** layer. Go ahead and perform these actions.

3. To stop the playhead at the end of our animation, we must use a stop() action. Select frame 60 and open the **Actions** panel from the application menu by choosing **Window | Actions**. The **Actions** panel appears with the **Script Editor** visible.

4. On line 1 of the Script Editor, write `this.stop();` to stop the playhead once it hits frame 60. This will ensure that the animation will not loop:

Fig. 6.38 – Stop action at frame 60 via the Script Editor

If you know what code to write, you can just start writing directly into the Script Editor here. If you need a more guided approach, we'll tackle that momentarily.

We want the user to be able to click on our little coffee bean symbol instance to be taken to a website. To make a **Movie Clip** symbol instance interactive, it must be given an **Instance Name** so the code can identify and address it.

5. Using the **Selection** tool, click on the **Bean** symbol instance to select it and look to the **Object** tab or the **Properties** panel.

6. There is an input field ready and waiting for an instance name to be given. Type `coffeebean` in the **Instance Name** field. Once this has been done, the instance is exposed to code:

Fig. 6.39 – Instance name added to the bean instance

7. Open the **Actions** panel at frame 60 once again if it has been closed. Instead of editing code in the Script Editor, we will now make use of the **Actions Wizard** to take us step-by-step through constructing the code. Click the **Add using wizard** button above the **Script Editor** to open it.

8. The editor disappears and is replaced by the wizard. **Step 1** asks you to **Select an action** from a long list of possible actions. Locate the action named **Go to Web Page** and click to select it.

9. You'll notice a preview of the code you are building is added to the tiny code editor at the top of the panel. Replace the highlighted URL with one of your own and then click the **Next** button to move on to **Step 2**.

10. **Step 2** asks you to **Select a triggering event** from a list of events. Choose **On Mouse Click** for your event and *Step 3* will activate.

11. In **Step 3**, you are asked to **Select an object for the triggering event**. Notice the given **Instance Name** of coffeebean appears as part of this list! Choose this object and click the **Finish and add** button to complete the steps and build the final code:

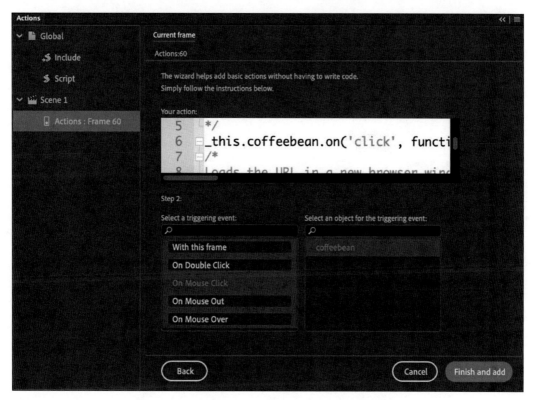

Fig. 6.40 – Click trigger added via the Actions Wizard

12. You can close the **Actions** panel and perform a **Test Movie** to view the animated advertisement and interact with it by clicking the little bean at the end.

The resulting JavaScript code created by the Actions Wizard is included here:

```
var _this = this;
_this.coffeebean.on('click', function(){
window.open('https://josephlabrecque.com', '_blank');
});
```

It is basically defining a variable, `this`, to preserve scope, followed by the registration of an event listener on our `coffeebean` object. If a `click` event is detected, the function to open a URL in the web browser is executed. Passing in the `'_blank'` argument opens the URL in a new window or tab. Pretty simple stuff!

In this snippet of code, all comments have been removed for clarity.

> **Note**
>
> We will be looking at a lot more JavaScript in *Chapter 10, Developing Web-Based Games*, and *Chapter 11, Producing Virtual Reality Content for WebGL*.

In this section, we had a look at features of the **Actions** panel and used both the Script Editor and the Actions Wizard to add interactivity to our digital advertisement.

Summary

In this chapter, we focused on creating a web-based digital advertisement using the HTML5 Canvas document type and introduced a number of new topics while doing so. We saw how to import bitmap images, create text objects, convert both object types to symbols, and animate those symbol instances through the use of Motion Tweens. Building on that, we also had our first look at the **Actions** panel and making our content interactive.

In the next chapter, we will have a deep look at an even newer way of animating content in Animate through the use of layer parenting.

7

Character Design through Layer Parenting

In the previous chapter, we built an animated digital advertisement targeting the native web and spent a lot of our energy focused on doing so through the use of **Motion Tweens**.

This chapter specifically focuses on a newer animation technique for characters and any other complex jointed mechanisms known as **Layer Parenting**. We'll begin with an exploration of **Advanced Layers** mode and then examine how to design a hierarchical character rig by establishing parent-child relationships across multiple layers through the **Layer Parenting** workflow. We'll then delve into animation using **Layer Parenting** structures and see how to add additional flourish to our animation through the addition of audio and automated lip syncing.

After reading this chapter, you'll be able to perform the following functions in Animate:

- Understand the benefits and potential drawbacks of using **Advanced Layers** mode.
- Build a set of parent-child relationships across your layers through layer parenting.
- Create character animation using layer parenting mechanisms.
- Import audio files and configure a set of visemes for use with automated lip syncing mechanisms.

Technical Requirements

You will need the following software and hardware to complete this chapter:

- Adobe Animate 2021 (version 21.0 or above)

- Refer to the Animate system requirements page for hardware specifications: `https://helpx.adobe.com/animate/system-requirements.html`.

Working with Advanced Layers mode

In this section, we'll have a look at **Advanced Layers** mode, how it differs from **Basic Layers** mode, and the benefits to using **Advanced Layers** within your Animate projects.

If you want to animate through **Layer Parenting** mechanisms, you must be able to use **Advanced Layers** mode within your Animate document. This is a special document setting that is on by default when using current versions of the software and allows for numerous advanced capabilities, such as **Layer Parenting**, **Layer Depth**, the use of the **Camera**, **Layer Filters**, and **Layer Effects**.

We'll first have a look at the two different layer modes available in Animate and a couple of items you should be aware of when choosing one over the other.

Assessing Layer Mode Benefits and Gotchas

While **Advanced Layers** is now enabled by default with any new document you create, there may be projects where you would prefer to work in **Basic Layers** mode instead. Additionally, you should be aware that you are changing the fundamental structure of any document you switch from one mode to another. These decisions will affect workflows and may invalidate any code that you may have written:

- **Basic Layers**: This could almost be thought of as a *classic* mode of working in Animate as it is basically how things have functioned for nearly two decades. When using this mode, you will not have access to certain newer workflows, such as **Layer Parenting**. Writing code that interacts with various symbol instances present on the stage, however, is a bit easier to accomplish.

- **Advanced Layers**: When using this mode, each layer will actually be transformed into a **Movie Clip** symbol, allowing more advanced workflows, such as **Layer Parenting**, in addition to all the workflows available in **Basic Layers**. The biggest problem when using this mode is when you are also writing code to target certain, specific symbol instances, as these instances may now be nested within an additional instance created from the layer and named accordingly.

To illustrate the potential issues with code, consider the following Animate project:

Figure 7.1 – Advanced layers and code considerations

Notice that we have a layer named `Face_Layer` and within that layer is a Movie Clip symbol instance with the **Instance name** of `face`.

When dealing with code, there are two possibilities. If we want to target the face instance and stop its internal timeline, we will normally write code (ActionScript, in this example) as follows:

```
this.face.stop();
```

However, under certain circumstances with **Advanced Layers**, since layers may be rendered as Movie Clip symbol instances themselves when using **Advanced Layers** features, you may need to include the name of the layer as well:

```
this.Face_Layer.face.stop();
```

Most of the features of **Advanced Layers** mode are geared toward visual effects more than anything code-based, but it is good to keep this in mind as a possibility as you work through various projects.

Note

There is an optimization in recent versions of Animate that will not publish container symbols based on layers if no advanced layer feature is in use. Because of this, we can more often use the shorter syntax without referencing the containing layer, even when making use of **Advanced Layers** mode.

Advanced Layers mode enables the following features in Animate documents:

- **Layer Parenting**: This feature allows you to establish a parent-child hierarchy between layers in the timeline. These relationships are retained even when animating the various assets associated with these layers, enabling the creation of a rigging system. This feature is the focus of the current chapter and will be covered in depth very shortly.

- **Layer Depth**: This feature can be used to manipulate the **z-depth** of various timeline layers apart from their actual order. Using this feature, you can have objects pass in front of or behind one another, and even use layers set at different depths to control a parallax camera effect in your animation. We will explore layer depth further in *Chapter 9, Working with the Camera and Layer Depth*.

- **Camera**: The **Camera** document exists on the main timeline and can be zoomed, rotated, and panned just like a real camera. It allows many more expanded cinematographic elements within your animated content. We will explore **Camera** alongside **Layer Depth** in *Chapter 9, Working with the Camera and Layer Depth*.

- **Layer Effects**: This feature allows you to make use of effects and filters on entire layers, just as you normally would apply to individual **Movie Clip** symbol instances. This feature is only available in **ActionScript 3.0**-based documents.

Now that we have a better understanding of what **Advanced Layers** mode does, we'll have a look at how to switch between that and **Basic Layers** mode within an Animate document.

Switching between Layer Modes

As mentioned previously, **Advanced Layers** mode is enabled by default in any new document you create. For older documents, you can always enable it if desired once the document has been opened in a newer version of Animate.

> **Note**
>
> In *WebGL glTF*-based documents, you cannot disable **Advanced Layers** mode, and the checkbox to do so is non-functional.

In older versions of Animate, the switch to toggle between layer modes was located in the timeline. In newer versions of Animate, you will find this option within the **Document Settings** dialog. To access **Document Settings**, click the **More Settings** button in the **Document Settings** section of the **Doc** tab within the **Properties** panel or choose **Modify | Document…** from the application menu.

The **Document Settings** dialog will then appear:

Figure 7.2 – Enabling advanced layers in Document Settings

There are a number of important settings within this dialog. Many of them, such as **Frame Rate**, **Stage Color**, **Width**, and **Height**, are available from within the **Properties** panel as well. Below all of these settings, toward the bottom of the dialog, you can find the **Use Advanced Layers** checkbox.

Any modification of this checkbox will cause an alert to appear immediately, letting you know what will happen based on your choice:

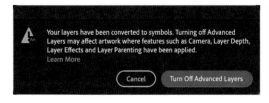 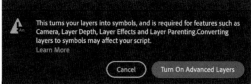

Figure 7.3 – Advanced Layers warning dialogs

It is immensely important to understand the repercussions that you may need to deal with when you switch between these various layer modes. It is best to have an understanding of what you want to accomplish in any project and choose the best layer mode at the beginning, so you don't have to deal with the hassle later on.

In this section, we explored the two available layer modes within Animate and gained an understanding of the differences, benefits, and drawbacks to each choice. Coming up, we'll put one of the advantages of **Advanced Layers** mode to use in the form of **Layer Parenting**.

Animating a Character with Layer Parenting

Layer Parenting is a feature of the **Advanced Layers** mode in a document that allows us to establish nested parent-child relationships between actual layers within the timeline. The benefit of doing so is that we can create a rig across our layers in this way through which the manipulation of any parent layer will also apply to its children and grandchildren.

A good way to envision this relationship is to visualize a human arm. If you want to move the hand without any other arm parts, it can easily be rotated at the wrist and does not affect the lower or upper arm. Moving the lower or upper arm, however, will also change the position of the hand since it has an attachment to both of those additional structures. **Layer Parenting** works in much the same way, but allows no incidental movements across other structures as more natural physical motion would.

> **Note**
> Animating through **Layer Parenting** is very precise in that the rotations, positioning, and other manipulations only affect the layer having its properties changed and attached child layers in precise ways. There is a more natural, less precise method of rigging called **Inverse Kinematics**, which we'll see in a detailed manner in *Chapter 8, Animating Poses with IK Armatures*.

We'll now have a look at how to set up an Animate document for **Layer Parenting** through the import and configuration of prepared visual assets.

Preparing assets for Layer Parenting

When setting up the assets in your project to be used for **Layer Parenting** workflows, all of the basic considerations still apply. You'll want to have layers named in a meaningful way, organized appropriately, with each object that will receive animation through tweening on a layer of its own.

> **Note**
>
> We've already prepared an FLA file for use in this project containing assets suitable for rigging with Layer Parenting workflows. You can find this, along with all the files, at `https://github.com/PacktPublishing/Mastering-Adobe-Animate-2021`.

Let's now have a look at our existing document named `WoodenDoll.fla` and modify it for **Layer Parenting**:

Figure 7.4 – The wooden doll

You will immediately notice a human-like figure that appears very similar to the type of posable wooden dolls used by sketch artists and sculptors. The doll is positioned within what appears to be a plain room with a floor and single wall visible.

Inspecting the timeline, you'll notice that the document has two layers, named **Room** and **Doll**:

Figure 7.5 – The document timeline and stage

The **Room** layer contains the background assets and is locked. The **Doll** layer includes a set of 15 individual movie clip symbol instances that make up the various parts of the wooden doll we will be rigging and animating through **Layer Parenting**. Since we will be animating these objects using Classic Tweens, it is very important to ensure that they are all symbols that have been given identifiable names.

Now that you are familiar with how the document is set up, let's organize things a bit better:

1. Since **Layer Parenting** involves creating parent-child relationships between different layers, we'll need to move all 15 objects out from the single **Doll** layer they are currently placed within and create a single layer for each and every one.

2. To do this easily, simply select all 15 objects in the stage within the **Doll** layer by drawing a selection rectangle across them with the **Selection** tool.

3. Right-click on the selected objects and choose **Distribute to Layers** from the menu that appears:

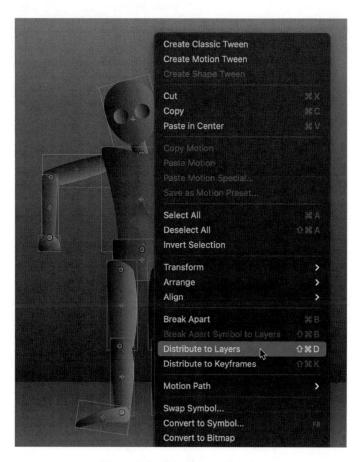

Figure 7.6 – Distribute to Layers

This will remove all 15 instances from the current layer and generate a new layer for every instance, automatically placing each inside its own layer.

4. With so many layers now part of the timeline, it may help to dock the entire **Timeline** panel to the side of the stage instead of beneath it:

Figure 7.7 – Assets arranged across layers

Notice that each of the new layers has a meaningful name as well. This is due to the fact that the **Distribute to Layers** option will automatically name each layer with the same name given to the object that the layer is being generated for. Pretty convenient!

Our character assets have now been imported into the stage and assembled into a meaningful layer structure within the timeline.

One important thing to know is that each of these body parts has been assembled to form the visual representation of the entire doll. The head is where a head should be, while the various arm and leg pieces are positioned as you would expect with a full doll.

Related to this is the fact that the **Transform Point** of each doll part, indicated by a white circle, has been positioned at the various natural joints along the body:

Figure 7.8 – The transform point acts as a joint

So, with the lower arm, for instance, the transform point is positioned at the elbow, where an arm would naturally rotate. You can always reposition any transform point by using the **Free Transform** tool to click and drag it to different locations. This will become very important once we rig our layers together and begin making adjustments and animations with it.

> **Tip**
>
> You may want to rearrange the automatically generated layer order if like items are not grouped together in a meaning way; for instance, making sure that all parts of the arms or legs are grouped alongside one another, so that they are easy to find in relation to their visual placement on the doll's body.

We'll further organize these layers into a hierarchical structure using the **Layer Parenting** view as part of our next task.

Establishing a Layer Hierarchy

With the various objects that make up our figure delegated to individual layers, we can now activate **Layer Parenting** and create our rig. When using **Layer Parenting** within Animate, each layer can be a parent or child of another layer, and while parent layers can have multiple child layers, child layers can only have a single parent layer.

Let's go ahead and establish our rig through **Layer Parenting**:

1. Our first task will be to open the **Layer Parenting** view. This is done by toggling the small **Show Parenting View** button above the timeline.

 It appears as a small square with lines extending to two additional boxes below it:

Figure 7.9 – Layer Parenting view enabled

 With this option enabled, a new column within the layers view appears. This new column is where we can establish parent-child relationships to construct our rig.

 Before clicking anything else, we should identify our root layer. This is the layer that will be the parent, grandparent, or even great grandparent to every other layer in our rig. With a human figure, the torso often makes the most sense.

2. To establish a parent-child relationship and begin building your rig hierarchy across the wooden doll layers, you will identify layers that will serve as children and drag them to their parent layers.

 Starting with **RUpperLeg**, drag the area of that layer with **Parenting View** activated onto the **Pelvis** layer:

Figure 7.10 – Pulling wires to establish relationships

 Note that a small line connects across layers as you drag and indicates that you are pulling a child toward a parent to establish this relationship. The workflow is always adding child layers to parent layers, and never parent to child.

3. You'll now continue to pull children to their parents in this same way. The **Pelvis** layer will become the child of **Torso**, our root layer:

Figure 7.11 – Parent-child relationships

The root layer is never dragged to another layer at all since it is not the child layer of any other layer whatsoever.

4. Move children to continue testing the dragging of child layers to parent layers in order to establish a fully formed rig. For instance, **LFoot** is a child of **LLowerLeg**, which is a child of **LUpperLeg**, which is a child of **Pelvis**, which is a child of **Torso**. **Head** is a child of **Torso** as well, as are **RUpperArm** and **LUpperArm**.

Create the remaining relationships in this manner:

Figure 7.12 – Completed Layer Parenting rig

5. You can now test your rig and see how everything functions. Select the **Free Transform** tool and rotate different parts of the doll. Notice that as you rotate any parent object, such as an upper arm, that both the lower arm and the hand also rotate along with it:

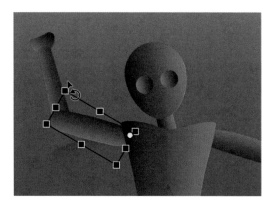

Figure 7.13 – Rotating parts of the completed rig

Again, note that the arm rotates around the transform point of the object, as indicated by a small white circle when the **Free Transform** tool is active.

With our layer hierarchy established through use of the **Layer Parenting** view, we can now easily add motion to the objects within each layer in order to take full advantage of these parent-child relationships.

The next step will be to perform some animation using our new **Layer Parenting** rig.

Animating using Layer Parenting

Now that we have our **Layer Parenting** relationships established across the timeline layers, we can animate our content with any tween type we would like to, so long as we adhere to the constraints and capabilities of each type.

You can animate your doll however you like, but here is a standard workflow when using **Layer Parenting**:

1. Arrange your various objects into a starting pose. I've set my wooden doll to appear to have been seated against the floor. You can do something similar through the use of the **Selection** or **Free Transform** tools:

Figure 7.14 – Choosing a starting position for the wooden doll

As you manipulate the various parts, notice how the parent-child relationships affect which specific parts need to be animated, and which others follow along as a result of these relationships.

2. Once you have settled on the initial position, scale, and rotation of your parented objects, you then go about inserting keyframes along each layer just as you would for a normal tween and continue to adjust object properties:

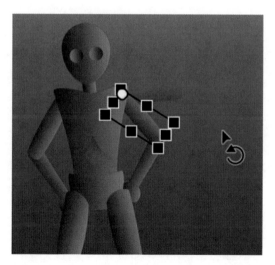

Figure 7.15 – Rotating and repositioning both parents and children

Tweening works the exact same way as always here, the difference being that Animate will interpret any change in parent properties and automatically perform the same interpretation of any child and grandchild layers.

3. The various keyframes can be staggered across the timeline in whatever way works best for your particular animation:

Figure 7.16 – Layer Parenting rig with classic tweens

It's a good idea when animating in this way to take it step by step, and to test and tweak on a regular basis! Keyframes can always be moved backward and forward as needed to create more natural motion and easing effects, and other tween adjustments can be made as you go.

When finished, you can always visualize the animation through the use of **Onion Skin Advanced Settings**:

Figure 7.17 – Advanced onion skin settings

This can be accessed from the controls above the timeline. These settings will allow you to view a range of frames in relation to the current playhead position in order to more finely tune your motion. I find viewing outlines in place of fully rendered fills provides a clearer view of the action.

By default, when using outline mode, the current frame is a red outline. Frames previous to the playhead position will be blue, and upcoming frames are shown in green:

Figure 7.18 – Motion visualization via onion skinning

My wooden doll is pulling himself up from a sitting position to a standing one. This can be easily understood through the use of the **Onion Skin** mechanisms. This is just one of many tools available within Animate to help you achieve your best animation.

In this section, we saw how to make use of **Layer Parenting** to establish a hierarchical relationship among the layers that compose a full character and then apply animation to that character once successfully rigged. Coming up, we will explore some additional considerations and features when performing character animation of this kind.

Exploring Additional Character Animation Features

While rigging a full character through the use of **Layer Parenting** and performing animation through various tweens certainly demonstrates the versatility of this rigging method, there are additional features that we can make use of to enliven our animation even further.

The method highlighted next will examine how to add recorded audio to your character and perform automated lip syncing using Graphic symbol looping properties.

Making Use of Graphic Symbols

In *Chapter 5, Creating and Manipulating Media Content,* we mentioned that Graphic symbol instances have a special **Looping** section within their **Object** properties. We'll now examine these settings in more detail.

To view the **Looping** properties, select any Graphic symbol instance within a project and look at the **Object** tab of the **Properties** panel:

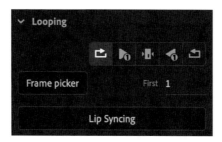

Figure 7.19 – Graphic instance looping

Looping determines how the Graphic symbol instance should handle playback and on which frame playback should begin. The options included are as follows:

- **Play Graphic in Loop**: This option will loop the symbol timeline so long as there are enough frames in the containing timeline.

- **Play Graphic Once**: This option will loop the entire symbol timeline up to its final frame so long as there are enough frames in the containing timeline.

- **Play Single Frame for the Graphic**: The playhead will hold upon the specified frame within the symbol timeline. There is basically no movement until another keyframe is added to the main timeline with additional instructions.

- **Play Graphic Reverse Once**: This option will loop the entire symbol timeline in reverse up to its initial frame so long as there are enough frames in the containing timeline.

- **Play Graphic in Reverse Loop**: This option will loop the symbol timeline backward so long as there are enough frames in the containing timeline.

The **Frame Picker** button will open the **Frame Picker** dialog, which displays each frame within the symbol, allowing you to choose the initial frame to start the looping option at, or hold the motion at a specific frame, visually.

Similarly, the **First** option beside the **Frame Picker** button allows the same functionality, but strictly by numeric input. Either mechanism will allow you to choose the starting frame for playback at that keyframe, with 1 being the default.

The final option here is the **Lip Syncing** button, which is used by Animate to automate a properly prepared Graphic symbols sync option through the use of **Adobe Sensei**, Adobe's cloud-based artificial intelligence.

Next, we will set up our project to use the **Lip Syncing** option to give our character a chance to speak.

Importing Audio for Stream Sync

As a feature-rich, multi-media authoring tool, Adobe Animate has support for many media formats. Most document types have full audio support as well. The greatest support for audio is found in ActionScript 3.0, HTML5 Canvas, and the various AIR document types. All three of these platforms can make use of a feature called **Auto Lip-Sync**, which automatically interprets included voice-based audio and determines which mouth shapes (or visemes) to insert at specific points in the voice performance. The first step to any of this is to record and import a suitable audio file.

In the files for this chapter, we have included an audio file named DollSpeak.mp3:

Figure 7.20 – Audio file properties

The file is a 16-bit stereo recording encoded for full compatibility with Animate at 44.1 kHz and with a sample MP3 rate of 128 kbps. It is a recording of the wooden doll "speaking" to the viewer across a brief period of 6 seconds. You can use this in your project or record your own voice using **Adobe Audition**.

> **Note**
>
> Animate can make use of various sound encodings and formats but, to avoid problems, it is best to use audio files encoded as 16-bit at 44.1 kHz. A good sample rate for an encoded MP3 is 128 kbps. These settings represent a solid standard when working in Animate, and deviating into something like 24-bit or 32-bit audio or 256 kpbs is highly discouraged.

We'll now import the MP3 audio file and make use of it within the timeline:

1. Choose **File | Import | Import to Library…** from the application menu and browse to the location of your audio file. Alternatively, you can drag the file from your file system directly into the **Library** panel. Either way, the MP3 will now display within the project library:

Figure 7.21 – The imported audio file

From here, you can view the audio waveform and preview the audio playback.

2. Like just about everything else in Animate, audio must reside within the timeline, attached to a keyframe. In your timeline, just above the **Head** layer, add a new layer and name it Audio.

3. With any frame of the **Audio** layer selected, look at the **Frame** tab of the **Properties** panel and examine the **Sound** section:

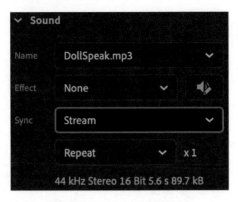

Figure 7.22 – Stream sync type

Select the `DollSpeak.mp3` file from the **Name** dropdown. Any audio files in your project library will appear in the dropdown for you to select.

4. Before moving on, it is very important to also set the **Sync** type to **Stream**. This is necessary for the audio to work with the automatic lip syncing feature, as **Stream Sync** will bind audio to each of your frames along the timeline, ensuring that the audio will neither drift nor lag. It also allows you to preview the audio by scrubbing the playhead.

5. Now look back to the timeline and examine the **Audio** layer. The chosen audio file is now assigned to this layer and the waveform appears across the frame span:

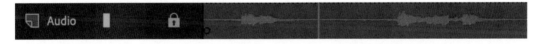

Figure 7.23 – A waveform appears in the audio layer

Scrub the playhead along the timeline to hear how the audio synchronizes across the assigned frame span.

With our audio file imported and assigned to a layer within our main timeline for **Stream Sync,** we can move on to setting up the various mouth parts to switch out according to sounds detected within the speech.

Configuring our Graphic Symbol Frames

With the audio file imported and configured within our project's main timeline, we now turn our attention to the head of our doll in order to establish various mouth shapes to use in simulating speech. Perform the following steps:

1. Open the **Library** panel and locate the **Head** movie clip symbol. Right-click on the symbol name and choose **Properties...** to edit the symbol properties.

2. Automated lip syncing can only be used with Graphic symbols, since this symbol type is the only one with dedicated **Looping** properties. In the dialog that appears, change **Type** to **Graphic** and then click the **OK** button:

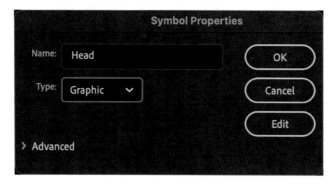

Figure 7.24 – Symbol changed from Movie Clip to Graphic

This action will not change the existing behavior of existing instances on the timeline. We will take care of that later on.

3. At this point, you will import a version of the **Head** symbol with all the layers and shapes already completed with appropriate mouth parts. Choose **File | Import | Open External Library...** and browse to the file named Head.fla within the exercise files.

4. The Head.fla file opens as another **Library** panel alongside the project library and contains only the **Head** graphic symbol. Drag the **Head** symbol from the imported library into the library of the current document.

5. Animate will ask what you want to do since there is already a symbol named **Head** in the library. Choose **Replace existing items** and then click the **OK** button:

Figure 7.25 – The Resolve Library Conflict dialog

The **Head** symbol has now been replaced within the project library with the one brought in from the external library.

6. Double-click on the Graphic symbol icon next to the **Head** symbol in order to edit the contents within it. We are brought within the symbol and can now manipulate the stage and timeline of the symbol itself:

Figure 7.26 – Head timeline with mouth parts and labels

Examine the **Head** timeline to discover a set of layers that include the static doll head visuals, a set of mouth and tongue shapes across two layers, and a layer dedicated to labels. The **Labels** layer will help us to identify each frame when we map the frames as visemes later on.

Explore each frame and notice how the various mouth and tongue shapes overlay the head visual and how they conform to the sound labels that have been given to them. I've kept the first frame without any mouth whatsoever so that we can keep it blank when desired.

7. Exit the symbol and return to the main timeline by clicking the left-facing arrow in the upper-left area above the Stage:

Figure 7.27 – Returning to the main timeline

Back on the main timeline, take note that our modification of the symbol itself has no immediate bearing upon existing instances along the timeline. We will remain on the main timeline to perform our next set of tasks.

> **Note**
>
> The mouth shapes and labels used here represent a standard set of vocal sounds that conform to established mouth forms called visemes. Of course, you can always draw your own mouth shapes if you like. The prepared Head symbol timeline can act as your guide if you wish to do so, or there are detailed examples to be found on the internet as well, in a variety of styles.

With our Graphic symbol property configured for use alongside the automated lip sync feature, we'll next assign the various frames to a proper viseme grid for lip sync interpretation.

Assigning Visemes and Automating Lip Syncing

Earlier in this lesson, we converted our **Head** symbol in the project library from a Movie Clip symbol to a Graphic symbol in order to prepare it for automated lip sync. If you recall, we noted at that time that this action would not change the behavior of any of the pre-existing symbol instances on the stage. In fact, if you now select any **Head** symbol instance on the Stage and look at the **Object** tab in the **Properties** panel, you will see that the behavior of the instance remains a Movie Clip in the **Instance Behavior** dropdown.

Before we even attempt to set up our visemes and employ **Lip-Syncing** to our project, we must first either create a new instance of the **Head** symbol or change the existing instance behaviors to use the Graphic symbol.

To change the behavior of any symbol instance, select it and make a new selection from the **Instance Behavior** dropdown in the **Properties** panel:

Figure 7.28 – Behavior changed to Graphic

No matter what behavior it previously exhibited, the symbol instance will now behave according to the behavior it has been assigned.

> **Tip**
>
> Even though you can change instance behavior between symbol types in this way, it is best practice to change the actual symbol type in the project library as well, for clarity and consistency. If you recall, we've already done this.

We'll now prepare our timeline and enter into the automated lip syncing workflow:

1. The first thing you must do is decide where in your existing animation you want the audio playback to start. I suggest starting the audio playback directly following any existing animation, or even removing your previous animation entirely for a clean start:

Figure 7.29 – Ensuring a clean start

In either case, shift the starting keyframe in your **Audio** layer to the point the audio playback should begin (if necessary) and add a corresponding keyframe within the **Head** layer so that they both align.

2. Scrub to the end of your timeline to ensure that you have enough frames for the audio waveform to complete. My audio file is 6 seconds in length, so I need to add enough frames to ensure at least 6 seconds of playback:

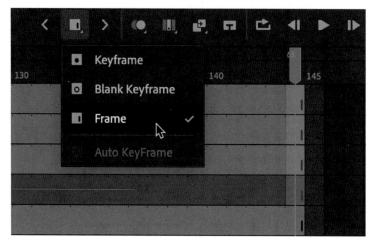

Figure 7.30 – Adding the required number of frames

If you need to add additional frames, go ahead and do so. Don't forget to add these extra frames across all your layers!

3. Select the **Head** instance on the stage that aligns with the start of your audio file and look at the **Object** tab of the **Properties** panel. **Instance Behavior** should be **Graphic**. Change it to a behavior of **Graphic** if it is either **Movie Clip** or **Button**.

4. With the **Graphic** behavior verified, look down to the **Looping** section of the **Properties** panel and click the button. The **Lip Syncing** dialog will appear.

5. The first task is to set up our visemes. You will see a grid of possible visemes, but each is identical at first. You must click each viseme and assign it to an appropriate frame derived from within the selected Graphic symbol. Since we also labeled each of our frames, this makes the assignment very simple.

Go ahead and assign each viseme to each corresponding frame from within the **Head** graphic symbol until they are all matched up:

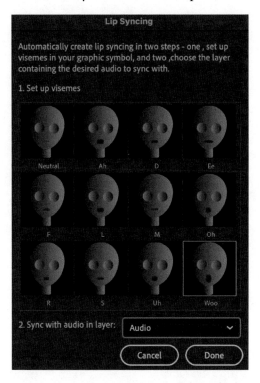

Figure 7.31 – Assigning visemes and the audio layer

6. The second task is to choose which audio layer we will use in the automation process. Since we only have a single layer with audio assigned to it, the **Audio** layer should be selected. If not, select the **Audio** layer from the dropdown.

7. With our visemes mapped and our audio layer selected, click the **Done** button to begin the automated syncing process.

The process should not take long, and when finished, your **Head** layer will include a set of automatically generated keyframes with specific visemes applied across the timeline in accordance with the sounds detected from within the spoken audio file:

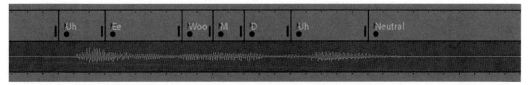

Figure 7.32 – Keyframes automatically assigned

8. You can use the playback controls above the timeline to test out the lip syncing and ensure that it has been applied to your satisfaction:

Figure 7.33 – The completed lip sync animation

You can now proceed to add in additional animation across the wooden doll body part layers by utilizing the existing **Layer Parenting** relationships to go along with the spoken audio and produce a fully realized character animation.

> **Note**
>
> If you need to adjust any viseme that was automatically assigned in error, you can always use the frame picker to select an alternative viseme for any keyframe.

In this section, we took our animated content created with **Layer Parenting** and gave our wooden doll character a voice and the mouth animations to go along with it through automated **Lip Syncing**.

Summary

In this chapter, we began with an overall exploration of **Advanced Layers** mode and why we would want to use it over **Basic Layers** mode for various projects. Following that, we put **Advanced Layers** mode into practice through the construction of a complex hierarchy of parent-child relationships using **Layer Parenting**. We also animated our newly created **Layer Parenting** rig through all the normal tweening mechanisms we've come to understand when animating symbol instances across the timeline. Finally, we added voice-based audio to our project and performed automatic lip syncing against that audio through a set of properly configured visemes and the **Lip Syncing** dialog.

In the next chapter, we will explore another type of rigging using **Inverse Kinematics** through the employment of armatures to be animated across various poses within an animated project.

8
Animating Poses with IK Armatures

In the previous chapter, we explored the use of **Layer Parenting** in order to establish a parent-child relationship among the various layers in an Animate document in order to create a type of rig to animate a character's body parts more easily.

In this chapter, we will now explore animating with **Inverse Kinematics** workflows through the use of fully rigged **IK Armatures**. Armatures in Animate are established by creating **IK Bones** using the **Bone tool** and exist on a single **Armature Layer**. We will build a multi-object armature and explore the various properties associated with each node in order to establish a solid and refined rig. We will then explore the ways in which **Poses** are managed, creating animation through **Inverse Kinematics**. Finally, we will also examine how to package a rig for sharing and reuse.

After reading this chapter, you'll be able to perform the following functions in Animate:

- Use the **Bone tool** to establish a rig and understand the concepts behind inverse kinematics.

- Adjust node properties such as joint constraints and physics on the established IK rig.

- Create animated IK content and manage rig poses across the timeline.

- Export a completed rig through the **Animate Asset** file type for sharing and reuse.

Technical Requirements

You will need the following software and hardware to complete this chapter:

- Adobe Animate 2021 (version 21.0 or above).

- Refer to the Animate system requirements page for hardware specifications: `https://helpx.adobe.com/animate/system-requirements.html`.

Building an Armature using Inverse Kinematics

We previously saw how to animate a character across layers with **Layer Parenting** mechanisms using the **Advanced Layers** mode. While simple enough to use, there are some limitations in the construction of your rig when using that method. Another rigging mechanism exists in Animate that is capable of similar results, but with a completely different workflow and set of tools. Animate is capable of producing animation through an **Inverse Kinematics** workflow through the use of the **Bone tool** and special **Armature** layers, and this will be the focus of the current chapter.

We'll first address how these two approaches differ from one other, and then build a rig using inverse kinematics.

Understanding Inverse Kinematics versus Forward Kinematics

Just like in the previous chapter, we'll be using the wooden doll artwork to construct our alternate rig. As with all files referenced in this book, you can locate this file through the following URL: `https://github.com/PacktPublishing/Mastering-Adobe-Animate-2021`.

> **Tip**
> If you would like to see the animation that we will create using inverse kinematics, you can always open the `Animated_WoodenDoll.fla` file and perform a **Test Movie** to see it in action before we get to work! Just remember to close it before moving on.

Locate the `WoodenDoll.fla` file and open it up within Animate. Just as in the previous chapter, there are two layers within this document: the **Room** layer, which is simply a background image; and the **Doll** layer, which contains a set of body parts that comprise our wooden doll.

Be sure to take a moment and refamiliarize yourself with these assets:

Figure 8.1 – The wooden doll starter document

As mentioned previously, both **Layer Parenting** and **Inverse Kinematics** share a number of aspects with one another. For instance, either one can be used effectively to produce complex, jointed, character animation.

Layer Parenting is by far the simpler workflow to adopt, as you have control over each individual object and changing the properties of any object will not affect any additional object so long as it is not a designated child of the modified object. It is easier to understand for beginners since layers are retained and animation takes place through normal tweening mechanisms.

Inverse Kinematics is a more complex approach as there are many more aspects to consider and tools to master. Alongside the technical aspects, the modification of any object along the chain will have an immediate effect upon the entire armature rig, affecting even the parent objects in a physical way. More thought has to be put into every aspect of armature rigging since each piece directly influences the other objects making up the armature and they can all have specific physical properties applied to them that differ from other parts of the rig.

Let's go ahead and compare both of these models, point by point.

Aspects of Layer Parenting

We saw how to use **Layer Parenting** in detail throughout *Chapter 7, Character Design through Layer Parenting*. This type of animation is sometimes referred to as **Forward Kinematics**, as you change the rotation and position of each joint from the top down. When animating an arm to wave at the viewer, for instance, you would begin by rotating the upper arm, then the lower arm, and finally the hand.

Keep in mind the following aspects of layer parenting:

- It works across many layers through parent-child relationships.
- Manipulating a child object will never influence a parent object.
- It is wholly controlled through **Parenting View** on the timeline along with the **Free Transform** tool.
- It lacks any sort of constraint mechanism.
- It requires the **Advanced Layers** mode to be activated.
- It makes use of normal tweening mechanisms to achieve motion.

Aspects of Inverse Kinematics

Inverse kinematics allows the creation of a skeletal structure known as an **Armature** that is then animated as a single object influenced by a set of physics-based parameters, making use of various **Poses** over time. This is the primary subject of the present chapter. When animating an arm to wave at the viewer, in this case, you could begin by manipulating any aspect of the arm as the rotation of the upper or lower arm will influence the other. You must be very careful!

To implement the aspects of inverse kinematics with those of layer parenting, consider the following:

- It works on a single, special layer type known as an **Armature Layer**.
- Manipulating a child object has physical influence over the angle and rotation of parent objects.
- It is controlled through special tools accessible from the toolbar, such as the **Bone tool**, in addition to the **Free Transform** tool, the management of **Poses** within an **Armature** layer, and special bone properties through the **Properties** panel.
- It includes the ability to constrain aspects of each joint by rotation, position, and more.

- It can be used with either the **Basic Layers** mode or **Advanced Layers** mode.
- It makes use of special pose mechanisms along with individual physical properties to achieve resultant motion.

This information should provide some general ideas regarding the differences inherent in both rigging models. We are intentionally using the same exact assets across both of these chapters in order to make the best comparison possible between rigging models.

With this background information around both models fresh in our minds, let's move on to rigging using inverse kinematics and the **Bone tool**.

Using the Bone Tool to Rig Symbol Instances

The **Bone tool** is the tool within Animate that we use to create **inverse kinematics** armatures from both collections of symbol instances and simpler vector shapes. We'll first explore the use of this tool with a collection of symbol instances as arranged within the sample document.

To access the **Bone tool**, you will likely need to edit the available tools through utilization of the **Drag and Drop Tools** panel.

You can open this panel by clicking the **Edit Toolbar...** button at the bottom of the toolbar:

Figure 8.2 – Locating the Bone tool

The **Bone tool** and associated **Bind tool** are located together, toward the bottom of the panel. Drag them onto the toolbar to make them available for working with your document.

> **Note**
>
> The **Bone tool** does not include any **Tool** properties that can be accessed from the **Properties** panel. You must create an armature first before setting various properties associated with IK.

You can use the **Bone tool** to construct an IK rig from separate symbol instances by placing bones across the individual body parts of the wooden doll:

Figure 8.3 – Bone tool

This action will connect all associated parts as a single **Armature** and also act as a complete rig that can then be adjusted and animated.

You use the **Bone tool** by dragging an initial root "tail" bone followed by additional bones that branch off from the root to assemble a rough IK structural rig. Think of the rig as a tree, starting with the trunk and then expanding from that across branches and roots. The various bones and joints can then have their properties adjusted through the **Properties** panel, which creates a more refined IK rig for use.

> **Tip**
>
> When making use of the **Bone tool**, I highly recommend that you disable snapping entirely. This can be achieved through the application menu by choosing **View | Snapping | Edit Snapping…** and unchecking all options from the dialog box that appears.

Let's now see the **Bone tool** in action as we create an IK rig for our wooden doll:

1. Ensure that the **Bone tool** is selected in the toolbar.

2. Click the upper center of the doll's torso and drag a bone up to the neck area. Release the mouse to establish your initial "tail" bone:

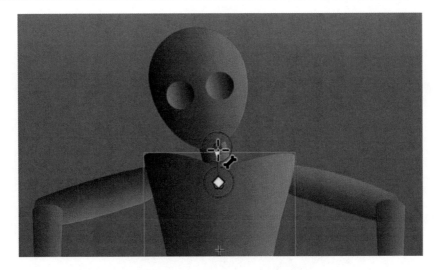

Figure 8.4 – Creating the tail bone connecting the torso and head

As you begin to create additional bones, take notice of how the tail bone of your rig has a slightly different appearance than any other bone you create.

3. It is now possible to click and drag from the origin point of the tail bone to create additional bones. Click and drag a bone from the torso to the upper left arm at the shoulder. A secondary bone is created.

4. From the shoulder of the upper left arm, drag another bone to the elbow on the lower left arm:

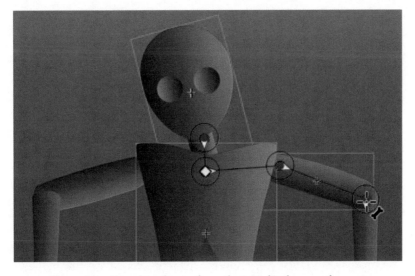

Figure 8.5 – Branching bones from the initial tail across the arms

5. Complete the arm branch by dragging a final bone from the elbow to the wrist.

6. Now, you'll need to create additional branches until the entire rig is established:

Figure 8.6 – Fully rigged rough IK armature

The fully rigged armature should include the following:

- A branch from the torso to the head

- Branches across both right and left arms

- A branch from the torso down to the pelvis

- Secondary branches from the pelvis down the left and right legs

> **Tip**
> If you have trouble dragging bones to the correct symbol instances to connect them, you can either rearrange things so that the **Armature_1** layer appears below the existing **Doll** layer, or arrange the various instances so the one you need is not obscured by any other.

Notice, as you go through the process of creating your IK rig, how the individual instances from the original **Doll** layer are removed from that layer and merged with the automatically created **Armature_1** layer as they are added to the armature itself.

The previous layer has been completely removed:

Figure 8.7 – Newly created armature layer

An **Armature layer** is a special type of layer in Animate that is only used with IK rigging. The keyframes appear as small black diamonds, very similar to what we've seen with **Motion layers** in the past. The layer icon changes to show a human figure in motion and the frame span background becomes green.

With our IK armature created in this initial state, we will next look to establish some refinements to the rig, ensuring that it will behave in exactly the ways we want it to during manipulation.

Refining the Rig Properties

Once an armature has been created, the **Selection** tool can be used to modify the appearance of the armature by moving its various body parts around. In its initial, rough state, you can get some rather odd results before adding constraints and other refinements.

Using the **Selection** tool, click and drag the arms of the armature to create a different pose:

Figure 8.8 – Adjusting unconstrained armature limbs

Not so good! The joints have no constraints, so the arms bend around in unnatural ways. In addition, it is possible for the arm to fly away from the shoulder altogether, making a real mess of our hard work.

A lot of beginners will simply rig up their assets with the **Bone tool** and think that's all there is to it. It is worth taking the time to inspect the properties of both the IK armature itself and also the individual **IK Bone** properties. We'll go ahead and do this now.

First for the **IK Armature** properties. The armature is bound to the layer, so you'll want to click on any of the frames that make up that layer and refer to the **Frame** tab of the **Properties** panel:

Figure 8.9 – Armature Frame properties

You'll notice immediately that you are editing **IK Armature** properties. We can provide a meaningful name to our armature here and choose to hide or reveal editing controls and hints that overlay the armature itself on the stage.

Looking further down, you'll find the **Ease** section:

Figure 8.10 – The armature's Ease properties

The **Ease** properties consist of a **Strength** slider, which accepts values from -100 to 100 and defaults to 0. This is just like the easing intensity values we've seen in some of the various tween types covered in previous chapters.

You can also select the type of ease from the **Ease Type** dropdown. This is similar to selecting an ease effect as part of a **Classic tween** or **Shape tween** and options include **None, Simple,** or **Stop and Start**. Each one of these two choices has four versions: **Slow, Medium, Fast,** and **Fastest**. By default, **None** is selected.

I'm going to set my Ease properties to a **Strength** of -40 and use **Simple (Medium)** for my **Type** selection.

We will also find an **Options** section further down the **Properties** panel:

Figure 8.11 – Armature options

From here, you can define your armature to have an animation type of **Authortime** or **Runtime**. **Authortime** allows you to use the tools within Animate to design the motion of our IK armature, while **Runtime** makes it so that you can actually change poses by interacting with the armature at runtime through use of the mouse cursor.

> **Note**
> Runtime armatures are only available when using ActionScript-based document types targeting Flash Player or AIR.

The **Armature Style** setting determines how the bone overlays appear on the stage as you modify the armature. The default setting is **Solid,** but you can also set this to **Wire, Line,** or **None**. This setting does not affect any functionality and is purely a personal preference as to how the various overlay controls appear. I tend to keep mine set to **Solid**.

The last setting in this section is a checkbox that allows you to **Enable springs** when selected or disable springs when deselected. **Springs** are an attribute of individual **IK Bones**, and I suggest leaving this enabled for most armatures. We will go into more detail regarding this feature when we look at individual bone properties.

To view properties specific to any individual bone, use the **Selection** tool and click on the bone itself, not the underlying asset, to select it.

An unselected bone appears violet in color, and a selected bone will display as light green:

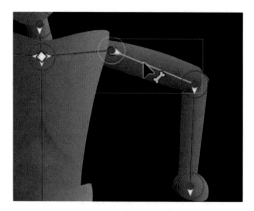

Figure 8.12 – Bone selection

With a bone selected, we can now explore **IK Bone** properties. Note that in some of these images, we've hidden the **Room** layer in order to better focus on the individual bones and related controls.

Be sure that the bone is still selected and look to the **Object** tab of the **Properties** panel to view the **IK Bone** properties for the selected bone:

Figure 8.13 – IK Bone properties

The first thing you'll want to do is rename each bone in a way that makes sense. I've selected the bone that is aligned to the upper left arm, so have named the bone **LeftUpperArm**. Similar to the overall **IK Armature** properties we saw earlier, we can also choose to hide or reveal editing controls and hints directly from each bone in this way. You will want to properly name every IK bone for organizational clarity.

At the bottom of the section, we notice four buttons with directional arrows on them pointing left, right, up, and down. This is a navigational feature that lets you easily traverse the entire armature, bone to bone, by clicking these directional buttons instead of using the **Selection** tool to select each and every IK bone.

> **Tip**
>
> Depending upon the structure of your armature, some of these directional buttons may be disabled. It all depends on the construction of your rig in relation to the presently selected bone.

The **Location** section follows this and contains not just location properties, but will display a number of additional settings as well:

Figure 8.14 – Location properties

Of course, you can view the x and y positions of the bone from here as the section header indicates, but you can also gauge the length of the **IK Bone** and its present angle. All of these settings cannot be adjusted from here; you need to interact with the armature directly for that.

There are also two settings here that can be manipulated. The little stopwatch icon indicates relative **Speed** and is measured from 0% to 100%. Modifying individual bone speed will provide additional variations of movement when the armature is animated. For instance, perhaps the upper arm moves more slowly than the lower arm due to the fact that it is closer to the torso and doesn't have as far to travel.

The second setting is the **Pin** checkbox. Enabling this will lock an individual bone in place, freezing all movement. This ensures that the movement of your entire armature is not too wild and can be used to ground the entire armature in place while allowing motion through the other bones.

The **Joint: Rotation** section is super-important for realistic movement:

Figure 8.15 – Joint: Rotation properties

You can disable rotation entirely by toggling the switch in the upper-right corner of this section to its off position, but it is often best to set angular constraints to each joint instead. If you enable the **Constrain** feature, you are then able to set the angles of constraint through the **Left Offset** and **Right Offset** settings.

Since we are dealing with the upper arm, the joint in question is that of the shoulder. Without a constraint set, the arm can rotate all the way around, and the same with the lower arm. That's not how the human body works at all!

We can see the constraints expressed upon our armature in a visual way as well:

Figure 8.16 – The difference that proper rotation constraints make is huge

The image to the left shows the initial state of our arm joints with no rotation constraints. The image to the right displays a more refined rig, with angular constraints at both the shoulder and elbow. This will enable more natural poses for our armature. You will want to perform these constraints across all **IK Bones**.

The next sections, **Joint: X Translation** and **Joint: Y Translation**, are both very similar to joint rotation in practice:

Figure 8.17 – Joint translation properties

Unlike with **Joint: Rotation**, these settings are all toggled off by default and if you want to use them, you will need to hit the toggle switch. **Translation** refers to the amount of movement across a certain number of pixels across all four directions on both the x and y axes. This is not normally something that can be applied to a human figure such as this, but is often used when rigging machinery. Think of the up and down movement of a set of engine pistons, for example. We won't be using this for our armature, but it's there in case you ever need it!

The final section has to do with **Spring**:

Figure 8.18 – Spring properties

If you recall, we mentioned **Spring** earlier when looking into the **IK Armature** properties. **Spring** provides a physical springiness to your motion even after the object has come to rest. The greater the **Strength** of the **Spring**, the more residual movement will occur. **Damping** is a way to dampen or buffer the **Spring** and determines how long it takes for the effects of the **Spring** to lessen and finally dissipate. Think of a tree branch following a gust of wind and how the movement slowly winds down over time. This is what can be expressed through **Spring**.

Now that you know how to refine your **IK Armature** and **IK Bones** through the use of these properties, you'll want to take some time to do so. Be sure to name each bone and set proper constraints where necessary, using the human form as a guide.

There are a number of tricks you can use when adjusting and testing your armature at this phase. Keep the following in mind as you refine your rig:

- Holding the *Shift* key while adjusting your rig parts with the **Selection** tool will isolate joint rotation to that specific bone.

- Holding down *Option/Alt* as you click and drag body parts with the **Selection** tool will allow you to relocate assets while keeping the rig intact.

- You can even adjust the transform point of each part using the **Free Transform** tool to modify joint position.

- Don't forget to use the arrange options as well to ensure the proper stacking order of the various parts.

When complete, change the name of the armature layer from **Armature_1** to WoodenDoll. Be sure to save your .fla document at this point as we'll be taking a slight detour in the next part before returning to our wooden doll.

We'll next have a brief look at using the **Bone tool** within shapes before moving on to IK animation.

Using the Bone Tool to Rig Shapes

So far, we've built our armature out of a collection of symbol instances. We can also create an armature as part of a shape as well. It is worth going into this a little bit to close out this section before animating our previously created wooden doll.

Creating an IK armature with an **IK Shape** is very similar to creating an **IK Armature** with **Movie Clip** symbol instances. The main difference is that you can build this using only a single shape object, while we previously made use of a set of different objects bound together using an IK armature.

We'll now explore how to use inverse kinematics using a single shape:

1. Create a new document of any size and use one of the shape tools to draw out a basic shape. I'm simply going to create a long, rounded rectangle for this example:

Figure 8.19 – Basic shape created

2. Select the **Bone tool** and drag out a bone at one end of the shape, covering about one fifth of the entire shape. This is the initial "tail" bone for your **IK Shape**-based armature:

Figure 8.20 – Dragging the tail bone

3. With the tail created, we can now drag out branching bones from this tail bone to create either a linear or multi-branch armature within the shape. Continue laying down additional bones across the IK shape until you reach the other end:

Figure 8.21 – Shape-based armature created

4. At this point, the shape has been converted to a special type of object in Animate called an **IK Shape** and contains a complete armature. Using the **Selection** tool, drag one end of your armature around to see how the bones affect the shape itself:

Figure 8.22 – Shape armature movement

The shape will morph along with the internal bone structure you've created.

> **Note**
>
> You can still refine this armature through use of the **IK Armature** and **IK Bone** properties, such as joint rotation constraints, joint translation, and spring that we examined previously. All of those settings work exactly the same, no matter what style of armature you create.

You may notice as you modify the armature with the **Selection** tool that sometimes, the edges of the shape become odd. We can further control such behavior through use of the **Bind tool**, which we will cover in the next section.

Using the Bind Tool to Refine Shapes

Only applicable to **IK Armatures** created with shapes, we can use the **Bind tool** to modify connections between existing bones and the shape control points that define the overall path. If you are having extreme and unwanted distortion in your shape as you adjust the armature, this tool can help refine and eliminate these oddities.

The **Bind tool** is likely going to have to be added to the toolbar through the **Edit Toolbar...** button at the bottom of the **Tools** panel. If you didn't add this tool alongside your **Bone tool** earlier, you'll want to do this now.

Its appearance is similar to the icon for the **Bone tool**, but with an additional little target reticle alongside it:

Figure 8.23 – Bind tool

The **Bind tool** is used to perform control point management within shape-based armatures.

If you select any IK bone in your armature, you will see the various control points attributed to that particular bone highlighted in yellow:

Figure 8.24 – Bone selected with associated control points

Control points are basically the shape path anchor points but, within an IK armature, are additionally associated with particular bones to enable the morphing of the overall shape as the armature shifts around.

You can also select any control point to highlight any of the bones associated with that point by then clicking a control point with the **Bind tool** selected. This gives you a good idea which points are controlled by which bones.

To change control point associations, you can select a bone and then hold down the *Shift* key to select additional control points you want to associate with the selected bone. To remove associations, you can hold *Option/Ctrl* and click any of the currently highlighted points.

> **Tip**
> Managing various control point and bone associations can help remedy any extreme morphing when dealing with IK shapes, although it can be very finicky to work with and we should be extra cautious when using this workflow.

In this section, we saw how to build **IK Armatures** using the **Bone tool** and then refine our armatures through the various properties and settings available. We explored the construction of armatures using both symbol instances and shapes, and further examined how to constrain joint rotation and translation in order to achieve a solid, capable rig. Coming up, we will explore how to create animation using our **IK Armature** through the use of **Poses**.

Animating an IK Armature

Now that we have created our armature and refined various properties, it's ready to animate. The animation of an IK armature is not done by using any of the tweening methods we've seen up to this point. Instead, we define various poses across the timeline and Animate will automatically fill in the frames between each pose. It is able to do this without creating any additional tween as the layer is already an **Armature Layer**, similar to how **Motion Layers** work when establishing a **Motion Tween**.

Let's define some additional poses to animate the wooden doll figure jumping into the air.

Creating Additional Poses

Looking at the **WoodenDoll Armature Layer** as it is right now, there is a single pose at frame 1. A pose is signified by a small diamond shape along the timeline. As expressed above, animation through IK armatures is done by defining poses as various spots along the timeline. A pose behaves very similar to a keyframe, except that a keyframe contains the properties for a single object while a pose contains the properties for all objects that make up your armature and is all handled through the single pose.

For this animation, we want our figure to jump into the air and then land again. We will require a set of four distinct poses for this animation to occur:

Figure 8.25 – The four necessary poses

You can think of the four poses in this way, and in this order:

- **Resting**: A pose where the figure is standing at a comfortable resting position.
- **Anticipation**: A crouching pose where the figure prepares to spring.
- **Active**: This is where the figure is actually up in the air at the apex of an active jump.
- **Recovery**: The figure hits the ground and, from this point, can go back to the resting or anticipation poses depending upon how many times you'd like it to jump.

Let's go ahead and create these **Poses** now. You can refer to the previous figure of all four **Poses** as a visual guide:

1. The first pose we need to create is our resting pose. This pose exists on frame 1 and, as you can see within the timeline, the pose itself already exists:

Figure 8.26 – The initial pose at frame 1

You will use the **Free Transform** tool to position and rotate each of the body parts so that it appears similar to the resting example:

Figure 8.27 – The resting pose

2. To create any animation, we need more than a single frame on the timeline. Extend the current frame span to the 3 second marker at frame 72 (assuming a 24 FPS document setting) to give a good amount of time to plot our poses across.

3. Let's now create our second pose. Recall that poses are represented by small diamond-shaped keyframes along the timeline. Move the playhead to frame 12 and use the **Free Transform** tool to adjust the various body parts so that the figure is crouching in preparation to jump, similar to the anticipation pose example:

Figure 8.28 – The anticipation pose

With two poses established, scrub the playhead along the timeline and see how the figure animates automatically between each pose. Each time we add a new pose, the frames in between poses will update, just as though we were using a tween.

4. Move the playhead to frame 18 to create a new arrangement representing the proposed action pose. Use the **Free Transform** tool to place the legs together and the arms stretched out widely. You'll also need to shift the armature position higher on the stage in order to fully realize the jumping motion:

Figure 8.29 – The active pose

5. The final pose represents the figure having jumped, now landing upon the floor in a recovery position on frame 22. Ensure that the figure is once again securely planted upon the floor by changing the overall armature position. Using the **Free Transform** tool again, bring the arms down a bit and ensure that the feet and legs look appropriate with regard to the floor beneath:

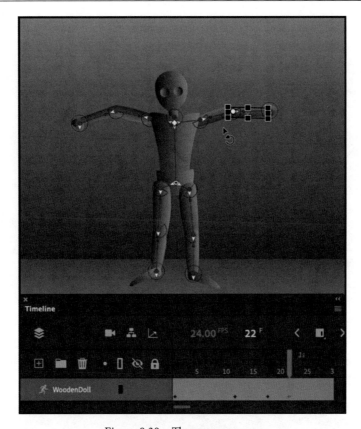

Figure 8.30 – The recovery pose

6. Test your animation by playing it back in the timeline playback controls or through the **Test Movie** command.

If anything needs to be adjusted, you can now go back and adjust the IK armature, the IK bones, or the individual poses to make everything as smooth and realistic as possible.

We now have a single jump cycle composed of four distinct poses, but we can naturally go further than this! Let's now see how to manage the various poses we've established in different ways.

Managing Armature Poses

Once you have your **IK Armature Poses** created, it is very simple to then copy and paste them wherever needed in order to produce a full animation. We'll proceed in both refining our overall animation and reproducing the completed animation cycle for our wooden doll figure.

Since we've already created our various poses, it is now just a matter of arranging them at different points along the timeline:

1. The first thing we want to do is place a hold on our initial resting animation for a few frames. Select the pose on frame 1 and right-click to summon the menu. Choose **Copy Pose** from the menu items that appear:

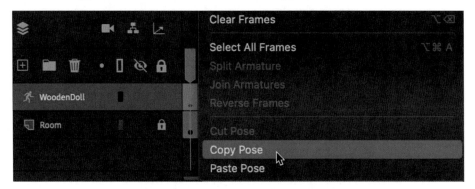

Figure 8.31 – Copying an existing pose

2. Now, select frame 7 and right-click again. Choose **Paste Pose** from that same menu to create identical poses across these frames, essentially creating a pause in the action:

Figure 8.32 – Pasted pose creates a pause

3. With the initial pose still present in the system clipboard, move to frame 25 and select it.

4. Right-click once again and choose **Paste Pose** from the menu that appears. This will bring the wooden doll back to a resting position following the anticipation, action, and recovery poses. We now have a full animation cycle defined within our timeline.

5. To repeat this cycle, we can copy and paste full spans of frames, including poses. Select frames 7-25:

Figure 8.33 – Frame span selected to copy

Right-click to summon the contextual menu for frame selections.

6. Choose **Copy Frames** from the menu that has appeared.

7. Select frame 30 and summon the right-click menu once again.

8. This time, select the **Paste and Overwrite Frames** option to paste in the frame span without extending the overall timeline:

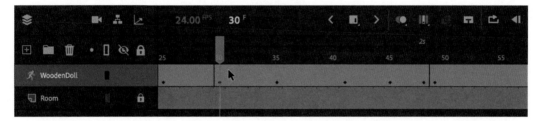

Figure 8.34 – Pasted frame span produces a repeated cycle

The frame span is added to our existing animation cycle as a separate armature frame span and, upon playback, the figure jumps twice.

Since we have multiple armature spans now, we can additionally manage these armature spans through the frame selection right-click menu by choosing **Join Armature** or **Split Armature** to manage your spans.

You can now continue adding additional jump cycles in this way and even go back and tweak the various poses to add some variability to the entire animation. It's entirely up to you!

Note

You can also choose **Clear Pose** from the right-click menu on an existing pose and this will remove it from the timeline in its entirety. The **Insert Pose** option right above **Clear Pose** will insert a new pose at the selected frame manually.

In this section, we explored how to animate our IK armature using poses and then how to manage those poses across the timeline. In the following section, we'll wrap this chapter up by examining how to share our carefully crafted rig as an **Animate Asset**.

Sharing a Completed IK Rig

While we can copy and paste frames and even entire layers from one document to another, it can be a bit cumbersome to do so and is very disorganized in practice. Animate now comes equipped with a new workflow for sharing rigged objects through the form of **Animate Asset** (.ana) files.

We'll now see how to export these files to either preserve them in an organized way, share them with colleagues, or make them available as a persistent resource through the **Assets** panel.

Saving a Rig for Reuse

If you've created an IK armature and you'd like to save it for use on additional assets in the future, Animate has a workflow that can be used to generate your rig as an **Animate Asset** for sharing or for direct use from the **Assets** panel.

If we want to preserve our wooden doll armature as a rig, we first need to wrap it within a symbol as follows:

1. Right-click on the **WoodenDoll** layer and choose **Convert Layers to Symbol** from the menu that appears.

2. In the **Convert Layers to Symbol** dialog, name it WoodenDoll and choose **Graphic** as the symbol type:

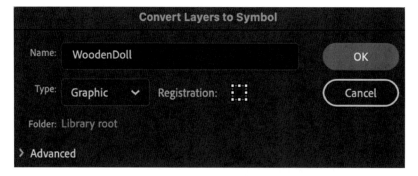

Figure 8.35 – Converting your armature to a Graphic symbol

We are using a **Graphic** symbol so that the armature animation will be viewable within the authoring environment timeline. If we created a **Movie Clip** symbol, the only way to preview would be via **Test Movie**.

3. When ready, click **OK** to perform the conversion. The full **IK Armature** layer is now wrapped within the symbol and an instance is placed within the timeline, replacing the layer that was there previously:

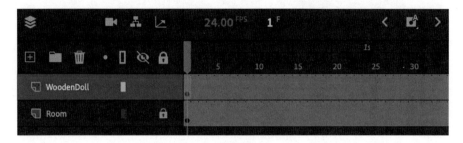

Figure 8.36 – The IK armature layer is replaced

Once you have your symbol created with a fully rigged armature within it, locate the symbol you want to export as a rig from the **Library** panel. We'll use the **Library** panel to export our rig as an **Animate Asset** (.ana) file.

To export a symbol from our document to use as a sharable asset, we perform the following steps:

1. Select the symbol in the **Library** panel and open the menu by right-clicking:

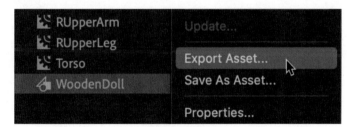

Figure 8.37 – Exporting an asset from the Library panel

You'll find two options here: **Export Asset…** and **Save As Asset…**. Either one will create the rig, but if we want to save to a .ana file, we'll need to choose **Export Asset…** and make a few selections in the dialog that follows.

2. Once **Export Asset…** is chosen, a dialog will open and present you with a number of options:

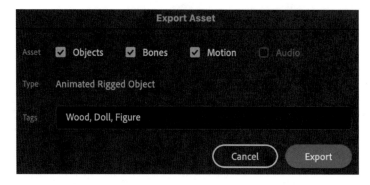

Figure 8.38 – Saving a rig for reuse as an animate asset

The dialog options include providing the asset with a *Name* and choosing which aspects of the asset you want to include: **Objects**, **Bones**, **Motion**, or **Audio**. Only those aspects of the asset that are available for packaging will be selectable. As we have no audio, that option is not available.

Depending upon your checkbox selections, the **Type** of asset to be saved will be displayed. In this case, I'm saving an **Animated Rigged Object**. You can also input a set of **Tags** here to help locate your asset once within the **Assets** panel through the integrated search mechanism.

3. Click **Export** and save your asset as an .ana file:

Figure 8.39 – An animate asset file

The animate asset now exists as an .ana file on your hard drive to be distributed to others or added to your own version of Animate through the **Assets** panel.

We'll next see how to import an .ana file from your local filesystem into Animate.

Importing a Rig within the Assets Panel

Let's close out this chapter by importing the .ana file we've created into our **Assets** panel for reuse. Of course, if the option to **Save As Asset…** were to be selected from the **Library** panel menu instead of **Export Asset…**, your asset would immediately be added to the **Assets** panel and no .ana file would be generated.

The first step to import an exported **Animate Asset** file is to open your **Assets** panel and click the **Custom** tab:

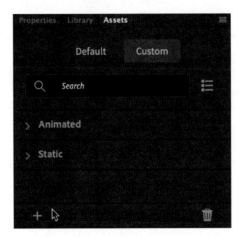

Figure 8.40 – Importing an animate asset

Depending upon whether you have added any assets previously, some may be present here, otherwise your panel will be completely empty. There is a small button in the lower-left corner of the panel that looks like a big plus symbol. This is the **Import Assets** button. Clicking this will open a file browser you should use to locate the .ana file you want to import.

Once you choose the file you want, it is added to the appropriate category within the **Assets** panel:

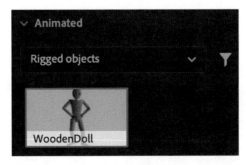

Figure 8.41 – Imported rigged object within the Assets panel

You should also perform a search from the panel based upon the tags that were input when you exported the asset. Once imported, an asset such as this can be used across Animate documents as a persistent resource.

> **Note**
> You can also import assets by using the **Assets** panel options menu in the upper-right corner by choosing **Import**. You can further manage your custom assets through this menu with options such as **Delete**.

In this section, we had a look at how to preserve and share our IK armature rigs, motion, and assets through the creation and use of **Animate Asset** files. These files can be used to preserve important assets or to share them with colleagues and the wider world!

Summary

In this chapter, we had a deep look at one of the most mystifying workflows in all of Animate – **Inverse Kinematics**. This is truly a professional-level animation workflow and one that can be easily done incorrectly without a proper understanding of all the different aspects involved in IK armatures, IK bones, poses, and the various settings attributed to each. You can now confidently rig an armature using inverse kinematics in a refined and believable way, and animate the character or figure attributed to your armature by creating and managing poses across the timeline. In the next chapter, we are going to put the focus on advanced layers once again, this time exploring the **Camera** document, **Layer Depth**, and **Layer Effects**!

9

Working with the Camera and Layer Depth

In the previous chapter, we saw how to build complex IK armatures and create fully animated figures using the tools and workflows present within the software.

In this chapter, we will examine the **Camera**, **Layer Depth**, and **Layer Effects**. All three of these features rely on **Advanced Layers** mode, which we first saw put to use in *Chapter 7*, *Character Design through Layer Parenting*. Using these features, we can create some pretty amazing parallax animations with just a few alterations to the depth of our layers and by manipulating the document-level camera. In the following sections, we'll explore various properties and workflows associated with the camera and see how to animate smoothly between various camera states. Once that has been covered, we'll then see how to apply filters, effects, and blend modes across entire layers within our animation.

After reading this chapter, you will learn the following:

- Learn the basics of adding the document camera and manipulating its various properties.

- Understand how to change the camera state and produce smooth movement.

- Invoking the **Layer Depth** panel and exploring the relationship between **Layer Depth** and the camera.

- Applying effects and filters to your layered animations.

Technical Requirements

You will need the following software and hardware to complete this chapter:

- Adobe Animate 2021 (version 21.0 or above).

- Refer to the Animate system requirements page for the hardware specifications: `https://helpx.adobe.com/animate/system-requirements.html`.

Understanding the Camera

While we've done a lot of animation so far with individual layers and objects, the document-level camera in Animate allows us to achieve even more. We can use it to zoom, pan, and rotate the entire contents of the stage as though we are using a real camera upon our animation. Not only that, but we can still layer and nest animated content as usual through the normal methods to create multiple levels of animation across any project.

One of the most common uses of the camera is to zoom in on a scene:

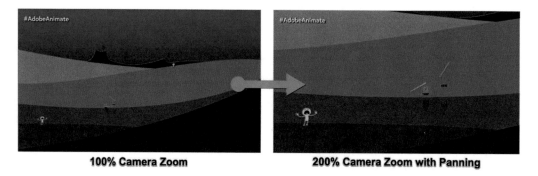

Figure 9.1 – The camera adds zoom, pan, and rotation to a scene

This can be an animated zoom or even a simple cut from one zoom level to another.

> **Note**
> The camera can only be used at the document level and not within individual symbol timelines.

We'll be making use of the camera in this chapter to add all sorts of interesting motion and effects to our content.

Examining the Starter Project

In order to make use of the camera right away, we have a starter project made specifically for this chapter that can be used to follow along with as we go over the different concepts involved. You can always use your own files if you wish to as the concepts can be applied across just about any content.

> **Note**
> You can find the starter file we use here within the exercise files at `https://github.com/PacktPublishing/Mastering-Adobe-Animate-2021`.

If you open `CameraStarter.fla`, you'll notice that the stage has been laid out with a number of varied assets ready to go:

Figure 9.2 – The starter project stage

The scene is that of a vast desert with rolling sand dunes. Far away is a set of rocky outcroppings and a steep cliff face. The sky appears free of clouds and a strange haze hangs over the horizon. The view is expansive with no obstructions apart from the dunes themselves.

Set across the various dunes of sand are animated characters that have been brought into our project through the Assets panel. They are all symbol instances that contain internal animations as graphic or movie clip behaviors.

Looking down to the timeline, you will see that these various objects have been organized into layers according to how close or far away they are from the viewer:

Figure 9.3 – The starter project timeline and layers

These layers have a particular order to them, with the closer layers being toward the top of the layer stack and the layers that are more distant being closer to the bottom. At the very top of the stack is an empty **Watermark** layer, which we will use later to add some text to our animation. At the very bottom of the stack is the **Sky** layer, which contains the background sky elements.

In between these two are the layers that focus on scenic content. Most of them only contain various shapes that make up the levels of the sand dunes, but there are a few layers with additional character elements that you should take note of:

- The **Closer** layer includes an instance of the **Complainer** movie clip symbol instance.
- The **Close** layer includes an instance of the **Cat Fight** graphic symbol instance.

- The **Far** layer includes an instance of the **Boy and Flower Monster** movie clip symbol instance.

- Finally, the **Farthest** layer includes no sand dune but rather the rocky outcropping with a dead tree and an instance of the **Bunny Hop** graphic symbol instance.

None of the layers include any motion at all. We are focusing on the camera in this chapter and will be using that mechanism alone to provide motion for our project, apart from any internal symbol animations.

Go ahead and click the **Test Movie** button to see the current state of the project. With only a single frame included as part of the main timeline, we only see movie clip symbol instances exhibiting any animation at all. Graphic symbol instances require additional frames upon the main timeline for playback, so our graphic symbol instances only display a single frame, thus no animation. It's a fairly lifeless scene!

It doesn't have to stay that way though. Let's explore how to activate and use the camera next.

Activating and Manipulating the Camera

In order to use the camera within our document, we must be first be using **Advanced Layers** mode as described in *Chapter 7, Character Design through Layer Parenting*. This is the default layer mode within all recent versions of Animate, so you likely will not need to do anything to enable this mode. With the camera available, you must next activate it for use in your document, as the camera is not activated by default.

> **Note**
> The camera is not available in WebGL-based documents, including VR document types.

The camera can be activated by clicking the **Add Camera** button at the top of the timeline:

Figure 9.4 – The Add Camera button

Once the camera has been activated within a document, the same control is switched to a **Remove Camera** button. When toggling this button to add or remove the camera, it is actually only activating or deactivating the camera. If you deactivate and then reactivate the camera at any time, all of your changes and settings will still be present!

> **Note**
>
> You can also activate the camera by selecting the **Camera** tool from the toolbar. You may need to edit the toolbar to be able to access this tool.

With the camera active, a number of changes across the Animate interface will become immediately apparent.

Across the timeline, a new **Camera** layer will be added at the very top of the layer stack:

Figure 9.5 – The dedicated Camera layer

This layer, indicated by a small camera icon and with the fixed layer name of **Camera**, is dedicated to the document **Camera**. The layer must exist at the very top of the stack and it cannot be moved. You also cannot add any content to this layer as it is meant to hold the camera and nothing else is allowed. In addition, the layer cannot be locked, have its visibility disabled, or be placed into outline mode as normal layers can.

You'll likely notice that a new icon is added to the timeline that appears as a small camera with a chainlink attached. We'll see what this option does a little later on!

Another big change to the interface occurs on the stage. A control overlay appears over the stage content toward the bottom:

Figure 9.6 – Camera overlay controls

The camera overlay includes a slider for either zooming or rotating the camera. The mode can be changed by activating either the rotation or zoom options that appear at the left of the overlay. Moving the slider to either side will adjust the selected property and will snap back to the center once released, allowing for additional adjustments.

In addition to the overlay, if you hover over the stage, you will see the cursor change to indicate the ability to pan the camera. If you click and drag anywhere on the stage with this icon visible, you can pan the camera.

> **Tip**
> When you pan the camera, the actual view moves opposite of the camera's pan direction. This may feel a bit odd at first but try to imagine you are actually moving a camera and not moving the stage content and it will likely feel more natural.

With the camera activated and the **Camera** tool selected, we can view the various properties associated with it in the **Tool** tab of the **Properties** panel:

Figure 9.7 – Camera tool properties

The **Camera** properties likely entail everything you'd expect from a virtual camera. The settings include X/Y position, zoom, and rotation values. Each one of these properties can be set in either the overlay controls or through the **Properties** panel. Setting them this way is more precise, and each setting includes a button to quickly reset each property to its default.

> **Note**
>
> There are also color effects and filters that can be set within the **Camera** properties, but these are only available when using an ActionScript 3.0-based document.

It is also important to mention that these property settings are bound to keyframes across the timeline. So, if you want to change a camera property at any point, you simply insert a new keyframe and make adjustments through the overlay controls or the **Properties** panel – whichever works best for your current task.

In this section, we had a look at the starter document and saw how to activate the camera and make adjustments to its properties. Coming up, we'll have a look at the layer depth settings and prepare our starter document to make use of this feature.

Understanding and Manipulating the Layer Depth

In this section, we are going to learn how to manipulate the depth of layers within an Animate project. While panning and zooming the camera can be very effective, we can enhance everything we do with the camera by using another feature of **Advanced Layers** mode in the form of **Layer Depth**. This feature allows us to place specific layers closer or farther from each other and the camera to simulate a difference of depth across each one. The result is that as the camera changes property setting values across time, the view shifts across the variety of depth settings, providing a feeling of enhanced immersion.

Let's explore the mechanism that allows us to adjust the depth settings of our various layers and then use it to modify the depth of the layers currently present within our project.

Activating the Layer Depth Panel

By default, the **Layer Depth** panel is visible in the **Essentials workspace**, minimized to icon view along the right-side column along with a number of additional panels. It can be difficult to locate this way. You can also invoke the **Layer Depth** panel by choosing **Window | Layer Depth** from the application menu, but a more direct method is to invoke it from the timeline itself.

The simplest way to invoke the **Layer Depth** panel is to click the **Toggle Layer Depth** button from the top of the timeline:

Figure 9.8 – Invoking the Layer Depth panel

Wherever the **Layer Depth** panel resides, it will then appear and allow us to visualize and manipulate the depth settings of our various layers.

Let's have a look at some of the features of the **Layer Depth** panel to become more familiar with its layout and function:

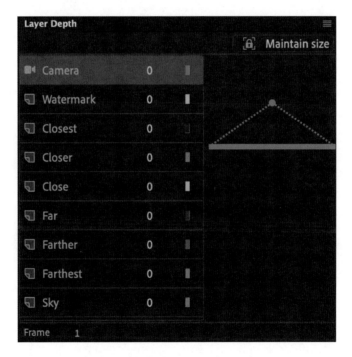

Figure 9.9 – Layer Depth panel

With the **Layer Depth** panel open, you can view the current depth setting for each layer and even visualize how close or far layers are from one another with the current settings. Since we haven't made any alterations yet, all layers are at a depth of 0 and equidistant from the camera itself.

Within the **Layer Depth** panel are a number of important things to note:

- **Left Column**: Contains all layers in the order that they appear on the timeline. The data value is the depth setting and the layer color corresponds to the visual depth indicator in the right column.

- **Right Column**: This is a visual representation of the layer depth in accordance with the depth values as expressed in the left column. Each layer is represented as a line and shares the color with the layer itself. The camera is also represented here as a blue dot with two dashed lines emerging from it.

- **Frame Number**: Just as with the **Camera** properties, **Layer Depth** values are tied directly to keyframes. This number represents the playhead position along the timeline for quick reference.

- **Maintain Size**: Changes the depth of the selected layer without affecting the size of objects embedded within the layer. If this is not selected, the layer content may scale in accordance with the modified depth value.

All of these different settings can be manipulated within the **Layer Depth** panel, but we should also keep a close eye on both the timeline and the stage as we do so. It will be easy to spot mistakes as changes are immediately reflected within the stage.

> Tip
>
> Normally, you need to click the **Maintain size** button each time you want to change layer depth. This can become tedious. If you hold the *Alt / Option* key while dragging the layer depth values, Animate will maintain the size of the layer without needing to interact with the button each time.

That's an overview of the **Layer Depth** panel itself. Next, we'll see how to use the various settings within to modify the depth of our layers across the timeline.

Modifying the Layer Depth

While you can make adjustments to the depth of a layer at any time, it is best to do so before performing any adjustments to the camera settings. As we're working through these concepts, have you noticed how we haven't actually done any work with the camera yet aside from exploring its various settings? That is because we want to establish the initial layer depth settings first. With the **Layer Depth** panel open, let's go ahead and assign a depth setting to each layer. Using the panel controls, there are two different ways of setting the depth of any layer.

The first way to adjust the layer depth is to either manually enter a number into the value field beside the layer name, or simply drag the value to either increase or decrease it:

Figure 9.10 – Numeric depth control

When making slight adjustments, dragging across the value field works well to nudge the layer, but if changing the depth by a larger number, you will likely want to simply click the value and type a new one in manually.

The second method of adjusting the layer depth values is to do so visually, by selecting a layer and dragging the highlighted layer marker up or down:

Figure 9.11 – Clicking and dragging layer markers

You can keep an eye on the value attributed to the selected layer to monitor its actual depth setting.

Positive numbers indicate that the layer is far from the normal field of view and more distant, while negative numbers indicate that the layer sits between the normal field of view and the camera position. If the layer is set to a depth that is behind the camera, as indicated by the blue dot intersected with dashed lines, then that layer is no longer in view at all as it is behind the camera.

> **Tip**
> If you have layers arranged as part of a layer folder, the folder will appear within the **Layer Depth** panel as well, allowing you to modify the depth of all contained layers simultaneously.

Let's set our layer depth values from top to bottom:

- **Camera**: We will not be modifying the camera position, but it is definitely something you could do to achieve a camera pass-through animation. Instead, we'll later adjust the camera pan and zoom settings as that will provide more control. Keep this at 0.

- **Watermark**: This should be at least 1 unit more toward the camera than all the other layers since we want it to be visible atop all layers no matter what. We'll set this to -151.

- **Closest**: Set this layer to -150. Note that this is only one unit farther away than the **Watermark** layer.

- **Closer**: The layers closest to the camera are all being set to negative numbers since they fall between the camera itself and the normal field of view. This layer will be set to a value of -100.

- **Close**: Leave this at 0. This layer remains at the normal field of view and so is the default depth value. It isn't necessary to have any layers at 0, but we do so here to illustrate the differences with positive and negative depth values.

- **Far**: The next four layers, including this one, all have positive numbers. Set the depth value of this layer to 200.

- **Farther**: The next layer will have a depth value of 400 since as we get farther away from the normal field of view, the distances are greater.

- **Farthest**: Finally, the layer that includes the craggy outcropping and cliff face is given a value of 650.

- **Sky**: The background imagery should be farthest away from everything else, so we give it a value of 1000.

Your completed depth settings within the **Layer Depth** panel should look like this:

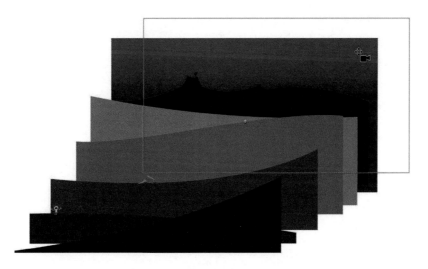

Figure 9.12 – Layer Depth settings

Notice that in our example here, the layer order in the timeline and the layer depth stacking order both share the same general order. They do not have to, though, as the layer depth overrides the normal layer order in the timeline. We will see an example of this shortly.

A good way to see the effect that these depth settings has upon our layers is to use the camera to pan around the stage:

Figure 9.13 – Layer depths visualized

You will see the various layers all moving at different speeds, depending on how far or close they are. When you have finished playing around with the camera, be sure to reset any of the values to their defaults.

We have now set up all our layers in this project to utilize the layer depth settings along with the camera. We can also modify the depth of layers across time without the use of the camera to create additional effects. Let's have a look at that workflow next.

Using the Layer Depth without the Camera

As alluded to earlier in the chapter, you don't have to enable the camera to use **Layer Depth**, and you don't have to have the layers in any proper order either since the depth setting overrides the layer order.

Take a look at the exercise file named `NoCameraDepth.fla` for a quick example of this:

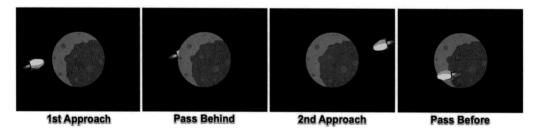

Figure 9.14 – Rocket passes before and behind the moon

In this example, we have two objects on the stage: a rocket ship and the moon. In the timeline, there is a layer for each of these objects and the rocket is animated in such a way that it first travels behind the moon and then returns to pass in front of it.

The **Rocket Ship** layer is always above the **Moon** layer though, so how does the rocket pass behind the moon at all? The **Layer Depth** settings, of course!

Notice that the **Moon** layer isn't animated at all but includes two keyframes along the timeline:

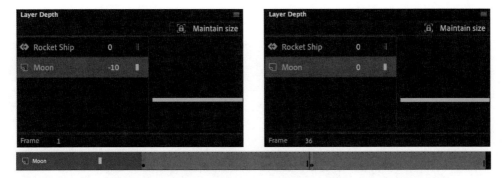

Figure 9.15 – Layer depth values are bound to keyframes

At frame 1, the **Moon** depth value is set to -10 while the **Rocket Ship** depth is at 0. This brings the moon closer to the viewer than the rocket. At frame 36, both layers have a depth of 0 and since their timeline order has the **Rocket Ship** layer above the **Moon** layer, the rocket is then visible above the moon. This technique can be used in many cases to swap depths across time for similar effects.

In this section, we explored the fundamental properties of the camera and explored how to manipulate the **Layer Depth** settings in a variety of ways. Coming up, we'll put all of this into play as we create different camera states and animate between them.

Animating the Camera

The camera is integrated into the timeline just like any other object in Animate, with certain restrictions. For instance, it is contained within its own layer and this special layer does not behave as other layers do. However, certain aspects of a normal layer workflow do precipitate onto the **Camera** layer as well. Primary among these is the handling of motion.

We'll now establish camera states through keyframes and animate between these states using techniques already addressed within this book.

Setting Camera Keyframes

As the document exists now, we have a single frame across all layers. In order to have any actual motion occur, camera-based or otherwise, we need additional layers.

First, be sure to lock all the existing layers. It's a good habit to lock and unlock specific layers as needed. The **Camera** layer can never be locked. Add frames up to and including frame 540 across all of the layers, including the **Camera** layer.

We now have 18 seconds of total frames across all layers:

Figure 9.16 – Frames extended across all layers

With our frame spans fully extended, we'll next add keyframes at specific points along the **Camera** layer and make adjustments to the **Camera** properties, such as zoom and pan. It is best to set the zoom value first, followed by the panning adjustments.

Let's plot out keyframes to signify specific key points across the animation:

1. An initial keyframe exists at frame 1 with the camera position at 0 along both the **X** and **Y** positions and the zoom level at 100%.

2. Add a keyframe at frame 20 to place a hold between these two keyframes:

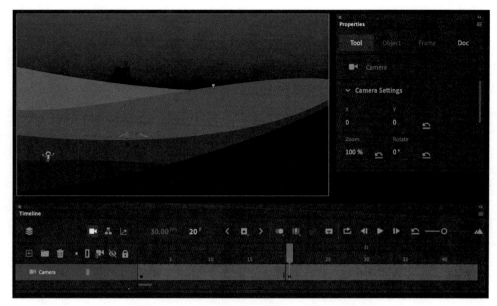

Figure 9.17 – Starting with the camera defaults

3. Now, add an additional keyframe at frame 60 and set the **Camera** properties as follows: set the **Zoom** value to 565 with an **X** position of 2110 and a **Y** setting of -850.

 The focus for this keyframe is on the **Complainer** animation:

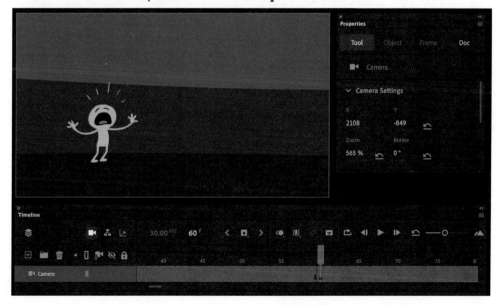

Figure 9.18 – Focus on the Complainer animation

4. Now, add a keyframe at frame 90 for a short hold with these same settings.

5. Place the next keyframe at frame 140 with a **Zoom** value of 1026, an **X** position of -2025, and a **Y** position of 1100.

This will focus the camera upon the **Boy with Flower Monster** animation:

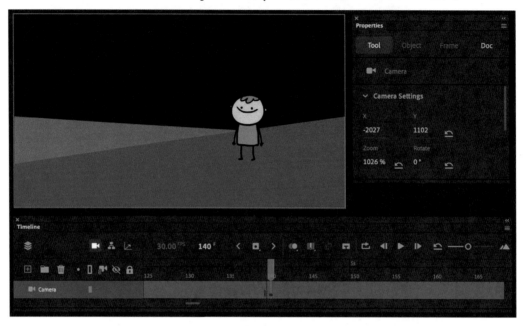

Figure 9.19 – Focus on the Boy with Flower Monster animation

6. Insert another keyframe at frame 200 to hold on the **Boy with Flower Monster** animation a bit, then add another keyframe at frame 230 with a **Zoom** value of 325, an **X** position of 362, and a **Y** position of -513.

This will zoom out somewhat and reposition the camera to focus on the **Cat Fight** animation:

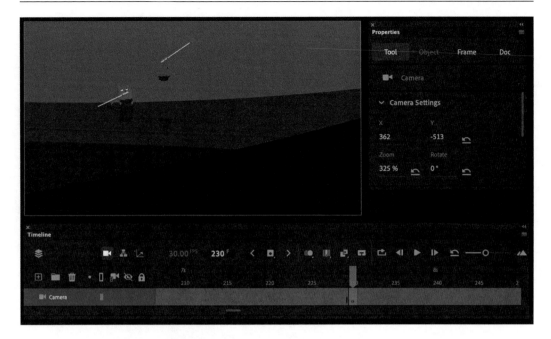

Figure 9.20 – Focus on the Cat Fight animation

From the **Cat Fight** animation, we'll pan up and zoom toward the base of the craggy cliff face in the distance.

7. Insert a keyframe at frame 280 and set a **Zoom** value of 1000, an **X** position of 4560, and a **Y** position of 1430.

You will begin to notice that the more extreme the zoom becomes, the more variable the numbers you input will be. Don't worry if Animate changes the values by a few units each time you change the camera settings – this is expected.

8. Place the next keyframe at frame 320 and this will allow us to pan the camera upward to view the **Bunny Hop** animation at the top of the cliff. Include a **Zoom** value of 3290, an **X** position of 14280, and a **Y** position of 11120.

Notice here that we've zoomed in a huge amount and can see all the details of the cliff, such as the tree and stone present there. At 100% zoom, this is almost impossible to see:

Figure 9.21 – Focus on the Bunny Hop animation

9. Finally, add a keyframe at frame 380 as a hold upon the **Bunny Hop** animation, and the last keyframe will sit at frame 450, where we pull back on the camera zoom to get a larger picture of the entire scene once more.

10. Adjust the camera settings at frame 450 so that the **Zoom** value is 150, the **X** position is 0, and the **Y** position is also 0.

If we play our project at this point, it consists of a collection of quick cuts as each keyframe is encountered. While a jumpcut like this can work in certain scenarios, we require a smoother motion from keyframe to keyframe.

Now that we have keyframes across the **Camera** layer holding specific camera settings at each one, we can add tweens and eases to establish smooth motion between them.

Adding Motion and Easing to the Camera

Motion can be applied to the **Camera** layer through the use of either a **motion tween** or **classic tweens**. We will be using classic tweens in this project, since it is simpler to plot out camera settings in keyframes beforehand and the ease effect presets can be interpreted and applied easily.

> **Tip**
> In order to achieve believable, smooth camera movement, ease effect presets are a must!

Our **Camera** layer currently contains keyframes for each camera state. Certain frame spans are meant to hold the camera at a specific position and zoom level while others are meant to contain movement from one keyframe to the next. We will be adding classic tweens and ease effect presets to those that are intended to feature camera movement.

Additionally, following the focus on certain character animations, we will insert keyframes on the layers that contain them and remove the characters from the stage. This will be good practice for toggling the camera off and on in order to best select each character for removal.

For each of the following frame spans, add a classic tween and the indicated ease effect preset:

- **Frame span 20–60**: Use the **Quad Ease-In** effect preset.

- **Frame span 90–140**: Use the **Sine Ease-In-Out** effect preset.
 Additionally, add a keyframe to the **Closer** layer at around frame 140 and remove the **Complainer** character.

- **Frame span 200–230**: Use the **Sine Ease-In-Out** effect preset.
 Additionally, add a keyframe to the **Far** layer at around frame 230 and remove the **Boy with Flower Monster** character.

- **Frame span 230–280**: Use the **Quad Ease-In** effect preset.

- **Frame span 280–320**: Use the **Quad Ease-Out** effect preset.
 Additionally, add a keyframe to the **Close** layer at around frame 320 and remove the **Cat Fight** characters.

- **Frame span 380–450**: Use the **Quart Ease-In-Out** effect preset.

When these actions have been completed, your timeline should look similar to the following figure:

Figure 9.22 – Timeline with camera tweens and keyframes

Note that those frame spans of the **Camera** layer meant to serve as a motion hold do not contain tweens and certain additional layers include keyframes to remove characters following their focus.

The bulk of our camera animation is now complete. Perform a test movie to see it in action!

Creating Text and Attaching Layers to the Camera

If you recall from earlier, we still have an empty layer right below the **Camera** layer named **Watermark**. This layer will be used to display a small, text-based #AdobeAnimate hashtag identifying the animation as having been created in Adobe Animate.

Let's create this text object now:

1. The first thing we need to do is select the **Text** tool:

Figure 9.23 – The Text tool

2. With the **Text** tool selected, look to the **Tool** tab of the **Properties** panel:

Figure 9.24 – Text tool properties

Be sure to choose **Static Text** from the dropdown. We'll explore additional text options, including the use of dynamic text in *Chapter 10, Developing Web-Based Games,* and *Chapter 12, Building Apps for Desktop and Mobile.*

3. Choose a bold font to use for the text – I've selected **Europa**, which can be synced to your computer from Adobe Fonts at `https://fonts.adobe.com/fonts/europa` with a Creative Cloud subscription.

4. Set the size value to `24 pt` and the fill color to pure white (#FFFFFF).

5. Unlock the **Watermark** layer if it is currently locked and select frame `1`.

6. Click in the upper-left area of the stage and type in the text `#AdobeAnimate`:

Figure 9.25 – The text object is created

7. Select the text object and look to the **Object** tab of the **Properties** panel to ensure the text object is positioned 40px along both the **X** and **Y** positions.

8. With the **Watermark** layer content in place, play back the project and note that the text immediately zooms past the camera and offscreen.

 We want the text to stay exactly where it is no matter what the camera does. In order to do this, we have to attach the layer the text exists within to the camera. This will basically have the layer ignore anything to do with the **Camera** layer and its various settings.

9. To attach the **Watermark** layer to the camera, simply activate the **Attach Layer to Camera** option:

Figure 9.26 – Attach Layer to Camera

Playing the project now will exhibit completely different behavior when it comes to our text overlay. It now stays put throughout the duration of the animation, unaffected by the camera.

In this section, we looked at establishing camera states and animating the camera across the timeline. We also spent a good deal of time adjusting our tweens and additional layer frame properties to achieve an interesting, dynamic animation, using nothing but the **Camera** and **Layer Depth** settings. Coming up, we'll finish off this animation by adding in some camera effects and layer filters.

Applying Layer Effects and Filters

Another advantage to **Advanced Layers** mode is that you can have effects and filters applied directly to a layer, which, in turn, affects all objects within that layer without having to modify the objects themselves. You can also add effects directly to the camera in a similar way.

> **Note**
>
> Layer effects, layer filters, and camera effects are all only available when using ActionScript 3.0-based document types.

We are going to add some effects to the camera in order to simulate a fade-in/fade-out to black and a filter to our **Watermark** layer in order to add some drop shadow to the text within.

Adding Effects to the Camera

Camera effects and layer effects both work very similarly, the only difference being that camera effects are applied via the **Camera** tool properties and layer effects are applied through the **Frame** properties.

Let's add both a fade-in and fade-out to our **Camera** layer:

1. First, add a keyframe at frame 10 within the **Camera** layer.

2. Move the playhead back to frame 1 and select the **Tool** tab within the **Properties** panel – you will see a section for **Color Effects** below the normal **Camera** properties such as zoom and position.

3. From within the **Color Effects** section, choose **Brightness** from the dropdown and pull the **Bright** value to -100:

Figure 9.27 – Adding a camera effect

The entire stage goes black except for any of the layers attached to the camera. This is the first step to create a fade-in from black.

4. Apply a classic tween on the **Camera** layer between frame 1 and frame 10 and add the **Sine Ease-Out** preset from the **Properties** panel.

5. Move the playhead to the end of the timeline at frame 500 and add a keyframe.

6. Add an additional keyframe at frame 530 and access the **Camera** tool properties, setting **Brightness** to -100 on this keyframe as well to establish a fade to black.

7. Create a classic tween between frame 500 and frame 530 and add the **Quad Ease-In** preset from the **Properties** panel to complete our fade effects.

If you preview the animation, you'll see that the movie begins by quickly fading in from black, proceeds as normal, and then fades out to black before completion.

We'll next finish this project by adding a layer filter to the **Watermark** layer.

Adding Filters to a Layer

Layer filters and layer effects are both added through the **Frame** tab of the **Properties** panel. We want to have our text within the **Watermark** layer pop out against the background and so will add a drop shadow to the entire layer through the **Filters** section of the **Properties** panel.

To add a filter to the **Watermark** layer, take the following steps:

1. Select the **Watermark** layer and choose the **Frame** tab of the **Properties** panel.

2. Locate the **Filters** section at the bottom of the panel and expand it if it is closed.

3. Click the **Add Filter** button at the top-right of the panel to invoke the filter selection overlay and choose **Drop Shadow**.

4. The **Drop Shadow** filter is added to the selected layer, making the text stand out even more:

Figure 9.28 – Drop Shadow filter added

From this point, you can modify any of the settings of this filter. The filter settings will differ between each filter type, but for any that allow a **Quality** selection, I normally choose **Medium**.

Looking at the timeline, notice that the keyframes within the **Watermark** layer now appear white instead of black as they normally do. A white keyframe indicates a filter or effect has been added to that layer.

In this section, we had a look at how we could add effects to the camera that affect all layers and filters for individual layer effects. Both of these features are available as part of **Advanced Layers** mode and help to perfect our overall animation.

Summary

In this chapter, we saw how to animate an entire project through the use of the document **Camera** even without that content itself being animated within the main timeline. We also explored the manipulation of the layer depth and then saw how to work with both the camera and layer depth together to create some amazing dynamic parallax movement within our animation. We wrapped everything up by implementing both camera effects and layer filters to add an additional feel of completion to our animation.

In the next chapter, we'll begin working with additional platforms and have a look at writing JavaScript code to target **HTML5 Canvas** in the form of a simple web-based game.

Section 3: Exploring Additional Platforms

For the final section, we will focus less on motion design and instead explore some advanced concepts and techniques associated with specific target platforms, such as coding JavaScript to develop web-based games and virtual reality experiences and using ActionScript to write a fully functional application for desktop and mobile devices. We will then wrap up by having a look at how to extend Animate's capabilities through the creation of custom in-app tutorials, internal scripting, and the use of third-party extensions.

This section comprises the following chapters:

- *Chapter 10, Developing Web-Based Games*
- *Chapter 11, Producing Virtual Reality Content for WebGL*
- *Chapter 12, Building Apps for Desktop and Mobile*
- *Chapter 13, Extending Adobe Animate*

10
Developing Web-Based Games

In the previous chapter, we took a deep dive into the **Camera**, **Layer Depth**, and a number of additional features available as part of the **Advanced Layers** mode in Animate.

We begin this chapter with an overview of our game concept and the HTML5 Canvas starter document, which already has a number of assets laid out in accordance with the techniques learned in previous chapters. We will then move on to prepare various assets on the stage and assets within the project library for interactivity. We'll also create all-new dynamic text assets for our gameplay screen that can display game data through our use of JavaScript. The majority of this chapter will be spent in the code editor as we build out the logic for our entire game bit by bit across the timeline and through the use of global scripts.

After reading this chapter, you'll be able to perform the following functions in Animate:

- Create a game using both designer and developer workflows in Animate.
- Configure and manage interactive content, game states, and data variables.
- Write JavaScript code to generate assets dynamically from the project library.
- Develop logic to control the game flow and manage all aspects of gameplay.

Technical Requirements

You will need the following software and hardware to complete this chapter:

- Adobe Animate 2021 (version 21.0 or above).

- Refer to the Animate System Requirements page for hardware specifications: `https://helpx.adobe.com/animate/system-requirements.html`. The CiA video for this chapter can be found at: `https://bit.ly/3a3Jmte`.

Understanding the Game Concept

The game we will build in this chapter makes use of one of the strongest aspects of Adobe Animate, and that is the ability to create assets with visual tools and then program them with code all directly within the same application. The game concept is very simple: you control a kitty that can walk back and forth across the screen and shoot energy balls upward. Enemy pigs are dropping from above and the kitty must ensure that none reach the ground by blasting them out of the sky. If three pigs get past the kitty, it's game over.

We'll be dealing with a lot of code in this chapter. If you've never written much code, don't worry! We will be stepping through the visual aspects of the game first and will slowly build up to the programming aspects. Even when in the thick of development, all the code will be provided and explained piece by piece.

Starter Document Overview

An HTML Canvas document named `GameStarter.fla` is available from the file downloads, and for this chapter, you are highly encouraged to download it. Once you have the Animate file on your local system, open it up and have a look at what has been prepared.

> **Note**
> You can find the starter file we use here within the exercise files at `https://github.com/PacktPublishing/Mastering-Adobe-Animate-2021`.

The starter project is an **HTML5 Canvas** document and will target the native web to run on any modern web browser. As we discussed in *Chapter 2, Exploring Platform-Specific Considerations*, an **HTML5 Canvas** document will specifically make use of the `<canvas>` element of HTML to render any static or animated content but it also features the ability to be interactive, making it the ideal platform for a web-based game.

The document itself exhibits a stage width of 640 and a height of 480:

Fig. 10.1 – Starter Document Settings

This is a 4:3 aspect ratio and often works well for games. The timeline is set to run at 24 frames per second and the background is black (#000000).

Before we get into the contents of the document, let's go over how we'll be programming the content. Since we are targeting the native web, we'll be using **JavaScript** to write all our code. JavaScript is fairly easy to pick up and start working with – especially since it can run within any standard web browser. JavaScript can be used within Animate when targeting HTML5 Canvas documents as we are doing in this chapter, but can also be used to program **WebGL glTF Extended**, **VR Panorama**, and **VR 360** document types.

> **Note**
>
> A great resource for writing JavaScript is the documentation located on the Mozilla Developer Network: https://developer.mozilla.org/en-US/docs/Web/JavaScript.
>
> If you'd like to have a comprehensive resource for learning JavaScript in the form of a book, I recommend *The JavaScript Workshop* from Packt: https://www.packtpub.com/product/the-javascript-workshop/9781838641917. I contributed a few chapters to this book and served as the lead author.

In addition to vanilla JavaScript, we'll also make use of the CreateJS JavaScript library within HTML5 Canvas documents. CreateJS is a set of libraries that includes EaselJS, TweenJS, SoundJS, and PreloadJS. Each of these libraries fulfills a different role in CreateJS but they all work together in making the HTML <canvas> element much easier to work with. Again, refer to *Chapter 2, Exploring Platform-Specific Considerations*, for a refresher.

> **Note**
>
> For deeper insight into how the **CreateJS** libraries function, you can access the **CreateJS** documentation from their website at `https://createjs.com/docs`.

With the general document settings and platform considerations covered, let's move on to examine how the document has been assembled.

Exploring the Timeline and Stage

Taking a look at the timeline, you'll notice two layers. Each of them has been divided into three sections separated by keyframes. These will serve as the three screens that make up our game.

Have a look at the starter document timeline:

Fig. 10.2 – Starter document timeline

The **Backgrounds** layer contains a bitmap image for all three of the timeline sections. In the first and third sections, we have a shape overlay to dim the background a bit and make any additional assets stand out. In the middle section, the background is presented as it is since this will serve as the gameplay screen. In the **Assets** layer, we have a number of assets that overlay the background imagery and vary from text to shapes to symbol instances depending upon the section.

The sections of the timeline can be referred to by different names for clarity. Here is how things have been configured:

- **Start Screen** – Covers frames 1-3 and represents the game start screen and title.

- **Game Screen** – Consists of the next three frames (4-6) and is where actual gameplay will occur.

- **End Screen** – This is the game over screen once you've lost the game and covers frames 7-9. There is no way to win the game.

Let's have a look at each of these screens in detail, beginning with the **Start Screen**:

Fig. 10.3 – Start Screen

We have our background image dimmed with a semi-opaque rectangular shape covering the stage. An instance of the player-controlled **Kitty** movie clip symbol instance appears on the left but has no interactivity associated with it. An animated **KittyOrb** movie clip symbol instance with a text overlay of **PLAY!** is present but also non-interactive at this time. Finally, we have the title **KITTY WARS** rotated slightly and include a black shape behind it.

Next, we'll focus on the **Game Screen**:

Fig. 10.4 – Game Screen

This is the screen where all of the gameplay will happen but since we haven't written any code yet, it is presently the most minimal. Our background is present without any obstruction and an instance of the player-controlled **Kitty** movie clip symbol instance appears standing upon the ground. That's it! We will be doing most of our work on this screen, adding dynamic text and writing the majority of our code to manage assets and game mechanics.

Finally, let's examine the **End Screen**:

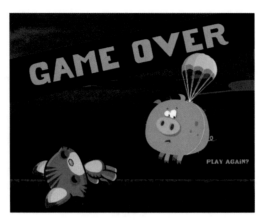

Fig. 10.5 – End Screen

Very similar in function to the **Start Screen** but while that screen is presented to the user initially, this one is presented when the game is over. It includes the background image dimmed with a semi-opaque red shape. There is also a version of the kitty that appears defeated and is laying upon the ground. An instance of the **PigEnemy** movie clip symbol is present as well to further illustrate that the game has concluded. Instead of the game title, we have a banner that reads **GAME OVER**. There is a small text prompt in the lower-right corner that prompts the user to **PLAY AGAIN?** if desired. Of course, none of this is interactive at all just yet.

We are now pretty familiar with the layout and function of each screen and how the timeline has been segmented to represent them. The last thing we need to look at is the project library and see what assets have been prepared.

Exploring the Project Library

Some of the library content, such as the **Kitty**, **PigEnemy**, and **KittyOrb** movie clip symbols, we've already seen within different screens. We also know there is a background image used across all three scenes. Some of these assets have been laid out upon the various screens already, but others will need to be instantiated for more dynamic, gameplay-focused usage – even many of the assets currently being used statically. It's good to keep this in mind as we explore the project library.

Open the **Library** panel and have a look at the assets within:

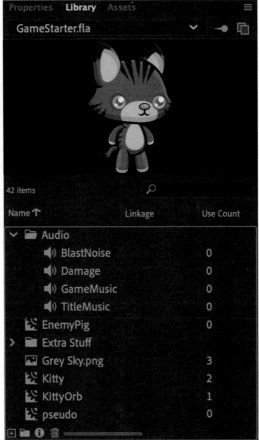

Fig. 10.6 – Project library

The assets you see within the **Library** panel have all been gathered from the **Assets** panel and somewhat reconstructed or rearranged to fit our needs for this game.

All the assets we need for our game are included within the **Library** panel:

- A folder of audio files for music and effects
- A set of movie clips for the player, enemies, clickable areas, and projectiles
- A background image in the form of a bitmap PNG

There is also a folder containing Extra Stuff that can basically be ignored – this contains some of the simpler assets that our more complex assets are constructed of. Some text and additional shape content has been constructed and placed on the stage but does not exist within the library.

Within the **Library** panel is a set of columns. In the preceding figure, we can see columns for **Name**, **Linkage**, and **Use Count**. These are all important when building a game in this way. The function of the **Name** of the symbol is obvious, this is the name we provide when the symbol is created. **Use Count** shows how many times a particular asset appears in some form on the stage, but this only counts objects that are manually placed upon the stage, like everything we've seen so far in our start document. **Linkage** is super-important for our game. This field, which is currently empty for all objects, can be used in conjunction with code in order to dynamically instantiate symbols from the library for use in the game during runtime. It is a very powerful feature and one we will be making use of shortly.

In this section, we opened the starter document and explored the timeline, stage, and library to familiarize ourselves with the assets and constructs that have been arranged for the game we'll be writing. Coming up, we'll perform further preparation across all three of the aspects before writing our JavaScript code.

Preparing the Game Timeline, Stage, and Library

As we've seen, a lot of asset gathering and preparation has gone into our game already. This merely serves as the foundation for the rest of our work in building the game. Elements such as layers to hold identifying labels and code must be created. Space for user interface elements such as dynamic text to relay information to the user during play should be included as well. Finally, clickable elements to start the game from the **Start Screen** or restart it from the **End Screen**. Additionally, we need to make the various items within our library accessible through code.

We will accomplish all of this as we work through the current section of this chapter!

Labeling the Timeline

When developing a game, we need to be able to switch between certain screens, whether we are starting the game, playing the game, or have reached the end of the game. One of the ways in which we can do this is through the use of frame labels. When we provide a keyframe with a label, we are able to target that frame through code.

We also need a layer dedicated to code. It is best practice when programming in Animate to have a layer – often named **Actions** – that contains all of our code and keeps it separated from any visual or animated elements. In this project, we are going to combine both the **Actions** layer and our labeling into a single layer, since they are so closely related.

Let's go ahead and modify the timeline, allowing the insertion of frame labels:

1. Create a new layer and name it `Actions`. Add keyframes at frame 4 and at frame 7:

Fig. 10.7 – Actions layer added with keyframes

This conforms to our previously established screen structure across the timeline. We'll be able to add frame labels to each of these keyframes, which represent each screen, and also include code specific to individual game states.

2. To add a frame label to a specific keyframe, select that frame and look at the **Frame** tab of the **Properties** panel.

3. Locate the **Name** field within the **Label** section to input your label identifiers:

Fig. 10.8 – Adding a frame label

Using the **Name** field of the **Label** section for any keyframe, we are able to direct the playhead to that specific frame through code. Be sure to use the **Type** of **Name** in the drop-down selection below the **Name** input.

Set the following label names across the timeline:

- **Frame 1** – Add a label of `startscreen`
- **Frame 4** – Add a label of `gamescreen`
- **Frame 7** – Add a label of `endscreen`

Notice how the frame labels you've entered appear along the timeline, attributed to each screen we've defined:

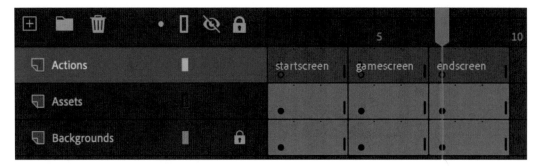

Fig. 10.9 – Our Actions layer with defined frame labels

When we write JavaScript code to move between different screens in our game, frame labels will help us be sure to direct the playhead to the correct frame, regardless of the assigned frame number. We also have specific keyframes to write our code in, directly bound to each screen.

Before moving on, be sure to lock all your layers. This will ensure that we don't mistakenly modify content or add any visual assets to our **Actions** layer, which should contain only code.

With our **Actions** layer created and specific keyframes configured and labeled, we can move on to adding user interface elements across each game screen.

Creating Dynamic Text and Clickable Overlays

We'll now focus our attention on the more dynamic components of our game. We need to create a new layer to contain dynamic text objects that we can write game data to on our **Game Screen** such as health and stats and also set up some clickable elements on our **Start Screen** and **End Screen**.

Let's prepare a layer that will be specifically used to hold our UI elements:

1. Create a new layer and name it UI, as it will contain all the user interface elements of our game:

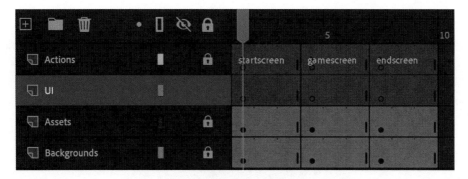

Fig. 10.10 – UI layer added

2. Additionally, add in keyframes at frames 1, 4, and 7, just like every other layer in this project. We will include different interface elements bound to each keyframe. With the three keyframes established, we can now go ahead and add different elements to each screen.

With the UI layer prepared, we can now work on building up the associated elements within this layer. We'll include clickable areas above the existing prompts and dynamic text elements to inform the player as to how they are doing during gameplay.

Let's begin with the **Start Screen**:

1. Select frame 1 of the **UI** layer.

2. You may have noticed a weird symbol in the **Library** panel named **pseudo**. This element is meant to exist as a non-visual, hit-enabled overlay. Drag an instance of this symbol onto the stage atop the **PLAY!** message.

3. Use the **Free Transform** tool to adjust the size and rotation of this instance so that it covers the visual elements of the blast and text:

Fig. 10.11 – Free Transform overlay

4. With the instance selected, look to the **Object** tab of the **Properties** panel and locate the **Color Effects** section. Take the **Alpha** property down to 1%, rendering it invisible. In order to be clickable, the object must not have 0% **Alpha** transparency!

5. We now must provide an instance name in order to be able to address this object through JavaScript code. Give this object an instance name of startbutton:

Fig. 10.12 – Instance name given

The **Start Screen** is now complete. We'll next move along to the **Game Screen** in order to add dynamic text fields to inform the user of both player health and the number of enemies destroyed.

Let's build up our **Game Screen** user interface elements by adding dynamic text objects:

1. First, move the playhead to the middle section of the timeline representing our **Game Screen** and composed of frames 4, 5, and 6. Be sure the **UI** layer is still unlocked and it is the active layer.

2. Select the **Text** tool from the tools panel and look at the **Tool** tab of the **Properties** panel.

3. Up to this point, we have used **Static Text** as we haven't needed to change the value of our text fields at runtime. Now that we need to update things such as player health and the overall score, we'll need to change the text values as the game is played.

 In order to accomplish this, set the text type to **Dynamic Text** in the **Properties** panel.

4. To effectively use **Dynamic Text**, we will need to use a **Web Font** for the text fields we create. To choose a Web Font, click the little globe icon near the font selection dropdown:

Fig. 10.13 – Invoke Google Fonts

This brings up a small overlay that allows us to select a **Web Font** service from a choice of **Adobe Fonts** or **Google Fonts**. Workflows for either are basically identical, so I am going to choose **Google Fonts**.

5. Once a service is selected, a dialog appears that allows you to filter through and search the font library chosen:

Fig. 10.14 – Add a web font using Google Fonts or Adobe Fonts

Locate a font for use within the game, select it, and choose **Done** for **Google Fonts** or **OK** for **Adobe Fonts**. The dialog will close, and the selected font will be added to Animate for use in your project. The **Output** panel will also appear, letting you know the font was added successfully. This is only informational, and you can switch directly back to the timeline.

I'm using a Google font called `Roboto Mono`.

6. Even though the font has been added, it isn't yet active in the **Text** tool. From the **Tool** tab of the **Properties** panel, locate the font selection dropdown and select the web font you just added:

Fig. 10.15 – Font selection dropdown

Web fonts are placed at the very top of the selection drop-down list so it should be very easy to locate.

7. With the font selection process complete, we need to set the remainder of our text properties. I've chosen white (#FFFFFF) for my fill color and have set the size value to 14 pt:

Fig. 10.16 – Text Tool properties

8. Click and drag across the upper-left corner of the stage (release the mouse around the midpoint of the stage) to add **Paragraph Text** with a set width. It should be about as wide as half the stage.

9. Type Health within the text object, as this will display the current player health. Within the **Paragraph** section of the **Properties panel**, be sure to set the text to align to the left.

10. To make the text stand out better against the background, you can add a **Drop Shadow** filter. With the text object selected, look to the **Object** tab of the **Properties** panel and click the **Add Filter** button and choose a **Drop Shadow** filter with the default settings:

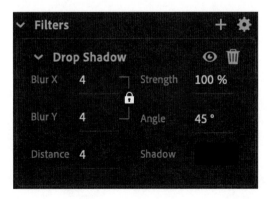

Fig. 10.17 – Drop Shadow filter

11. With one text field complete, we'll now copy it to create the second. Duplicate the text field by holding the *Alt* key and click-drag a copy onto the opposite side of the stage.

12. Change the text within the new text object to a value of `Blasted` and in the **Paragraph** section of the **Properties** panel, set the text to align to the right.

13. The final task in preparing our **Dynamic Text** objects is to provide a unique instance name for each one. Select the text that reads `Health` and in the **Object** tab of the **Properties** panel, input an instance name of `healthdisplay`. This will be used to let the user keep track of player health.

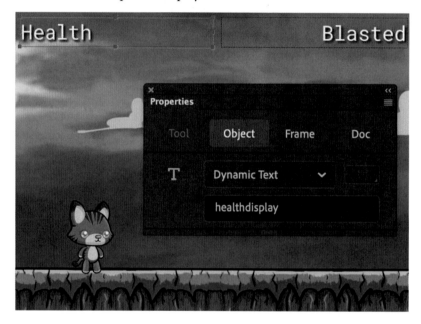

Fig. 10.18 – Instance name provided

An instance name allows us to manipulate the **Dynamic Text** object through code. Be sure to add another instance name to the second text object that reads `scoredisplay`. This will eventually reflect the current score.

We'll next complete the interactive setup for this game by adding a clickable replay option to the **End Screen**:

1. Select frame 4 of the **UI** layer. It is a good idea to ensure any other layer is locked.

2. We'll use another instance of the **pseudo** symbol, just like we did for the **Start Screen**. Drag it from the **Library** panel onto the stage over the **PLAY AGAIN?** message.

3. Use the **Free Transform** tool to adjust the size and rotation of this instance so that it covers the visual elements of the messaging:

Fig. 10.19 – Transform overlay across the prompt

4. With the instance selected, look at the **Object** tab of the **Properties** panel and locate the **Color Effects** section. Take the **Alpha** property down to 1%, making it basically invisible.

5. We will now provide an instance name in order to be able to address this object through JavaScript code. Give the object an instance name of `reduxbutton`.

That should take care of the user interface elements across all three states of our game:

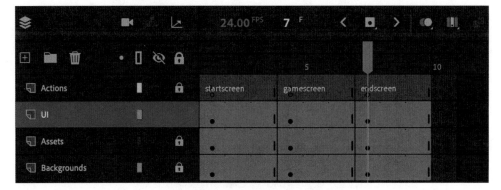

Fig. 10.20 – The completed timeline

The **Start Screen** and **End Screen** both have what will eventually be clickable elements and the **Game Screen** is ready to program.

The next thing we need to do is supply similar linkages through the **Library** panel.

Adding Linkage IDs within the Library

When building our game, we'll need to create instances of different objects such as enemies and projectiles on the fly, during runtime. In order to instantiate symbols in the library on the stage as the game is in play, we must first provide **linkage IDs** to each item we want to address via JavaScript.

The **Linkage** column will, by default, display to the right of the **Name** column within the **Library** panel:

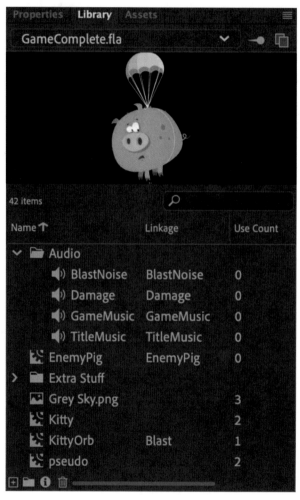

Fig. 10.21 – Linkage IDs are assigned

Inputting a linkage ID is a simple action. Just double-click within the **Linkage** column aside each item you want to provide a linkage ID for. You can assign these IDs to both symbols and audio files for programmatic playback.

Set the following linkage IDs within the game project:

- **BlastNoise** – Assign a linkage ID of `BlastNoise`. This will be used when the kitty shoots a projectile into the sky.

- **Damage** – Assign a linkage ID of `Damage`. This will be used when a pig enemy breaches the stage.

- **GameMusic** – Assign a linkage ID of `GameMusic`. This will be used for the general gameplay music.

- **TitleMusic** – Assign a linkage ID of `TitleMusic`. This will be used as the music for both the start screen and end screen.

- **EnemyPig** – Assign a linkage ID of `EnemyPig`. Enemies will be generated randomly and move toward the ground.

- **KittyOrb** – Assign a linkage ID of `Blast`. This is the projectile fired by the kitty to stop the enemies from reaching the ground. Note that the linkage ID can be the same as or differ from the symbol name.

You might have noticed the actual **Kitty** Movie Clip symbol does not receive a linkage ID even though it serves as the player. Instead of providing a linkage ID to the symbol, since there is only a single player object, we will give the **Kitty** symbol instance already on the stage an instance name in order to control it through code.

Select the **Kitty** instance on the stage at frame 4 and provide an instance name of `player`.

In this section, we completed all game preparations upon the stage, timeline, and library in various ways to make our content addressable through code in the application of frame labels, linkage IDs, and instance names. Coming up, we'll write all the JavaScript code necessary for our game to function.

Programming the Game with JavaScript

As mentioned in the previous section, *Preparing the Game Timeline, Stage, and Library*, since we are targeting the native web with an HTML5 Canvas document, we'll be programming our game with JavaScript. Most code in Animate is bound directly to specific keyframes and is executed when the playhead reaches that frame.

The code we will write is composed of **variables** and **functions**. When we want to hold data or change data, we use variables. The first time a variable is declared, we use the keyword `var`. When we need to group a set of instructions together to perform a task, we group them all within a function and then invoke that function when we want to execute the code.

As we start building the code for our game, recall that certain objects exist on the stage already and have been given instance names to allow us to manipulate them. In addition to this, there is a set of objects that only exist within the library and have been given linkage IDs that will allow us to create instances of these symbols and sound files at runtime.

The first step in our programming journey is to establish a set of global variables in our game. We'll do this next since many other bits of code will rely on these variables.

Creating Global Variables

Document types that support JavaScript, including HTML5 Canvas, have the ability to use **Global Scripts**. Any code placed within the **Global | Script** section of the **Actions** panel is unique, in that the code there is not bound to any specific frame on the timeline. The reason this is so important is that when variables and functions are defined as **Global**, they can be accessed from any nested timeline or varied scope within a project.

To add code to the global scripts area, open the **Actions** panel (**Window | Actions**) and twirl down the **Global** category in the left-hand column:

Fig. 10.22 – Actions panel global scripts

Selecting **Script** and writing your code in the code editor will establish the variables and functions you create as **Global** in the scope.

We will declare a set of variables within this area, so they are accessible throughout our game. Enter these declarations into the script editor:

```
var _this;
var stagew;
var stageh;
var health;
var score;
```

These five variables are simply declared here and will be populated with data values from within the frames-based code of our game. We will explore exactly what the data values and other references are intended for once we declare them as part of the **Start Screen**.

It is often helpful to keep small utility functions as global as well. We'll declare a function called `randomize` that can be accessed across our game. Enter the following code in the same **Global** scripts area along with the previously defined variables:

```
function randomize(min, max) {
    return Math.round(Math.random() * max) + min;
}
```

The `randomize` function accepts a minimum and maximum number value and returns a random number between them. This is great for randomizing the value of position, scale, opacity, and so on.

> **Note**
>
> You likely have noticed the other option within **Global** called **Include**. The **Include** option allows you to link external JavaScript files into your project for use within a game or application. For instance, you could import a JavaScript-based game engine or some sort of effects library here for use within your game!

With our global variables and a global function established, let's move our attention to programming the **Start Screen** and game initialization functionality.

Programming the Start Screen

The **Start Screen** is pretty simple in terms of user-facing functionality but there is a bit more we need to do here than account for a single button-press to start the game. We'll also look at the one-time establishment of core game data structures and make it possible to re-initialize the game parameters for this screen.

The first code we write in frame 1 of the **Actions** layer mostly defines values for our **Global** variables. Type the following code into the script editor:

```
if (_this == undefined) {
    _this = this;
    _this.stop();
    stagew = stage.canvas.width / window.devicePixelRatio;
    stageh = stage.canvas.height / window.devicePixelRatio;
```

```
        createjs.Sound.play("TitleMusic");
}
```

There are a set of important variables we need to set right from the start as these will be used on every screen of our game and, for the most part, correspond with the Global variables already declared.

We only need to execute these assignments when the game first loads though. There is no need to declare the game width and height or preserve reference variables at any other time – these stay the same no matter what and do not change value. To ensure we only perform these assignments once, never to be repeated, we check to see whether we've assigned a reference to _this yet by checking if (_this == undefined) {}. If we haven't, it returns undefined and we can safely assign the references and data.

In the code block that follows, we first set _this to refer to this, which preserves a reference to the main timeline since that is where we currently are, in the global scope. We can now make use of _this to invoke stop(), which immediately stops the playhead at frame 1. We then preserve the width and height of the game stage in order to perform various calculations in our code against player, enemy, and projectile positions.

> **Note**
>
> Notice that we divide the actual canvas width and height by the device pixel ratio. The devicePixelRatio property will normally return either 1 or 2. The reason this is necessary is in order to target both retina and non-retina screens as browsers will increase the <canvas> pixel density when necessary. This ensures our calculations will be correct.

The last thing we do is play the **Start Screen** music. Our sound object has been given the linkage ID of TitleMusic in the library, so we can easily reference it and begin playback here. We do so by invoking the play() method within createjs.Sound, which taps directly into the audio management capabilities of CreateJS and SoundJS.

When a user clicks the **PLAY!** button, we need to switch to the **Game Screen**, but we'll also use this opportunity to set up additional items within the game. Type the following code below the existing code:

```
_this.startbutton.on('click', function () {
    init();
});
function init() {
    health = 3;
```

```
    score = 0;
    createjs.Sound.stop("TitleMusic");
    createjs.Sound.play("GameMusic");
    _this.gotoAndStop("gamescreen");
}
```

If you recall, we gave our PLAY! object an instance name of startbutton so that it could be addressed with code. The first thing we do is create an event listener on this object and have it run a function called init(), which will initialize and start the gameplay.

The init() function itself sets initial values for the player health and the game score. The useful thing about setting values for things such as health and score in this way is that it can effectively reset the game whenever it is clicked, restoring player health and resetting the score.

We also stop the TitleMusic, which is already playing, and then immediately play the GameMusic right before moving the playhead to the **Game Screen** at the frame 4 keyframe, which includes the frame label of gamescreen.

The **Start Screen** programming is now complete. We'll next move on to gameplay and begin by focusing on player movement.

Programming player actions

In the game, we want the player instance to be able to move back and forth across the bottom of the stage based on directional arrow keypresses. We also need the player to fire projectiles up to the sky to eliminate enemies.

Select the keyframe at frame 4 of the **Actions** layer and type the following:

```
window.addEventListener("keydown", handleKeys);
function handleKeys(e) {
    var newPosition;
    if (e.keyCode == 37) {
        newPosition = _this.player.x - 30;
        if (newPosition <= 0) {
            newPosition = 0;
        }
        createjs.Tween.get(_this.player, {override: true}).
to({x: newPosition}, 300, createjs.Ease.quintOut);
        _this.player.play();
```

```
                    _this.player.scaleX = -1
            } else if (e.keyCode == 38) {
                fireWeapon();
            } else if (e.keyCode == 39) {
                newPosition = _this.player.x + 30;
                if (newPosition >= stagew) {
                    newPosition = stagew;
                }
                createjs.Tween.get(_this.player, {override: true}).
to({x: newPosition}, 300, createjs.Ease.quintOut);
                _this.player.play();
                _this.player.scaleX = 1
            }
        }
```

We add an event listener to `window`, so that any part of the browser viewport can listen for keypresses. We have it listen for a `keydown` event and when that occurs, invoke a function named `handleKeys`.

Within the `handleKeys` function, we detect which key was pressed by tapping into the event data that is captured by the keypress and reading the `keyCode` property within. This is numeric code that tells us exactly which key was pressed. The left arrow key is 37, the up arrow key is 38, and the right arrow key is 39. Depending upon which of these three keys is detected, our code responds differently.

If a left or right arrow press is detected, we set a variable called `newPosition`, which is calculated based on the direction and represents where the character should end up on the stage. The new position will be 30px to the left or 30px to the right. Here, we compare the new position to the previously calculated stage width (alternatively, the left of the stage at 0px) to ensure the player does not move off the screen. Additionally, if an up arrow press is detected, a function called `fireWeapon()` is invoked. We will create that function in a bit.

To animate the character moving, we invoke the `play()` method on the player instance and also adjust the `scaleX` property to force the instance to face the correct direction when walking. To actually move the player to a new position, we use the `Tween` command in `CreateJS`. This command accepts a reference to an instance on the stage and tweens it along to a different position. We can set the length of time this will take, in milliseconds, and even apply `Ease` presets from `CreateJS` as part of the command.

If you were to test the game right now, the `player` instance's internal animation would be constantly looping since it is a Movie Clip symbol. We only want this to play when the user interacts with the arrow keys, so need to stop the internal animation.

Double-click the **Kitty** symbol in the **Library** panel and type the following code in the **Actions** layer at frame 1:

```
this.stop();
```

This will effectively stop the walk cycle until we give the command for it to `play()` through the movement code. Once it hits frame 1 after playing, it will stop once again.

As part of our keypress listener, we invoke a function called `fireWeapon()` when an up arrow keypress is detected. We need to instantiate projectiles when this occurs and have some way of managing them as well.

Add a few line breaks below the `handleKeys()` function and enter the following lines of code below it:

```
var blasts = new createjs.Container();
stage.addChild(blasts);
function fireWeapon() {
    var blast = new lib.Blast();
    blast.x = _this.player.x;
    blast.y = _this.player.y;
    blasts.addChild(blast);
    createjs.Sound.play("BlastNoise");
}
```

The first thing we do is create a `CreateJS Container` for our projectile `Blast` instances. By adding the instances to a `Container` in this way, we are able to keep track of and check the properties of each `Blast` instance in a loop later on. The Container is added to the stage.

The `fireWeapon()` function creates a new `Blast` instance from the library through use of the given linkage ID. We then set the position just atop the player instance and add the new `Blast` instance to our `Container`.

Lastly, we generate sound playback from the library so the firing of the projectile makes an audible sound.

Projectiles are to be fired against an invading set of enemies. We'll next write the code to generate the enemies for our game.

Programming Enemy Behavior

The enemies in this game are pigs that parachute down from the sky. Their goal is to reach the ground beyond the height of the stage and the player's goal is to shoot them out of the sky before that happens.

To generate our enemies, we'll create an `addEnemy()` function that can be called from within our eventual game loop, as enemies are needed. Type the following below the previous code block:

```
var enemies = new createjs.Container();
stage.addChild(enemies);
function addEnemy() {
    var enemy = new lib.EnemyPig();
    enemy.x = randomize(50, stagew - 50);
    enemy.y = randomize(100, 2000) * -1;
    enemy.speed = randomize(0.5, 3);
    var direction = randomize(-1, 2);
    if (direction == 0) {
        direction = -1;
    }
    enemy.scaleX = direction;
    enemy.gotoAndPlay(randomize(1, 120));
    enemies.addChild(enemy);
}
```

Enemies are added to a `Container`, much like the `Blast` projectiles are, and for the exact same reasons. When we write the game's heartbeat function, or game loop, we can constantly monitor both enemies and projectiles and respond to collisions, movements, and boundary extremes.

Within the `addEnemy()` function, we instantiate `EmemyPig` from the library and then make heavy use of the global `randomize()` function in order to add some variability to the enemy position, fall speed, facing direction, and internal animation starting frame. Lastly, we add the new `EnemyPig` instance to our `Container` with these given properties.

At this point, our player character is set up with a full move set, projectiles can be generated, and enemies can be spawned as well. The game loop ties all of this together and that is what we will write next.

Programming the Game Loop

The game loop (or heartbeat) is a function that runs continually and monitors the game environment for changes. When changes are discovered, a set of additional instructions are executed as the program requires. The game loop brings everything together in a meaningful way and controls all the reactions between elements within the game structure.

To begin writing our game loop, we make use of the `CreateJS Ticker` (which in Animate is bound to our document's FPS value) and a function that executes at every `tick`.

Write the following JavaScript below any previous code:

```javascript
var heartbeat = createjs.Ticker.on("tick", gameLoop, _this);
function gameLoop(e) {
    _this.healthdisplay.text = "Health: " + health;
    _this.scoredisplay.text = "Blasted: " + score;
    /* BLAST MANAGEMENT PLACEHOLDER */
    /* ENEMY MANAGEMENT PLACEHOLDER */
}
```

It is important to give your `Ticker` listener an identifier so that we can properly manage it later on. We set the listener to a new variable called `heartbeat` here, which will allow us to easily turn off the game loop once a game over occurs.

The game loop can also be made to constantly monitor and update things such as player `health` and overall `score`. Recall that we created dynamic text fields upon the stage for each and gave them both instance names. This allows us to output `health` and `score` data within related text objects to let the player know how the game is going.

Following this are two placeholder `comment` blocks. Comments in JavaScript are not executed but can serve as developer notes or placeholders like this. Single-line comments in JavaScript are written like this: `// COMMENT`, whereas multiline comments are written like this: `/* COMMENT */`. Of course, you can use multiline comments for a single line as well.

The first of these comments has to do with projectile monitoring and management. Delete that comment and type the following code in its place:

```javascript
for (var i = blasts.numChildren - 1; i >= 0; i--) {
    var b = blasts.getChildAt(i);
    b.y -= 10;
```

```
if (b.y < -50) {
    blasts.removeChild(b);
}
var blastTarget = enemies.getObjectUnderPoint(b.x, b.y, 0);
if (blastTarget) {
    enemies.removeChild(blastTarget.parent.parent);
    blasts.removeChild(b);
    score++;
}
}
```

We begin this code block with a `for` loop. The `for` loop is constructed as follows:

```
for(index; condition; adjustment){ body }
```

- For our `index`, we set variable `i`, which is assigned the number of projectiles within their `Container` minus 1. We remove one because we want the `index` of the projectile and not the total number of projectiles. If there are no projectiles present within the `Container`, the index value will be `-1`.

- `condition` checks to see if our index value is greater than or equal to 0. Indexes in JavaScript begin with 0 and count upwards, so an index of 1 is actually the second spot and not the first, which is 0.

- Finally, we make an `adjustment` to the index value for the next iteration of our loop. In this case, we decrement the index value by `1` each time the loop runs. When all projectiles have had their turn, the loop terminates.

- Within the curly braces is the `body` of our loop, which runs once for each loop iteration.

Within each loop iteration, we begin by creating a reference to a specific projectile with `getChildAt()`. Passing in the current index, we target a specific projectile instance within the `blasts Container`.

Once we have the reference established, we can manage the blast projectile. We set a new position for the projectile that is `10px` closer to the top of the stage than it currently is. We then check the position to see whether it has gotten so high as to have left the stage. At that point, we remove the instance entirely.

The last block of code is all about collision detection. We use the `getObjectUnderPoint()` function of CreateJS to check and see whether the position of the projectile overlaps with any of our enemy instances. If it does, we remove the enemy it collided with, the projectile itself, and increment our `score` by a value of `1`.

The second comment placeholder in our game loop has to do with enemy monitoring and management. Delete that comment and replace it with the following:

```
for (var i = enemies.numChildren - 1; i >= 0; i--) {
    var e = enemies.getChildAt(i);
    e.y += speed;
    if (e.y > stageh + 50) {
        enemies.removeChild(e);
        health--;
        /* GAME OVER DETECTION PLACEHOLDER */
    }
}
if (enemies.numChildren < 10) {
    addEnemy();
}
```

Very similar in construction to our projectile management loop, we manage enemies in a `for()` loop as well. The logic is exactly the same, except we are performing the loop against the `enemies Container`.

Here, we move each enemy down the stage toward the bottom by a number based upon the random `speed` value that was assigned upon generation. If the enemy position is more than `50px` below the stage bottom, we remove the enemy instance and decrease the player's `health` by 1 point. It is at this time that we can also detect whether the health is low enough for a game over, but that is a placeholder comment for now.

Following the `for()` loop, we do a simple check to see whether the number of enemies we currently have at play is less than `10`. If it is, we invoke `addEnemy()` to add another. Since this is part of the game loop, enemies will be constantly generated as the need arises.

The last bit we need to write is the game over detection and cleanup script. Replace the game over detection comment with the following code block:

```
if (health <= 0) {
    createjs.Ticker.off("tick", heartbeat);
    window.removeEventListener("keydown", handleKeys);
    stage.removeChild(enemies);
    stage.removeChild(blasts);
    createjs.Sound.stop("GameMusic");
    createjs.Sound.play("TitleMusic");
    _this.gotoAndStop("endscreen");
}
```

The only condition for a game over is if the player's `health` drops to `0`. When that happens, we disable the `Ticker` so the game loop no longer runs, remove the `keydown` listener, remove all instances of enemies and projectiles by removing their associated `Containers`, stop the `GameMusic` playback, play the `TitleMusic` again, and send the playhead to the **End Screen**. This effectively ends the game.

With the **Game Screen** code in place, all we need to do is program the **End Screen** events and the entire game is complete!

Programming the End Screen

The **End Screen** contains the least amount of code of any of our game screens since all we have to do is add an event listener to detect whether the player wants to go another round.

Select the keyframe at frame 7 of the **Actions** layer and write the following within the script editor:

```
_this.reduxbutton.on('click', function(){
    _this.gotoAndStop("startscreen");
});
```

This should be easy to interpret by now. The Movie Clip instance with the instance name of `reduxbutton` is given an event listener of type `click`. Once a click is detected, we go back to the **Start Screen**.

Once on the **Start Screen**, the initial setup is ignored since those references already exist. When the player clicks the `startbutton` again, `health` and `score` are reset to their default values and the game begins again.

In this section, we programmed an entire game using JavaScript for the native web. We examined how to write code to control existing elements on each screen, how to generate new elements from the document library, and how to write a game loop and associated logic to monitor and respond to all sorts of game events. Coming up, we'll consider a few things to finish the project in Animate through **Publish Settings**.

Finishing the Game Project

Now that the code has been written and the game is functionally complete, it makes sense to look back across everything we've done and reflect upon how it is all organized within Animate.

Have a look at the **Actions** panel now that the game has been written:

Fig. 10.23 – Code bound to specific locations

Notice that in the left-hand column of the **Actions** panel, specific chunks of code are listed and organized according to the specific objects, layers, and frames they have been bound to. We have global script code, code segmented across the main timeline, and a bit of code within a symbol. It all works together to create a cohesive gameplay experience!

To finish up the project, there are a few considerations you may want to look over to add some extra polish to how the game is published.

Open the **Publish Settings** dialog by choosing **File | Publish Settings…** or from the **Doc** tab of the **Properties** panel under **More Settings…**:

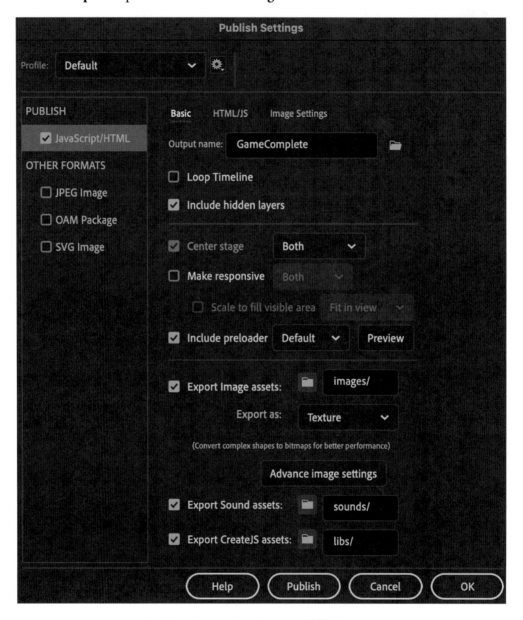

Fig. 10.24 – HTML5 Canvas Publish Settings

There are a lot of options here, as we discovered in *Chapter 4, Publishing and Exporting Creative Content*. For our game project, let's choose to **Center stage** and **Include preloader** for our options. This will center the game on the HTML page that is generated and add in a little preloader animation to let the user know the game is loading.

In this section, we finished our game project by looking over the organization of the code we've written and by tweaking our **Publish Settings** to provide the user with a more refined game experience.

Summary

We accomplished so much in this chapter! We began by examining the starter document, which already had a number of assets in place, all derived from the **Assets** panel. We then went through each screen and library item in order to further organize our timeline with frame labels and to provide instance names and linkage IDs where needed. The bulk of our time in this chapter was spent in the **Actions** panel writing all the JavaScript code that controls the player character, enemy and projectiles, internal variables and references, and how all of these elements interact with one another to produce a full game experience for the web. Closing out, we gave the **Publish Settings** a quick look and adjusted some of the attributes for our published game content.

In the next chapter, we'll explore a somewhat related web-based project in the form of **Virtual Reality** experiences using **WebGL glTF** document types.

11
Producing Virtual Reality Content for WebGL

In the previous chapter, we explored the concept of game development for the native web and programmed an entire game using JavaScript and the **HTML5 Canvas** document type.

This chapter will focus on the **virtual reality (VR)** and **WebGL glTF** document types within Animate. Virtual reality is cutting-edge technology and Animate has its own take on this space using both panoramic and 360-degree **VR** concepts. We'll get an overview of the VR document type within the software and then move directly on to assembling our virtual reality environments with scenes and textures. Once the environments are established, we'll add in additional assets as part of each scene, animate them using the **Asset Warp** tool, and write code to allow interaction with the user. Finally, we'll explore a panel in Animate specifically for testing and adjusting VR content.

After reading this chapter, you'll be able to perform the following functions in Animate:

- Discover a variety of VR and WebGL document types in Animate and how to create content specifically for each format.

- Understand specific workflows for creating, managing, and testing VR environments.

- Use the **Asset Warp** tool and **warped object** workflows to produce subtle animations on imported drawings.

- Write code that allows the user to move between scenes and interact with objects.

Technical Requirements

You will need the following software and hardware to complete this chapter:

- Adobe Animate 2021 (version 21.0 or above)

- Refer to the Animate System Requirements page for hardware specifications: `https://helpx.adobe.com/animate/system-requirements.html`. The CiA video for this chapter can be found at: `https://bit.ly/3af4qgw`.

Overview of Virtual Reality Documents

In this section, we are going to get an overall idea of the VR document types within Animate and how they relate to one another. Following this, we'll see how to configure scenes in our project and apply photographic background textures to those scenes.

Though separated into two distinct classifications, both the VR and WebGL document types are based upon the WebGL glTF standard at their core. When using VR document types, we get a few extra workflow choices within Animate as opposed to the more general WebGL glTF document types.

> **Tip**
> To learn more about the WebGL glTF specification, visit `https://www.khronos.org/gltf/`.

All of the VR and WebGL document types can be found under the **Advanced** category of the **New Document** dialog:

Fig. 11.1 – Both the VR and WebGL document types are considered BETA

While we will be focusing on virtual reality projects in this chapter, it is important to understand that these document types are built on a standard WebGL glTF foundation. The WebGL glTF specification is basically a platform-agnostic asset delivery format specifically geared toward **3D** and **GPU**-accelerated content.

Here are the differences between these four choices, in order of complexity:

- **WebGL glTF Standard**: Conforms to the standard specification and can be played back in any environment that supports standard WebGL such as the Babylon.js Sandbox: `https://sandbox.babylonjs.com/`.

- **WebGL glTF Extended**: Builds upon the standard specification by extending it for fuller usage within the Animate environment to include things such as interactivity.

- **VR Panorama**: Adds extra tools in Animate to define layers as cylindrical VR textures and makes use of the **VR View** panel for positioning symbol instances in 3D space and testing projects.

- **VR 360**: A variant of the **VR Panorama** document that applies the VR textures to a sphere in place of a cylinder.

There are also a set of limitations to consider for each of these platforms. For instance, **WebGL glTF Extended** allows the use of **Button** symbols, but both VR formats do not! When it comes to sound, the VR formats can only make use of **Event Sync** when it comes to sounds. An additional limitation is that all four document types only allow **Static Text**. Remember again, all four of these formats are in beta and limitations are to be expected.

Note

Depending upon the type of project you'd like to work on, you can create either a **VR Panorama** or **VR 360** document. Aside from a few small differences, they function the same. I've included assets for either format in the files for this chapter, which can all be downloaded from `https://github.com/PacktPublishing/Mastering-Adobe-Animate-2021`.

Let's create a new virtual reality document in Animate to work with in this chapter:

1. Create a new document by choosing **File | New** and clicking the **Advanced** category of the **New Document** dialog.

2. Choose either **VR Panorama** or **VR 360**, noting that both are considered beta. The beta label indicates that Adobe is still working on these document formats and that certain aspects may change in future releases of Animate.

3. Check that the document properties are set to 550px in width and 400px in height with a framerate of 24fps. We will need to adjust these settings later but the default is fine for now.

4. Click **Create** and save your new document via **File | Save** once it appears in Animate.

The new document is pretty plain right now and looks just about identical to any other freshly created document in Animate.

Now that we have our document created, we can move along and start preparing it for use aligned with our project concept.

Managing Scenes for Virtual Reality

The use of **scenes** in VR projects is not required but they allow some pretty interesting user experiences. For instance, you can allow the user to explore the experience and, by interacting with different objects in the world, they can travel to additional rooms and environments. In our project, the user will be able to move from a park to a pond and back again.

Traditionally, scenes within an Animate document break the main timeline into manageable chunks. So an animator might create one scene as an establishing shot and then have the second scene serve as a tighter shot focused on some action or a character.

> **Note**
> HTML5 Canvas and WebGL glTF Standard documents cannot make use of the scenes feature within Animate, but just about every other document type can! Scenes effectively break the main timeline up into segments and were originally used to construct scenes within a running animation.

As mentioned, we will include two scenes within this project, so let's create those now:

1. Open the **Scene** panel by choosing **Window | Scene** from the application menu:

Fig. 11.2 – Scene panel

The **Scene** panel appears. This panel allows you to create, duplicate, and delete scenes. You can also reorder and rename scenes from here.

You should only have a single scene named **Scene 1** when you first start out. This is basically your main timeline.

2. Double-click upon **Scene 1** and type in a new name of Park. This will contain all assets related to the park-based environment we create.

3. Click the **Add Scene** button that appears as a small plus icon in the lower-left to create a new scene.

4. Rename your new scene to Pond:

Fig. 11.3 – Scene management

Like layers, library items, frame labels, and such, it is always a good idea to name your items in a way that provides organization and helps with recollection.

Clicking on either scene name within the **Scene** panel will switch to that particular scene. You can also switch scenes through the use of the **Edit Scene** selector above the stage:

Fig. 11.4 – Scene switcher

Of course, you can include as many scenes as you like within a project like this. We are going to stick with two here and keep things fairly simple.

Now, before we start importing image content into our project, it is good to get familiar with how you can acquire or generate your own photography for tasks like this.

Capturing Photographs for Virtual Reality

While you can get 360 **equirectangular** and **panoramic** photographs from various stock photo services, it is always good to know how to generate your own – especially for projects like this. With VR documents in Animate, you need to use something for your environmental texture. If targeting VR 360, the texture is wrapped across the inside of a sphere with the user viewing from the center outward. For VR Panorama, we wrap our texture across the inside of a cylinder instead.

> **Note**
> You can also simply draw out your own content for VR textures using software such as Adobe Photoshop, Illustrator, or even within Animate itself! It all depends on whether you want your environment to be photorealistic or not.

In the exercise files for this chapter, you will find examples of the same scene captured in both equirectangular and panoramic formats.

The easiest way to understand each is probably to just open them up and have a look:

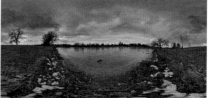

Fig. 11.5 – Panoramic versus 360 photograph

The panoramic image is very wide without much height and includes a bit of distortion to the perspective when viewed as a flat photograph. The 360 equirectangular photo will always present itself in a 2:1 ratio of width to height and is massively distorted when viewed as a flattened photograph.

With modern mobile devices, it is actually a very easy task to capture these types of photographs. It is a bit of a tedious process with Android or iOS, as you must use camera software that can guide you to generate these photos based upon the capture and integration of multiple shots to compose the image.

> **Tip**
>
> Mobile device camera software normally does a fine job, but for even greater precision and ease, you can use hardware that is made specifically to shoot photos using these modes. Generally, I'd suggest using what you have first and upgrading if needed.

I captured the sample photographs using a Google Pixel 3 XL running Android 11 and using the native camera application:

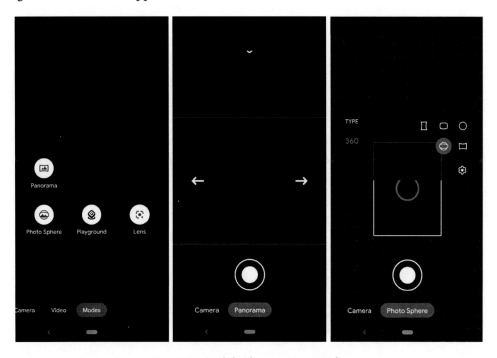

Fig. 11.6 – Mobile phone camera modes

The preceding screenshots should provide a good idea of what is available for this sort of image capture on mobile devices today. As you can see in the first screenshot, the camera app has a number of modes to choose from. I can access both **Panorama** and **Photo Sphere** from the **Modes** option on this screen.

With **Panorama** selected, you simply press record, and the software guides your movements in order to capture a full panoramic image. You stand on one spot and rotate slowly in one direction until you've captured the entire view.

For **Photo Sphere**, you may need to check your options, as displayed in the preceding screenshot, to ensure that you are creating a **360** photograph and not some other format. Once you press record, the software will prompt you to turn your camera toward different spots in order to capture a full set of photographs to stitch into a proper equirectangular image.

With our panoramic and equirectangular images on hand, we are ready to return to Animate and integrate them into the scenes we have created.

Adding Textures to Virtual Reality Scenes

Probably the most important step in creating a VR environment with Animate is to implement the photographic content we've gathered as textures. These textures define the background of the world we create within each scene.

To define a photograph as a texture, we take the following steps:

1. Make sure you are currently in the **Park** scene and if not, switch to it using the scene switcher above the stage.

2. Locate the appropriate park photograph in your file system. I'm using the file named `PXL_20201223_195419259.PHOTOSPHERE.jpg` since I am using a **VR 360** document type.

3. Drag your image file from the file system and onto the Animate stage.

4. Select the new bitmap object on the stage and look at the **Object** tab of the **Properties** panel. Set the **x** position to 0 and the **y** position to 0. You could also use the **Align** panel to align it to the top left.

 Looking at the stage at this point, you will notice the photograph is much, much larger than our tiny stage. If using the equirectangular photograph, for instance, the stage width is 550 but the bitmap object width is 4000! We need to adjust our stage size to perfectly match the bitmap object size.

5. Select the **Doc** tab of the **Properties** panel to view document properties and locate the **Document Settings** section.

6. Click the **Match contents** button to resize the stage in accordance with its contents:

Fig. 11.7 – Adjusting the stage size to Match contents

The stage width and height are automatically set to match the width and height of the bitmap object.

7. We will now mark our layer to be used as a texture when published. Click the **Mark for Texture Wrapping** option within the **Layer_1** layer:

Fig. 11.8 – Mark for Texture Wrapping

This marks the layer for texture wrapping and the contents of the layer, in this case, an equirectangular photograph, will be used across the inside of a sphere. The distorted, flat photograph will appear with normal proportions when wrapped as a texture, but you will not see these effects until you test.

8. You will want to rename the layer named **Layer_1** to `Texture` for clarity before moving on.

The **Park** scene is now set up with a photographic texture. You will need to switch over to the **Pond** scene and perform the same set of steps there.

> **Note**
> You can mark as many layers as you want in this way but once a layer is marked as a texture, any animation or interactivity that was present in the layer will be disabled.

Once you've completed both scenes, they should each contain a single layer named **Texture**, which is marked as a texture. Each scene includes either a photograph of the pond or a photograph of the park, in accordance with the scene name.

Again, you can use either the panoramic or equirectangular versions of these photographs for your content:

Fig. 11.9 – Panorama versus 360 differences

If you choose **Fit in Window** from the **Zoom** dropdown in the upper-right area above the stage, you will see the full scene. Aside from the perspective differences between the VR Panorama and VR 360 document types, everything else should be the same no matter what document type you have chosen.

> **Note**
>
> For the remainder of this chapter, I'm going to focus on the VR 360 version of our document, but any of the steps that follow can be used on either document type.

You can actually perform a **Test Movie** right and your VR experience is fully workable just through this initial setup of importing photographs and marking them as texture layers. When viewing in the web browser, simply click and drag across the environment to change your view within the environment.

In this section, we had an introduction to using virtual reality within Animate and how it relates to WebGL glTF file types and saw how to manage scenes within a VR document. We then explored the use of mobile device cameras to gather our own photographs suitable for VR use as textures and imported those photographs into our VR documents to be used as textures within each scene. Coming up, we'll add some additional visual content to our VR scenes through the use of imported 3D renders and create some animated content using the **Asset Warp** tool.

Adding Additional Content

As we saw in the previous sections, the simple act of importing properly generated photographs as textures within a virtual reality document goes quite far in establishing our VR environment. This is Adobe Animate though and we are able to add additional objects to our scene to be used for the purposes of interactivity and animation!

We'll first set up some additional objects to eventually be used to move between the **Park** and **Pond** scenes in the form of 3D rendered signage. Then, we'll get playful and add a small character drawing that can be animated using one of the most powerful creative motion tools in Animate – the **Asset Warp** tool.

Importing Transparent 3D Renders

Recall that we have two scenes established for our virtual reality experience: **Park** and **Pond**. We ultimately want the user to be able to locate a sign within each scene that directs them to the other scene. Clicking a sign will transport the user to the other scene.

To create the signage assets, I used **Adobe Dimension** to configure and generate 3D models, which were then rendered as transparent PNG files. Dimension comes packed with a set of models, materials, and more to be used in the creation of 3D scenic renders.

> **Tip**
>
> To learn more about Dimension, visit the following URL: `https://www.adobe.com/products/dimension.html`.

These renders have been made available alongside the photographs in the exercise files for you to download and are named `ParkSign.png` and `PondSign.png`.

Let's set up our signage for each scene:

1. Insert a new layer above the **Texture** layer by clicking the **New Layer** button.

2. Name the new layer `Sign` as this will contain our interactive signage:

Fig. 11.10 – Sign layer added across scenes

3. Locate the `ParkSign.png` and `PondSign.png` image files within your file system and drag each into the appropriate scene. `ParkSign.png` should be placed in the **Pond** scene and `PondSign.png` goes in the **Park** scene.

4. Once the sign images have been placed on the stage, within the **Sign** layer of each scene, you'll want to reposition them to areas that make the most sense:

Fig. 11.11 – Position the signs properly in each scene

I placed my `ParkSign.png` at an **x** of 460 and a **y** of 930. My `PondSign.png` is placed at an **x** of 3450 and a **y** of 958. You might also choose to resize the signs, but I left them at their native size in my examples.

The signs are now placed within each scene but are only decorative at this point. We will make them interactive later on in this chapter.

> **Note**
>
> Since we are dealing with WebGL glTF as the basis of our VR experience, we can also import **GLB** and **GLTF** models for use directly within Animate! However, they are a bit buggy when used within VR documents and sometimes will not render properly. This is why we are using PNG-based renders from our Adobe Dimension 3D models.

With our signage placed at appropriate spots within each scene, we'll now move our attention to animating content with **Warped Objects** and the Asset Warp tool.

Animating with the Asset Warp Tool

We'll now have a look at how to use the Asset Warp tool to create warped objects, and how to animate with these unique object types within the software. We'll import a bitmap image and convert it to a smoothly animated character dwelling within the **Park** scene.

You can use the Asset Warp tool on both shapes and bitmaps. As you add pins using the tool to various locations across the object, a distortion mesh is created. Moving these pins will adjust the mesh and so transform the underlying content. Pin positions can be changed across keyframes and Classic Tweens can be used to animate the content.

I have a figure drawn and painted with **Adobe Fresco**, a digital drawing and painting application, that will work great for this:

Fig 11.12 – Spectre PNG file

You can find `spectre.png` in the exercise files for this chapter alongside the others we've already worked with.

> **Tip**
>
> To learn more about Fresco, visit the following URL: `https://www.adobe.com/products/fresco.html`.

Let's add the image to our scene and prepare it for animation:

1. Add new layer within the **Park** scene and rename it `Spectre`.

2. Import the file named `spectre.png` to the stage either by dragging it from the file system or by choosing **File | Import | Import to Stage...** from the application menu.

3. Select the image on the stage and look at the **Object** tab of the **Properties** panel. Set the **x** value to 1380 and the **y** value to 1015. **height** should read a value of 160. This places the figure beneath the large tree.

4. With the object still selected, click the **Convert to Symbol** button:

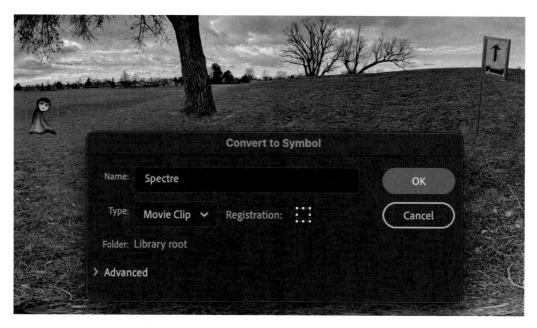

Fig. 11.13 – Convert image to a Movie Clip symbol

In the dialog that appears, provide the name of Spectre and be sure to select **Movie Clip** from the **Type** selection menu. We are using **Movie Clip** to allow the looping of its internal animation since the main timeline only consists of a single frame, and for interactivity purposes later on. **Movie Clip** allows both of these features. Click **OK** when finished.

5. Double-click on the symbol instance in the **Park** scene to enter the symbol timeline.

6. Select the **Asset Warp** tool from the toolbar:

Fig 11.14 – Asset Warp tool

7. You will now click on various points across the bitmap image to create warp pins and a unified mesh:

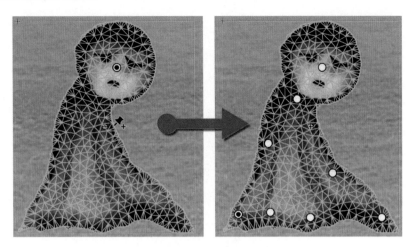

Fig. 11.15 – Setting warp pins

It's up to you how many warp pins to use and where to place them, but I suggest referring to the previous figure as a general guide.

With our warped object created, we can now explore some of the properties unique to this asset type.

Select **Warped Object** on the stage and look at the **Object** tab of the **Properties** panel:

Fig. 11.16 – Object Warp Options

A warped object has a couple of unique properties that can be exploited within the **Warp Options** section of the panel:

- **Mesh** – This is a toggle switch that will display the mesh when active or hide the mesh when not active. It is active by default.

- **Handle mode** – **Open** handle mode is the default and is more impactful to the surrounding mesh fragments:

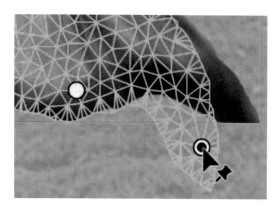

Fig. 11.17 – Moving pin locations modifies the mesh

A **Fixed** handle is less impactful but also allows you to rotate the mesh around it.

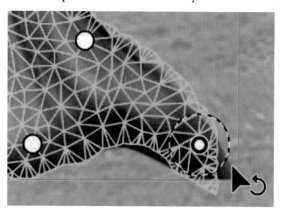

Fig. 11.18 – Fixed Handle mode can rotate around pins

Play around with both handle modes to see what works best for your chosen assets. The most important thing is to make decisions about which handle modes to use before any animation is attempted.

With our warped object established, we'll now have a look at animating between mesh states, as established through regular keyframes.

Animating Warped Objects

When you convert a bitmap or shape into a warped object, it doesn't become a symbol and cannot be found within the **Library** panel. Despite this, a warped object can behave very much like a symbol and can be animated through the use of Classic Tweens in a similar way to symbol instances. We are now going to establish keyframes across the layer containing our warped object and will make use of Classic Tweens to animate between these keyframes. Any variation in the mesh between keyframes will cause a distortion effect similar to moving cloth or morphing shapes.

> **Note**
> Again, I cannot stress enough how important it is to establish the warp points needed and mask decisions around each of their handle modes before creating additional keyframes or attempting any animation.

Let's perform the tasks necessary to animate our little **Spectre** image:

1. The first thing to do is to establish a set of keyframes across the timeline. The animation will be very subtle, so we only need a few. Insert keyframes at frames 16, 43, and 65:

Fig 11.19 – Add keyframes across the timeline

2. We'll now modify the pins already placed across the **Warped Object** mesh in order to provide small distortions across the timeline. Using the **Asset Warp** tool, shift the various pin locations slightly at frames 16 and 43:

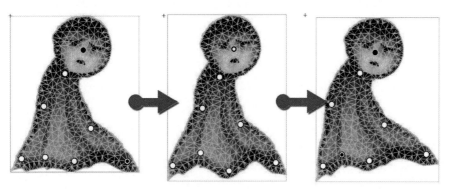

Fig 11.20 – Adjust the mesh pins across keyframes

Do not modify anything at frames 1 and 65 as we want these to be identical in order to create a smooth animation loop.

As you shift the pin locations, the mesh becomes distorted and the image along with it. Move pins to adjust the mesh, but you don't want to shift things too much, else the distortion effect may become too severe.

3. Once your modifications have been made within the necessary keyframes, add a Classic Tween to each of the frame spans:

Fig. 11.21 – Classic Tween applied to Spectre

You can now preview the animation and ensure everything loops correctly by enabling the **Loop** option above the timeline. It should create a seamless loop of the subtle, smooth animation.

Once satisfied with your motion, I suggest that you convert the tweens to frame-by-frame animation. With the virtual reality projects in Animate, your animation will likely be much smoother when this step has been taken! The bad aspect of this is that you will not be able to render it as a warped object anymore.

To do this, select all the tweens and right-click, choosing **Convert to Frame-by-Frame Animation** from the menu that appears, and choose the desired keyframe density.

Tip

Before converting to frame by frame, you can also make a copy of the symbol from the **Library** panel. That way, you can always tweak things even after conversion.

In this section, we imported a set of external image files to be used as interactive and animated objects within our VR experience. We also explored the Asset Warp tool in creating and animating warped objects within VR space. Of course, you can use these tools and techniques in other document types as well! Coming up, we'll tie both scenes together and complete our VR experience by writing a little code.

Writing Code for Virtual Reality Interactions

As we've seen in previous chapters, there are a number of different approaches to writing code in Animate. When we programmed our small game in *Chapter 10, Developing Web-Based Games*, we did so by writing our JavaScript directly into the script editor of the **Actions** panel. For other projects, such as the clickable advertisement in *Chapter 6, Interactive Motion Graphics for the Web*, we used the Actions Wizard to guide us.

Unlike coding within HTML5 Canvas documents, we cannot leverage CreateJS for our virtual reality project. Even though all web-based document types in Animate use JavaScript as the programming language, the WebGL glTF and VR document types within Animate use a completely different library from what we've seen before. This is a WebGL-based runtime library that Adobe has created specifically for these document types. Thankfully though, the Actions Wizard supports this runtime, so it is fairly easy to work with when programming simple interactions.

Moving from Scene to Scene

Our first task will be to program the signs already placed within each scene to allow the user to click on each one to load up a different scene. If the user is in the **Park** scene and clicks the pond sign, they will be taken to the **Pond** scene. Once at the **Pond** scene, if they click the park sign, they will be taken back to the **Park** scene.

Before writing any code, we need to prepare our document and the various objects within it for interactivity. This won't be anything new as we've performed these tasks a few times already in earlier chapters:

1. Our signs within each scene are bitmap images right now. In order to make them interactive, they must be converted to movie clip symbols. Convert both `ParkSign.png` and `PondSign.png` to movie clip symbols by selecting each and using **Modify | Convert to Symbol** from the application menu.

2. Each of the symbol instances will need to be given instance names to make them available for interactivity. Give them instance names of `ParkSign` and `PondSign` within the **Object** tab of the **Properties** panel.

3. Additionally, we will provide the movie clip instance containing our **Warped Object** animation in the **Park** scene with an instance name as well. Select the movie clip symbol instance and give it an instance name of `Spectre`.

4. The timeline for each scene will also need a layer without any visuals that we can bind our code to. Create a new layer at the top of the layer stack in each scene and give it the name `Actions`.

Okay, each scene has been configured with the intention of making the animated figure and the set of sign instances interactive. It's now time to move ahead and write some JavaScript code for each sign that will listen for mouse clicks from the user and respond by loading the alternate scene.

Let's program both of our sign instances using the **Actions** panel and Actions Wizard:

1. Switch to the **Park** scene and ensure that you have selected frame 1 of the **Actions** layer.

2. Open the **Actions** panel by choosing **Window | Actions** from the application menu.

3. Click the **Add Using Wizard** button at the top of the panel to enable the Actions Wizard. The script editor will be replaced by a step-by-step interface.

4. In **Step 1** of the interface, we are prompted to select an action. Locate **Go to Next Scene** and select it:

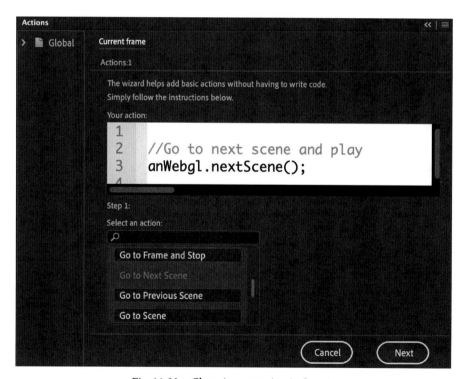

Fig. 11.22 – Choosing an action in Step 1

5. Click **Next** at the bottom of the panel interface to move on to the next step.

6. **Step 2** prompts you to select a triggering event. Choose **On Click** so that a mouse click will trigger the action previously chosen in **Step 1**.

7. The final task is to select the object that will listen for our triggering event. Since we have provided instance names for two instances within the **Park** scene, they appear here. Choose **PondSign** and click **Finish and add**.

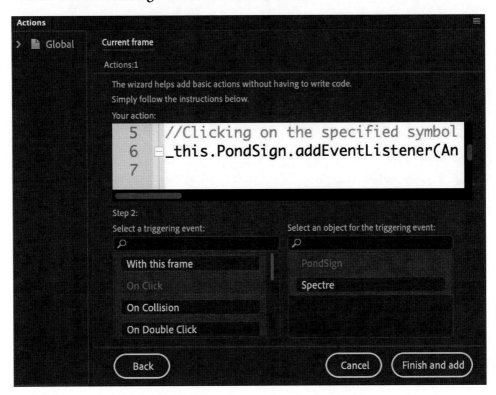

Fig. 11.23 – Choosing a triggering event and object

The Actions Wizard interface goes away and is replaced by the script editor with our completed code within it.

The code for moving from the **Park** scene to the **Pond** scene when a user clicks the sign that reads "Pond" is as follows:

```
{
    var _this = this;
    _this.PondSign.addEventListener(AnEvent.CLICK, function()
{
    anWebgl.nextScene();
    });
}
```

The code establishes a reference variable of `_this` for scope retention, and then adds an `AnEvent.CLICK` event listener to the `PondSign` instance. When a click is detected, the next scene in the order of scenes is loaded via the `nextScene()` method.

> **Note**
> Be sure that your **Park** scene is listed first and your **Pond** scene last within the **Scene** panel, else this code will not work!

You could always switch to the **Pond** scene now and run through all those steps again, choosing instead to go to the previous scene when the **ParkSign** instance is clicked, but there is a faster way.

Since we've already done most of the work, we can simply duplicate the existing code and adjust it to our needs:

1. Copy the entire code block from frame 1 of the **Actions** layer by selecting it and using the keyboard shortcut *Command / Ctrl + C*.

2. Switch to the **Pond** scene and select frame 1 of the **Actions** layer within that scene.

3. Open the **Actions** panel again and paste the copied code into the script editor using the keyboard shortcut *Command / Ctrl + V*.

4. In the code, change `_this.PondSign.addEventListener` to `_this.ParkSign.addEventListener` and change `anWebgl.nextScene();` to `anWebgl.prevScene();`.

 That's all that needs to change!

The code for moving from the **Pond** scene back to the **Park** scene when a user clicks the sign that reads `Park` functions basically the exact same way as the previous code:

```
{
    var _this = this;
    _this.ParkSign.addEventListener(AnEvent.CLICK, function()
{
    anWebgl.prevScene();
    });
}
```

With our signs in each scene properly programmed, we can now run a **Test Movie** and more fully experience the VR project.

We'll next make our little **Spectre** instance interactive as well, through the use of the Actions Wizard.

Interacting with Animated Objects

Making our signs interactive is a necessary function within this VR project because we need a mechanism for the user to be able to switch from one scene to another. We can also make other objects interactive just to be playful, and add some other things for the user to do while exploring the environment we've created.

Let's add some interactivity to the Spectre symbol instance and make it respond visually in reaction to various mouse movements:

1. Since we are programming interactions for the Spectre symbol instance, be sure to switch to the **Park** scene and select frame 1 of the **Actions** layer.

2. Open the **Actions** panel and click the **Add Using Wizard** button at the top of the panel to enable the Actions Wizard.

3. We will scale the instance up whenever a mouseover action is detected. For **Step 1**, choose the action called **Set Scale Along X-Axis**.

4. Now choose **Spectre** from the set of objects.

5. Change the value of the highlighted code that appears to 3. This scales the visual object by a factor of three.

6. Click **Next** at the bottom of the panel to proceed to the next step.

7. To code the mouseover event in **Step2**, choose **On Mouse Over** from the triggering event list.

8. Now choose **Spectre** from the set of objects and click **Finish and add**.

The following JavaScript code is added to the script editor:

```
{
    var _this = this;
    _this.Spectre.addEventListener(AnEvent.MOUSE_OVER,
function () {
        _this.Spectre.scaleX = 3;
    });
}
```

This code tells the Spectre instance to listen for a mouseover event and then react to that by scaling its width by a factor of 3.

We want to scale the height of our Spectre instance along with its width and need to have the scale reset when the mouse cursor moves off the Spectre instance.

Perform the following adjustments to the code using the script editor:

1. Add a line of code beneath `_this.Spectre.scaleX = 3;` that reads `_this.Spectre.scaleY = 3;` in order for the instance to scale in both width and height simultaneously.

2. Copy the entire code block using the keyboard shortcut *Command / Ctrl + C*, add a few line breaks beneath it, and paste a copy there using *Command / Ctrl + V*.

3. In the secondary code block we just created, change `AnEvent.MOUSE_OVER` to `AnEvent.MOUSE_OUT` to detect when the cursor leaves the object.

4. Change the existing scale values from 3 to 1 in order to reset the scale when the mouse leaves.

The completed mouseout event code should look like this:

```
{
    var _this = this;
    _this.Spectre.addEventListener(AnEvent.MOUSE_OUT, function
() {
        _this.Spectre.scaleX = 1;
        _this.Spectre.scaleY = 1;
});
}
```

Click the **Test Movie** button in the upper-right corner of the Animate interface to run the completed VR experience in your web browser. Click the signs to move from one scene to the other and interact with the **Spectre** animation to have it scale in accordance with our programming.

The project is now complete, but there are some additional features to know about. We'll conclude this chapter by exploring the **VR View** panel in order to refine the placement of our various objects within each scene.

Refining Perspective within the VR View Panel

You may have noticed when interacting with your VR project in the web browser that some of your interactive objects perhaps looked a bit odd in their initial placement within the VR environment. Recall that the content of the **Texture** layers in each scene looks completely distorted within the authoring environment and only appears without distortion when rendered in a running project. The various other visual objects we added to the environment actually appear without distortion inside of Animate, but here is the tricky bit: when viewed within the VR environment, they may not visually map the perspective of the environment, based upon the user perspective. We are basically trying to fit a round peg into a square hole no matter what we do. A tool to assist us in refining both placement and perspective is the **VR View** panel.

You can open the **VR View** panel by choosing **Window | VR View** from the application menu:

Fig. 11.24 – VR View panel

It appears as a floating panel initially, but you can always dock this to the interface as with any panel in Animate. To render your VR project within the panel, click the **Launch VR View** button in the panel's center.

The currently active scene will render in a similar way to how you would view the project in a web browser:

Fig. 11.25 – VR View launched

This is a great way to quickly test how your VR project will appear without having to leave Animate to view your content in a web browser. If you change scenes in Animate, the **VR View** panel will then adapt to display the selected scene. You can even click and drag to scroll around the environment, although any interactive elements will not function in this view.

The reason for this is that the various symbols you've established can be moved around and even transformed using your mouse cursor once selected:

Fig. 11.26 – Adjusting objects in VR View

It is much easier to place objects against a distortion-free perspective than the flat Animate stage with distorted environmental textures. While the use of **VR View** may not be necessary for your project if you've placed everything correctly on your first try, it's a good tool to be aware of for those times you need it.

In this section, we prepared our visual objects for interactivity and then added the ability to move from one scene to another using JavaScript and the **Actions** panel. We then wrote additional code to make the animated figure react to mouse movements in order to add additional options for the user to explore. Finally, we had a look at the **VR View** panel and how it can be useful in refining object placement and perspective against a properly rendered environmental texture.

Summary

In this chapter, we examined all aspects of virtual reality documents within Animate alongside their relation to WebGL glTF documents and the wider glTF specification. We gained an understanding of how VR 360 and VR Panorama documents differ from one another and explored how to generate photographic textures in formats appropriate to each document type. Expanding upon this, we implemented our photographic imagery as textures across different scenes and imported renders of 3D models and a small drawing into our scenes. With everything positioned within each scene and subtle animation added to our drawing with the Asset Warp tool, we then wrote JavaScript code to enable the user to interact with the various imported visual objects and animations in different ways.

In the next chapter, we will explore how to enable the Adobe AIR runtime and will build a small application with this amazing cross-platform technology.

12
Building Apps for Desktop and Mobile

In the previous chapter, we designed an interactive virtual reality experience using beta document types in Animate based on WebGL standards.

For this chapter, we'll focus on the Adobe AIR platform and build a small utility application for browsing photographs. To develop this application, we'll need to download and install an AIR SDK and make use of ActionScript 3.0 as a programming language. We'll populate our application with the help of both components and button symbols, two features of Animate that we haven't explored until now. In closing, we'll examine how to convert the application for use on iOS and Android.

After reading this chapter, you'll be able to perform the following functions in Animate:

- Learn how to download and install the **AIR SDK** from either Adobe or HARMAN.
- Lay out an application interface using text, **Button** symbols, and **Components**.
- Write `ActionScript` code within an **AS3 Class** to develop a simple desktop experience.
- Navigate AIR publish settings and target both desktop and mobile platforms using the same code base.

Technical Requirements

You will need the following software and hardware to complete this chapter:

- Adobe Animate 2021 (version 21.0 or above).

- Refer to the Animate system requirements page for hardware specifications: `https://helpx.adobe.com/animate/system-requirements.html`. The CiA video for this chapter can be found at: `https://bit.ly/3iUDbM7`.

Working with the Adobe Integrated Runtime

In this section, we will download and install an **AIR Software Development Kit (SDK)** within Animate and configure a new **AIR for Desktop** document using the chosen SDK version.

AIR is simply one of the most amazingly flexible development platforms available. We went over the general history and usage of AIR in *Chapter 2*, *Exploring Platform-Specific Considerations*, but will really dive into building with the platform now. Since it's been a while, I suggest perhaps going back to that chapter to refresh your memory.

We are going to use AIR to build a photo browser application in this chapter. The user will be able to select a folder from their local filesystem and any image files from that folder will display within a data grid. We'll write a bit of logic so that only image file types will be displayed in the grid. When the user chooses a file from the grid, the image will be rendered within the application.

The first step in all of this is to install the AIR SDK in order to work with AIR documents.

Installing an AIR SDK in Animate

Before 2020, Animate would include the most recent version of the AIR **SDK** packaged along with it, so it was easy to get started with the platform. Following the June release of that year, users would be greeted with a notice when attempting to create a new AIR-based document for the first time.

The notice appears when choosing **AIR for Desktop**, **AIR for iOS**, or **AIR for Android** from the **New Document** dialog:

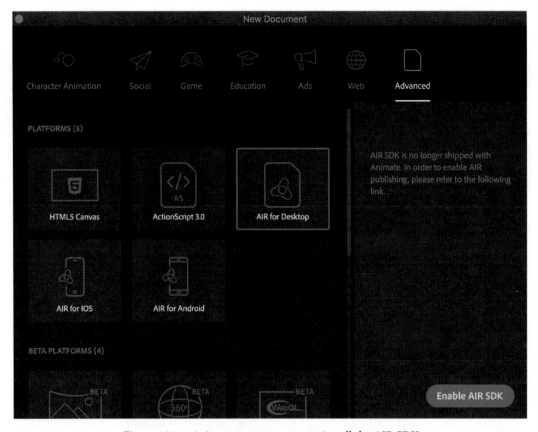

Figure 12.1 – Animate prompts users to install the AIR SDK

The notice reads: **AIR SDK is no longer shipped with Animate. In order to enable AIR publishing, please refer to the following link**.

Clicking the **Enable AIR SDK** button at the bottom of the panel brings the user to a page hosted by Adobe (`https://helpx.adobe.com/animate/kb/get-started-with-latest-airsdk.html`) that explains how to acquire and install a chosen version of Adobe AIR:

- The final version of the AIR SDK maintained by Adobe (version 32) is now found only through the AIR SDK archives: `https://helpx.adobe.com/air/kb/archived-air-sdk-version.html`.

- To locate and download versions of the AIR SDK as maintained by HARMAN (version 33+), you'll visit the HARMAN website: `https://airsdk.harman.com/download`.

> **Note**
>
> While Adobe provided the AIR SDK freely, as its development and maintenance was supported by their tooling, HARMAN does charge a licensing fee for use of the SDK. Thankfully, most users who are not using the SDK for commercial purposed can make use of it for free, with the inclusion of a quick splash screen to help market the technology.

In order to locate and download an AIR SDK on your computer, perform the following steps:

1. From the **New Document** dialog, choose **AIR for Desktop** from the **Advanced** category.

2. Click the **Enable AIR SDK** button and you will be taken to a website with links to various SDK versions.

 I suggest visiting the HARMAN site at `https://airsdk.harman.com/download` as the most recent version of AIR can be found there.

3. Once at a download location, agree to the terms of usage and choose which version of the AIR SDK you'd like to download for use in Adobe Animate.

 You can choose between macOS and Windows SDK versions and select either the main builds of the SDK or those to be used alongside **Apache Flex**. When dealing with Animate, you'll seek out the non-Flex builds.

 Choose a version of the **Full AIR SDK with new ActionScript Compiler** to download.

4. The AIR SDK downloads to your computer as a `.zip` archive.

5. Open the `.zip` file and examine the contents. There are a large number of files and folders included, and they are all necessary for a working SDK installation:

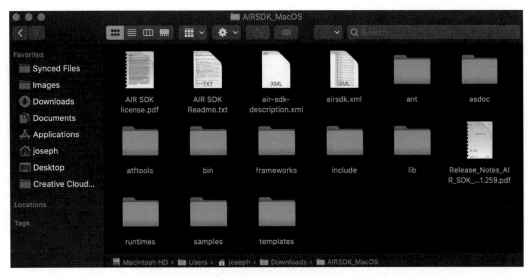

Figure 12.2 – AIR SDK contents

6. Developers will often have a specific directory created specifically to house various SDKs and related tools. I suggest naming the folder something like `AIR SDK 33` and placing it in the `Documents` or `User` directories since these are both easily located. Place the contents of the `.zip` file in a new folder with an easily identifiable name.

> **Note**
>
> **Apache Flex** (formerly **Adobe Flex**) is a development platform that makes use of **Flash Platform** technologies, including **ActionScript 3.0** and the **MXML** markup language, for cross-platform application development: `http://flex.apache.org/`.

Once you have completed copying the `.zip` archive's full contents into the folder you've created, you'll want to make note of that location when we go to install the SDK in Animate. You can install many different versions of the AIR SDK – just be sure to keep each one in its own unique directory with an identifiable name.

We'll now turn our attention back to Animate to install the AIR SDK so that we can develop applications and games using the technology:

1. To install a new AIR SDK for use in Adobe Animate, open the software and look at the application menu.

2. From the **Help** menu, choose the option labeled **Manage Adobe AIR SDK…**:

Figure 12.3 – Opening the AIR SDK management dialog

3. The **Manage Adobe AIR SDK** dialog will appear:

Figure 12.4 – There are no AIR SDK versions installed

If you haven't installed any AIR SDK in the past, this will be empty, but if you have other versions of the SDK installed, they will appear here.

4. Click **Add New SDK** (the small plus button) to open a browse dialog and use it to locate the folder where you previously unzipped the AIR SDK archive contents.

5. Click the **Choose** button in the file browse dialog with the SDK folder selected to install it as a usable AIR SDK within Animate:

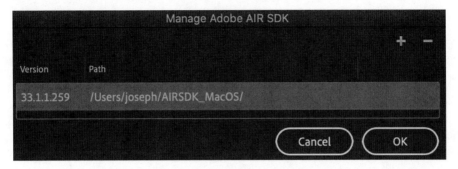

Figure 12.5 – Our new AIR SDK version is installed

6. The SDK version and path will appear for the chosen SDK. Click **OK** to close the dialog.

The AIR SDK is now integrated within Adobe Animate, but we will likely need to provide additional permissions to run and test any documents we create.

Before we do that, we'll need to create a new AIR document and perform some basic configuration to set up our project.

Configuring an AIR for Desktop Project

With at least one version of the AIR SDK installed, we can now create and manage **AIR for Desktop**, **AIR for iOS**, and **AIR for Android** documents. While you might think you have to make platform decisions at this point, these three choices can always be modified even when your application development is complete by switching the target platform. We'll see how to do this at the end of the chapter.

Let's create a new **AIR for Desktop** document to work with in this chapter:

1. Open the **New Document** dialog once again by choosing **Create New** or **More Presets...** from the **Home** screen in Animate.

2. Select the **Advanced** category and choose **AIR for Desktop** from the document types listed within:

Figure 12.6 – AIR documents can now be created

Because we have at least one version of the AIR installed and ready to go, Animate now displays the document details along with a **Create** button.

3. Click the **Create** button to have Animate generate a new **AIR for Desktop** document.

4. In the **Properties** panel, change the width to 500px and the height to 700px. Change the background color to black (#000000):

Figure 12.7 – AIR document settings

5. Save your document by choosing **File | Save** from the application menu and provide a meaningful name. I suggest something like `PhotoBrowser.fla` for a filename.

Aside from these basic document settings, we'll also add in a text-based header to the application to provide it with more of a visual identity before laying out all the interactive components in the next section.

To create a text header for the application, perform the following steps:

1. Select the **Text** tool from the toolbar.

2. In the **Tool** tab of the **Properties** panel, configure the tool by choosing a font, size, and color:

Figure 12.8 – Text tool settings

The text object is non-interactive, so should be **Static Text**. I've chosen an Adobe Font called **BadTyp** (`https://fonts.adobe.com/fonts/badtyp`) for the text header, made its size `50pt`, and have set the fill color to white (`#FFFFFF`). In the **Paragraph** section, I've chosen to **Center Align** my text.

3. Click and drag a new text object across the stage and type PHOTO BROWSER:

Figure 12.9 – The application header

The text object is nearly the size of our stage and the text remains centered.

4. Check the **Object** tab of the **Properties** panel with the text object selected to verify its **Position and Size** properties:

Figure 12.10 – Header position and size

The **width** should be `464px` with an **x** value of `18` and a **y** value of `20`. This will position the header down the stage a little bit while also centering it within the application.

Our AIR project is now configured with both **Document Settings** and a nice title header for the application.

Testing your AIR Project

Before we conclude this section, we should ensure that we are able to run the AIR project effectively in order to test features as they are built.

To test an AIR document, the process is very similar to any other document type we've seen. Click the **Test Movie** button in the upper-right corner of the Animate interface, or you can have finer control over how you test by selecting **Control | Test Movie** and choosing an option from the menu that appears:

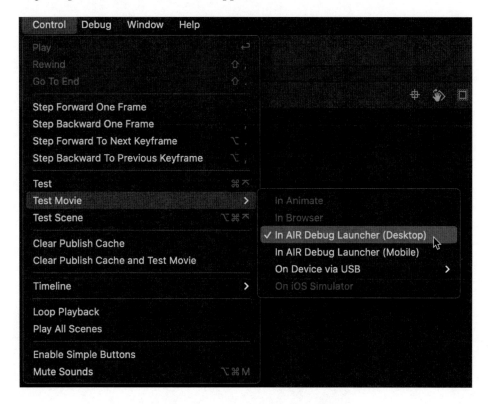

Figure 12.11 – Test Movie menu options

Here is a quick overview of the options presented by this menu:

- **In AIR Debug Launcher (Desktop)** is the default for AIR for Desktop applications and launches very similar to an ActionScript 3.0 document.

- **In AIR Debug Launcher (Mobile)** is the default with AIR for iOS or AIR for Android applications and includes a mobile device simulator.

- **On Device via USB** is an additional option with AIR for iOS or AIR for Android and allows you to test mobile applications directly on device hardware connected by a USB cable.

If you are using Adobe Animate on Apple macOS and have downloaded and added the AIR SDK from an internet download, you will likely be presented with a number of security warning dialogs when attempting to run an AIR document with the **Test Movie** option for the first time:

Figure 12.12 – macOS security warning dialog

If this occurs, simply open your Apple **System Preferences** and locate the **Security & Privacy** option. From here, choose the **General** tab and look at the section with the text **Allow apps downloaded from** and you should see an alert about either the **AIR Debug Launcher** (**ADL**) or the AIR framework processes:

Figure 12.13 – Choosing the Allow Anyway option in Security & Privacy

Choosing **Allow Anyway** will grant permission for these processes to run without problem from Animate. Depending upon how many dialog warnings you receive, you may need to allow multiple processes before macOS stops alerting you of these processes.

When using **Windows**, simply provide permission to these processes if prompted by the system dialogs. It is normal for everything to just work without any additional procedures when developing AIR projects on Windows.

In this section, we downloaded and installed the **AIR SDK** within Animate, allowing us to create AIR documents. We also created and configured a new **AIR for Desktop** project, added an application title header, and explored the AIR testing options. Coming up, we will focus on the elements required in our application interface to allow a user to interact with the application.

Building a User Interface

In this section, we'll focus on all the interactive parts of the interface we'll build for our AIR application, starting out with a look at how to construct **Button** symbols, followed by the use of precompiled **UI Components**, and wrapping up with a more in-depth look at advanced Movie Clip symbol properties.

Let's start off by building the **Button** symbol that a user will click to choose a folder of photographs within the application.

Working with Button Symbols

Button symbols are not supported in every document type in Animate and are pretty unique as their internal timeline is constrained to four isolated states. Nonetheless, **Button** symbols are very useful for applications like the one we are building in this chapter.

The easiest way to start building a **Button** symbol in Animate is by creating a simple shape:

1. Choose the **Rectangle Primitive** tool from the toolbar:

Figure 12.14 – The Rectangle Primitive tool

2. Look at the **Tool** tab of the **Properties** panel and set the **Rectangle Options** value to 4 to enable slightly rounded corners. Set the fill color to a dark gray (#595959) value.

3. Draw a rectangle primitive across the stage slightly less than its width:

Figure 12.15 – The Rectangle Primitive object

4. The object should measure 480 x 60 and have an **x** position of 10 and a **y** position of 150. Verify this through the **Properties** panel.

5. Select the object and choose **Modify | Convert to Symbol** to summon the **Convert to Symbol** dialog:

Figure 12.16 – The Convert to Symbol button

In the dialog, name the new symbol ChooseFolderBtn, since this is the button a user will click to choose a folder of files. We are creating a **Button** symbol, so be sure the **Type** selection is set to **Button**.

6. When finished with the dialog, click **OK** to create the new **Button** symbol. The **Rectangle Primitive** on the stage becomes a **Button** symbol instance.

7. With the instance still selected, in the **Object** tab of the **Properties** panel, enter an instance name of ChooseFolder:

Figure 12.17 – Button instance name

Recall that providing a Movie Clip or **Button** symbol instance with an instance name will allow us to address this object with code.

With our **Button** symbol created, we can now enter into its internal timeline and complete setting up our button to provide it with a set of interactive states and a text label so that the user knows what the button's function is.

1. Double-click the Button instance on the stage to enter the symbol and look at the timeline.

2. Rename the existing layer to **Skin** as this will hold our button skin variants. Notice that the **Button** symbol timeline includes four distinct frames with names above each one: Up, Over, Down, and Hit.

3. Duplicate the initial keyframe at frame 1 across all 4 frames by clicking the **Insert Keyframe** button with frame 1 selected. All 4 keyframes are identical.

4. With each keyframe, we are going to change the color of the shape fill on that keyframe to distinguish between button states:

 a) **Up** – Leave the color at #595959. This is our resting state.

 b) **Over** – Change the color to a lighter gray color at #999999. This is the hover state.

 c) **Down** – This is the state of the button when pressed. It will be a darker gray fill color at #333333.

 d) **Hit** – You can leave this be, but I like to change any non-visible elements to a vivid green (#00FF00). The **Hit** state is not rendered visually and determines what pixels count toward an interaction with a mouse cursor. You can make the hit state a completely different shape from the visual elements, but in this case, we want it to be identical.

5. Create a new layer above the **Skin** layer and rename it to Text.

6. Within the **Text** layer, use the **Text** tool to create a simple button label that reads Choose Photograph Folder:

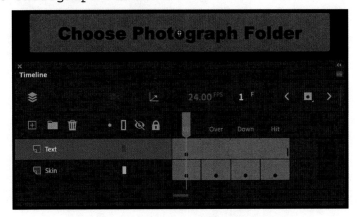

Figure 12.18 – The completed button timeline

Use whatever text settings that look good. I used a 27pt, **Arial Black** font with a completely black fill. Notice that this text spans all four states, though you could create keyframe variants with this layer as well, if desired.

When your internal button timeline is complete, click the **Scene 1** label in **Edit Bar** above the stage to return to the main timeline.

One of our three user interface elements is now complete. For the remaining two elements, we will use prebuilt **Components**.

Using Components within an AIR Project

Components are a feature of HTML5 Canvas, ActionScript 3.0, and AIR documents. They are prebuilt, modular packages that generally serve a single function. Some take the form of a video playback, or a progress bar, or even a data grid or media display mechanism, as we'll use for this project.

Note

The set of available components will differ drastically between HTML5 Canvas documents and all other document types that support the use of components.

We will make us of two different components in this project: the **DataGrid** component, and the **UILoader** component:

1. To access any components in an AIR document, we must first open the **Components** panel. To do so, choose **Window | Components** from the application menu:

Figure 12.19 – The Components panel

The **Components** panel lists a number of different component types. We will be using components from the **User Interface** folder.

2. The first component to locate is the **DataGrid** component. This component is useful for displaying data in columns and rows. Drag an instance of the **DataGrid** component onto the stage. A placeholder is now visible on the stage.

3. Select the component instance on the stage and set its properties in the **Properties** panel. The **width** should be 480, with a **height** of 160 and the position should be an **x** of 10 and a **y** of 220. This places it nicely below the **Button** instance.

4. The second component to locate is the **UILoader** component. This component is useful for displaying images and other media. Drag an instance of the **UILoader** component onto the stage. A placeholder will be visible on the stage.

5. Select the component instance on the stage and set its properties in the **Properties** panel. The **width** should be 480, with a **height** of 300 and the position should be an **x** of 10 and a **y** of 390. This places it directly below our **DataGrid**.

6. While we can adjust general settings for components within the **Properties** panel, we need to adjust component-specific settings for our **DataGrid**. In order to do this, we will need to invoke the **Component Parameters** panel. With the **DataGrid** instance selected on the stage, you will find the **Component Parameters** button in the **Properties** panel:

Figure 12.20 – The Component Parameters button

This opens the **Component Parameters** panel and displays all parameters for the selected **DataGrid** component.

7. We only need to tweak two of these parameters. Set **rowHeight** to 4 0 and **horizontalScrollPosition** to off:

Figure 12.21 – Component parameters

These settings will make each piece of data more clickable, especially if we were to publish this app to a mobile device. **UILoader** does not require any parameter adjustments.

You may need to scroll down in the **Component Parameters** panel to locate both parameters.

The user interface elements of our AIR application are now in place and the project is ready for programming with ActionScript:

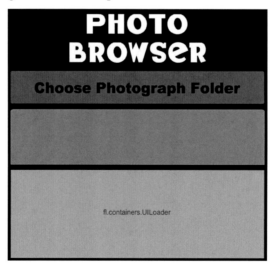

Figure 12.22 – The completed layout

Our user interface elements have now been established within the project layout. Before moving on to the next section though, we should explore some additional properties of movie clip symbols, as they are also incredibly useful in building application interfaces.

Exploring Advanced Movie Clip Symbol Settings

We've now established our application interface through the use of **Button** symbols and **Components**. If you look in the **Properties** panel with a component selected, you'll discover that these components are actually Movie Clip symbols! Additionally, in place of any of the objects we've used for layout, Movie Clip symbols are always a great choice for interactive controls in AIR applications.

> **Note**
> While we won't be using Movie Clip symbols in our project, apart from the existing components, it is good to have an understanding of their advanced properties.

With the more common Movie Clip settings covered in *Chapter 5*, *Creating and Manipulating Media Content*, let's expand from that overview and have a look at the **Advanced** settings of Movie Clip symbols available to us. To access these advanced properties, select a Movie Clip symbol in the **Library** panel and right-click to open the contextual menu and choose **Properties…**. Once the dialog appears, twirl down the **Advanced** settings.

The first section of the **Advanced** settings is the most important and appears at the top of the expanded portion of the dialog:

Figure 12.23 – Movie Clip advanced settings

The first option you see here is actually more of a design setting than anything to do with development. When enabled, the **Enable guides for 9-slice scaling** option will allow you to enter into a symbol from the **Library** panel and modify a set of guides to specify which visual areas of your symbol should scale and which should stay their original size if an instance of the symbol is scaled. This allows a good amount of control for properly resizing UI elements that you create so that different sized instances can easily be created upon the stage from the same exact symbol. This is only available with ActionScript 3.0 based documents.

Below this are the **ActionScript Linkage** settings:

- **Export for ActionScript** – This generates a **LinkageID** in the **Library** panel that allows symbol instantiation through code, just as we did with JavaScript in *Chapter 10, Developing Web-Based Games*.

- **Export in frame 1** – This makes a symbol marked for export available for instantiation at the beginning of the timeline. Notice that our app exists on a single frame; this is very important for single-frame projects, especially in conjunction with the use of **Linkage ID**.

- **Class** – You can specify a custom ActionScript 3.0 **class** for your symbol, otherwise Animate will generate a default one for you.

- **Base Class** – This is the class that your custom class extends through ActionScript code. It appears in the form of a **package**, and the default for a Movie Clip symbol is `flash.display.MovieClip`.

Again, most of these options have to do with ActionScript development. While very convenient, unless you are creating applications or games using AIR, as we are in this chapter, they likely will not matter much.

Following the **ActionScript Linkage** settings are two additional groups of settings:

- **Runtime Shared Library** – This option will package up your symbol into a SWF file, which you can then make available as an online resource only for the intention of sharing linked symbol assets at **runtime**. This was heavily used while Flash Player was most popular, but is no longer very useful.

- **Authortime Sharing** – Somewhat similar to sharing assets at runtime, this option allows the creation of a symbol package that you can share among Animate users to access various shared symbols during **authortime**, within Animate itself. This fact alone makes this a much more valuable feature and can even be used in other document types, such as **HTML5 Canvas**.

Most Animate users will have no need for either of these settings, but it is good to be aware what each is for.

In this section, we built out our entire user interface using custom **Button** symbols and prebuilt components. We also had a look at advanced symbol properties that tie directly into ActionScript programming. Coming up, we'll start writing all the ActionScript code to drive the functional aspects of the application.

Programming an AIR Application

In this section, we'll use **ActionScript** to tie all of our interface components together into a unified application. **ActionScript** is similar to **JavaScript** in some ways (they are both based on **ECMAScript**), but very different in other ways, since they are derived from different branches of the specification.

While we could write all of our ActionScript code using frame scripts, it is better to leverage the **Object-Oriented Programming** features that are so prominent in the language and create a **Document Class**.

Establishing a Document Class

We'll now create a **Document Class** and bind it to our .fla document. The **Document Class** will exist as a .as file and exists separately from the .fla file. When you use a **Document Class** for your project, it must extend either the MovieClip or **Sprite** classes, depending upon whether you require animation or not in your main document timeline. Extending one class with another will give you access to all the functionality you write, plus all the functionality that is within the base class. It's a powerful way of programming!

Let's go ahead and instruct Animate to create a new **Document Class** for us:

1. Open the **Publish Settings** dialog from the **More Settings** button in the **Doc** tab of the **Properties** panel.

2. Within the **Publish Settings** dialog, locate the **Script** selection dropdown and click the small wrench icon to the right of it:

Figure 12.24 – AIR Publish Settings

3. This opens the **Advanced ActionScript 3.0 Settings** dialog:

Figure 12.25 – Advanced ActionScript 3.0 settings

This dialog contains imported ActionScript settings for your project. You'll want to check and be sure that **Export classes in frame** is set to 1 and that **Automatically declare stage instances** is selected. They should be by default, but it never hurts to check.

4. In the **Document Class** input, type in Main for the class name and click the small pencil icon next to it to edit the class definition.

 You will likely receive a warning from Animate informing you that it cannot find the specified class file. This is expected, as we have yet to save it! Dismiss the warning dialog if it appears.

 A new **ActionScript** class appears within Animate.

5. Click **OK** to commit your choices and you'll be left looking at the actual starter code for your class fully displayed with Animate, and not just through the **Actions** panel.

6. Save the class using **File | Save** and name the file `Main.as` since a class filename in ActionScript must be identical to the class name.

The newly created **Document Class** will look like this:

```
package {
    import flash.display.MovieClip;
    public class Main extends MovieClip {
        public function Main() {
            // constructor code
        }
    }
}
```

This is boilerplate that defines a **Document Class** named `Main`, which `extends` `flash.display.MovieClip`. Note that we also have to import `flash.display.MovieClip` in order to use it. Within the class is a single function called a constructor function. Any code within this function runs immediately upon initialization.

> **Note**
> Any additional functions we create later will go below the constructor function, one after the other. These functions and any variables created must all exist within the class definition.

Be sure that the class **Target** dropdown is set to bind to your Animate document named `PhotoBrowser.fla`:

Figure 12.26 – The target of Main.as is PhotoBrowser.fla

Once everything looks to be set, we can move on to write the rest of our application code within the `Main` class.

Writing ActionScript Code

The first task we have is to import a set of additional classes to be used within the application. Type the following `import` statements direct beneath the existing `import`:

```
import flash.filesystem.File;
import fl.controls.DataGrid;
import fl.data.DataProvider;
import fl.containers.UILoader;
import flash.events.MouseEvent;
import flash.events.Event;
import flash.events.FileListEvent;
```

We'll touch upon each of these classes as we get to them in the various functions we'll define further on.

Directly following `public class Main extends MovieClip {`, enter a set of variable declarations:

```
var photoDirectory:File;
var photos:Array;
var photoGridProvider:DataProvider;
```

These are class-level variables that are accessible from any function within the class. `photoDirectory:File` will be used to reference a selected folder, `photos:Array` will hold references to each image file we find, and `photoGridProvider:DataProvider` will be used to display these files within our **DataGrid** component.

The next lines of code will go directly within our constructor function beneath the line that reads `public function Main() {`:

```
ChooseFolder.addEventListener(MouseEvent.CLICK,
chooseDirectory);
PhotoGrid.addEventListener(Event.CHANGE, photoSelected);
PhotoGrid.columns = ["Name", "Type", "Size"];
photos = new Array();
photoGridProvider = new DataProvider();
PhotoGrid.dataProvider = photoGridProvider;
```

The first line adds a `MouseEvent.CLICK` event listener to the `ChooseFolder` button symbol instance. When a click is detected, we will invoke a function named `chooseDirectory`. We also add an `Event.CHANGE` listener to the `PhotoGrid` **DataGrid** component instance. When the selection is changed by the user, the function named `photoSelected` will fire off. We also set the column names within `PhotoGrid` directly afterward to *Name*, *Type*, and *Size*.

The remaining lines of code instantiate the class-level variables declared previously.

All that is left is to write the various functions referenced in our listeners and any additional functions they will need to invoke. We'll begin with the `chooseDirectory` function and will place it directly after the closing curly brace of the constructor function:

```
private function chooseDirectory(e:MouseEvent):void {
    photoDirectory = new File();
    photoDirectory.addEventListener(Event.SELECT,
directorySelected);
    photoDirectory.browseForDirectory("Select Photo
Folder...");
}
```

This is where the `photoDirectory File` variable is instantiated. This will clear out any existing references from a previous folder selection. We then add a listener to this file of the `Event.SELECT` type, which will trigger when a new folder is selected and will invoke a function called `directorySelected`. We have to open a system-level file explorer in order for the user to browse the filesystem and make a folder selection, so use the `browseForDirectory()` method of the `File` class to do so.

We'll next write the `directorySelected` function in response to the folder selection. Place this code directly beneath the previous function:

```
private function directorySelected(e:Event):void {
    photoDirectory.getDirectoryListingAsync();
    photoDirectory.addEventListener(FileListEvent.DIRECTORY_
LISTING, directoryListed);
}
```

In this function, we first invoke the `getDirectoryListingAsync()` method to get a list of all the files within the selected directory. We need to listen for an event to tell us when this process has completed so that we can perform further manipulation on the file references, so listen for the `FileListEvent.DIRECTORY_LISTING` event and this will invoke the `directoryListed` function once it is safe to do so.

The `directoryListed` function will do most of the work in this application. We'll write it directly beneath the previous function:

```
private function directoryListed(e:FileListEvent):void {
    photos = new Array();
    for(var p:uint = 0; p<e.files.length; p++){
        if(e.files[p].extension == "jpg" || e.files[p].
extension == "png" || e.files[p].extension == "gif") {
            photos.push(e.files[p]);
        }
    }
    photoGridProvider.removeAll();
    for(var i:uint = 0; i<photos.length; i++){
        photoGridProvider.addItem({"Name":photos[i].name,
"Type":photos[i].extension, "Size":photos[i].size});
    }
}
```

In this function, we start by clearing out `photos` Array to prepare it for holding the valid image file references from our `FileListEvent`, which was triggered from the initial folder selection.

We then set up a `for` loop to iterate over all the files that were detected within this folder. For loops in ActionScript work exactly like they do in JavaScript, if you recall their usage from *Chapter 10, Developing Web-Based Games*. For each iteration, we check the file extension to determine whether or not it is an image file. If it is, we then add the file reference to our `photos` Array.

Once the `Array` is built, containing only image files from the chosen folder, we can populate our `DataGrid` component with data. First, we will remove any existing data from `photoGridProvider` so that it is empty. We then run another `for` loop, but this time it simply adds information about each image file to `photoGridProvider`, which is then reflected within the visible `DataGrid` component for the user to select.

The final function to write is the one that is invoked when the user selects an image reference from the `DataGrid` component. Place this function directly beneath the last one:

```
private function photoSelected(e:Event):void {
    var selectedPhoto:File = photos[e.target.selectedIndex];
    PhotoViewer.source = selectedPhoto.url;
}
```

This function simply created a new `File` variable reference called `selectedPhoto` and populates it with data from a certain position of the `photos` `Array`, which matches the row selected by the user as part of the visible **DataGrid** on the stage. The `source` property of our `PhotoViewer` `UILoader` component on the stage is then set to the `url` property of that `File` reference, thereby rendering the visible image within the `UILoader` component for the user to view.

Once all of your code is written, perform a **Test Movie** and locate a folder of image files to see the application in action:

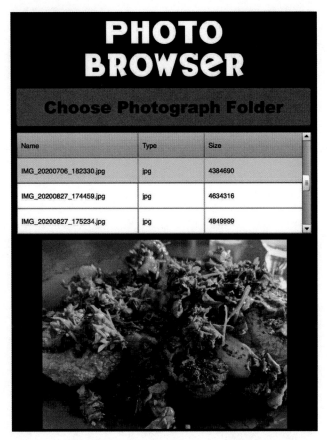

Figure 12.27 – The completed application

In this section, we created our **Document Class** in ActionScript, bound it to our project, and then wrote all of the code necessary for our application to function. Coming up, we will finish off this chapter with a look at how to convert our AIR for Desktop project to be used on mobile devices.

Converting an AIR Application for Mobile Devices

We developed our application using **AIR for Desktop**, but it is possible to create versions of the application using **AIR for iOS** and **AIR for Android** so as to target mobile devices as well. Since the underlying code is all ActionScript, and AIR includes the ability of publishing ActionScript to mobile platform packages, we can often convert our documents without much hassle.

> **Note**
>
> For a refresher regarding the various platforms that AIR can target, you may want to refer to *Chapter 2, Exploring Platform-Specific Considerations*, and locate the sections on Adobe AIR. To further explore the publish settings available across different AIR targets, refer to *Chapter 4, Publishing and Exporting Creative Content*.

In order to convert a document from one AIR target to another, perform the following steps:

1. With the existing project open, choose **File | Save As…** from the application menu and save a copy of your `.fla` file with a meaningful name.

 Note that this `.fla` file will still make use of the `Main.as` file for all functionality, so you will likely want to re-engineer your class file to be more modular or simply have a **Document Class** for each version of the app.

2. Open the **Publish Settings** dialog from the **More Settings** button in the **Doc** tab of the **Properties** panel.

3. Within the **Publish Settings** dialog, locate the **Target** selection dropdown and select it to locate alternative AIR runtimes, such as **AIR for Android** or **AIR for iOS**:

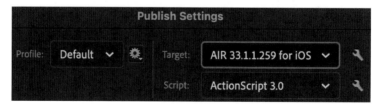

Figure 12.28 – Changing the target in AIR Publish Settings

4. Click **OK** and the dialog disappears. Your document will now publish to the platform you've chosen.

You will likely want to consider some of the mobile-specific classes in ActionScript when looking through your code and testing against mobile hardware. You will also need to take screen size and dynamic interface scaling and positioning to mind. There is a lot to consider!

Of course, there is a lot more to know about design and development for mobile devices. While such topics are beyond the scope of this book, there are many other resources dedicated to such development.

> **Tip**
> I cover a number of mobile-specific design and development considerations and functionalities in my book, *Flash Development for Android Cookbook*, which is focused on AIR for mobile devices: `https://www.packtpub.com/product/flash-development-for-android-cookbook/9781849691420`.

In this section, we converted our **AIR for Desktop** project to target mobile devices through **AIR for iOS** and **AIR for Android**.

Summary

In this chapter, we wrote an entire application from scratch using Adobe AIR! We first downloaded and installed an AIR SDK within Animate and then created a new document with that SDK and configured it for desktop usage. Following this, we built the application interface with the use of button symbols and special premade Movie Clip packages called components. Next, we created a new ActionScript class and wrote all of our application code to develop a fully functioning application. Finally, we had a look at how to convert our desktop project for use on mobile devices using the same AIR technologies.

The final chapter of this book is next, in which we'll explore a number of neat ways of extending Adobe Animate yourself or through the work of others.

13
Extending Adobe Animate

In the previous chapter, we built a working application in ActionScript that interacts with native filesystems through the use of Adobe AIR on desktop and mobile.

This chapter concludes our book with an exploration of a set of options available to extend Adobe Animate. We can extend Animate through the creation and execution of custom in-app tutorials and will walk through how to accomplish this screen by screen. We can also use a JavaScript API, **JavaScript for Flash (JSFL)**, to automate actions in the user interface or make use of the **Custom Platform Support Development Kit (CPSDK)** to extend the power of Animate to new platforms.

After reading this chapter, you'll be able to perform the following functions:

- Build custom in-app tutorials that can be executed and navigated within Animate itself.

- Extend Animate processes and actions through the use of the internal JSFL scripting language.

- Gain an understanding of the role of the CPSDK for adding additional platform targets to Animate and make use of such plugins as a user.

Technical Requirements

You will need the following software and hardware to complete this chapter:

- Adobe Animate 2021 (version 21.0 or above).

- Refer to the Animate system requirements page for hardware specifications: `https://helpx.adobe.com/animate/system-requirements.html`. The CiA video for this chapter can be found at: `https://bit.ly/3qWiFh6`.

Creating Custom In-App Tutorials

In this section, we'll explore how to build in-app tutorials within Animate. The software comes with a number of these tutorials already installed. They can be accessed by choosing **Help | Hands-on Tutorial** from the application menu and then choosing a specific tutorial to run. These tutorials run within the application, highlighting tools and panels as the user works through them within Animate.

The tools to build these same types of tutorials are now available to any Animate user through a built-in extension. All you need to do to get started is open **Window | Extension | Hands-on Tutorial Creator** to access this feature.

With the panel open and ready, you'll then proceed step by step through the process, building out various cards that contain explanatory steps, preview images or animations, and contextual prompts anchored to the application interface.

The first screen you see allows you to either create a new tutorial or edit one that has already been created and saved as a `.zip` archive:

Figure 13.1 – Create a new tutorial or edit an existing tutorial

To edit an existing tutorial, choose **Open** from the radio selection and then select **Browse** to find the tutorial bundle you want to modify.

Whether you are creating a new tutorial or are editing an existing one, you'll next be taken to the details screen:

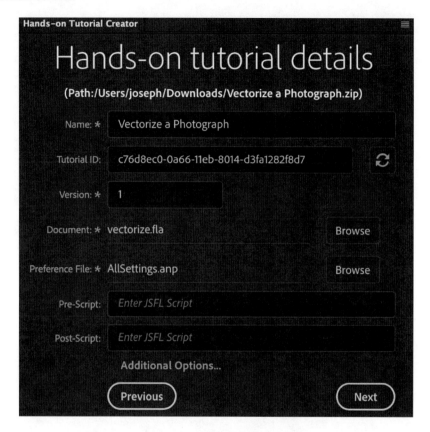

Figure 13.2 – Tutorial details screen

Here, you are able to modify general properties such as **Name** and **Version**, alongside an autogenerated tutorial ID.

You must have an existing Animate authoring document file (`.fla`) prepared as a starter in addition to an Animate **preferences file** (`.anp`). The document file can be empty or may contain content across the timeline, stage, and library. An Animate preferences file can be exported from **Preferences | Export Preferences...** and is useful for arranging the workspace and other preferences exactly as you want it for the tutorial you are creating.

Optionally, you can also include **JSFL** scripts to run alongside the tutorial. JSFL scripts allow you to automate certain processes within the Animate software while it is open. You can read more about JSFL in the next section.

There is also a set of additional options, which allow the inclusion of an overview video to welcome and inform the user, as well as a full description of the tutorial. If you choose to access these properties, you can include a preview image or even an animated SWF to give the user an overall idea of the tutorial contents and the expected results.

Clicking **Next** will take you to the **Card list** screen of the **Hands-on Tutorial Creator** panel:

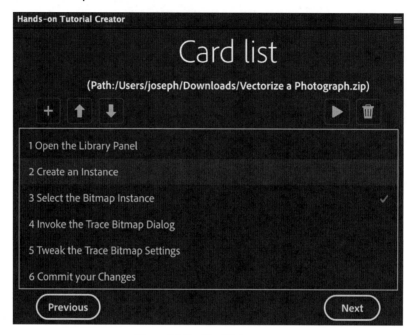

Figure 13.3 – Card list screen

This section is where most of the work takes place and cards are created. Each step in your tutorial is a card and here is where you manage the order and details of each step.

Initially, no cards will be present in a new tutorial, so the first step would be to click the **Add Card** (+) button to add a new card. The **Move the Card Up** and **Move the Card Down** arrow buttons allow you to change the order of a selected card within the card list and the **Preview Selected Card** button provides an in-app preview of the selected card. The **Delete Selected Card** button will, of course, remove the selected card.

Whether you are editing an existing card or creating a new one, you will be taken to the **Card details** screen:

Figure 13.4 – Card details screen

Each card you create must have a title and a description. Similar to the overall tutorial details, a card video can also be provided that will appear as part of the visual card along with the title and description text.

Cards can be anchored to specific portions of the Animate interface so that they are in close proximity to their content. You accomplish this when you choose an anchor node by clicking on the Animate user interface once the **Choose** button is activated. The card can be anchored to the top, bottom, left, or right of the selected anchor node with the **Anchor Side** drop-down selector. Choosing the **Highlight** option will place a blue circular indicator overlay at the chosen anchor node.

Labels for the card's **Previous** and **Next** buttons can also be customized to read whatever you like. A card can also be marked to be excluded from the list of steps by choosing the **Do not count as step** checkbox. This is good to provide a card with additional or expanded information but isn't itself an actual step in the overall tutorial.

You can preview individual cards while you edit them and see exactly how they will appear in the interface. Clicking **Ok** will bring you back to the card list.

From the overall card list, you can choose **Next** in order to publish your tutorial:

Figure 13.5 – Publish tutorial screen

When publishing your tutorial, you can include additional assets in the form of **Animate asset** (.ana) files for the user to access during their interaction with your tutorial. When the tutorial is activated, any Animate asset files that are included here will be populated within the **Custom** area of the **Assets** panel.

When the tutorial is complete, choose a folder on your filesystem and click **Save** to generate a distributable .zip file. This file contains all the settings, images, videos, assets, data, and anything else your tutorial comprises. Because it takes the form of a ubiquitous .zip archive, it can easily be distributed to other Animate users. The archive also acts as a backup in case you'd like to edit your tutorial further.

To use a tutorial, it must be imported to the **Help | Hands-on Tutorial** menu by choosing **Import Tutorial...** and locating the `.zip` archive. Once a tutorial is imported, it becomes part of the menu of hands-on tutorials under **Help** and can be launched from there.

> **Tip**
>
> If you ever want to remove your custom tutorial from the list of tutorials, they can be removed by choosing **Remove Tutorial** from the **Hands-on Tutorial** menu. The default tutorials that ship with Animate cannot be removed.

In this section, we examined the workflow for creating a hands-on tutorial that can be generating using Animate, distributed to other Animate users, and installed with their version of Animate in order to learn in a hands-on manner, within the program. Coming up, we'll have a look at another mechanism you can use to extend Animate functionality through JSFL scripts.

Writing JSFL Scripts

In this section, we explore the use of **JSFL** scripts in Animate. Using JSFL scripts will allow the automation of certain tasks that can be run with a menu-based command within an Animate document. These scripts can generate objects or manipulate objects that exist within a document. In our example for this chapter, we'll create a randomly generated splatter pattern across a document using JSFL.

This is one of those features that users will often hear about but never actually explore. JSFL scripts can not only improve workflows when dealing with repetitive tasks, but they can also be used to encapsulate specific procedures to share with others.

All of the JSFL commands can be executed and managed by selecting **Commands** from the application menu:

Figure 13.6 – The Commands menu

You have a number of different options here, but any installed JSFL scripts will appear in the lower portion of the **Commands** menu. By default, you will have four commands but can always add your own JSFL scripts as part of this menu. Choosing **Run Command...** from this menu lets you browse for a .jsfl file anywhere on your local system to run as a command.

The two main ways of writing JSFL scripts are to either write the code manually or to use the **History** panel. Either way, you'll first need to create a new JSFL (.jsfl) file in order to write any scripts.

Let's create a new .jsfl file now:

1. From the **Home** screen in Animate, click on **Create New** or **More Presets** and the **New Document** dialog will appear.

2. Click the **Advanced** category along the top of the dialog in order to choose a new document by specific document type.

3. Scroll down past the **PLATFORMS** and **BETA PLATFORMS** groupings and you will find a new header for **SCRIPTS** at the very bottom. A set of code-based file types can be created here, including ActionScript 3.0 class files and JSFL script files.

4. Choose **JSFL Script File** and then click the **Create** button to generate a new JSFL file that you can edit directly within Animate:

Figure 13.7 – JSFL Script File

The JSFL file opens in Animate very similar to how ActionScript (.as) files were edited in *Chapter 12, Building Apps for Desktop and Mobile.*

5. You'll want to save the file right away. Choose **File | Save** from the application menu and a save dialog will appear:

Figure 13.8 – Saving the JSFL file

The save dialog lets you define a name and location for your new file. There is only a single file format to choose from.

6. Type in a name for the file. We'll be writing JavaScript code to generate a splatter pattern across the screen in this example, so I've named mine `Splatter.jsfl` and saved it to a location that is easy to remember.

7. Click **Save** to save your new `.jsfl` file.

While we could just start writing code, there is a useful mechanism within Animate that makes it very easy to preserve certain actions for the purposes of automation. This is accessible through the **History** panel.

The **History** panel keeps a step-by-step record of every action taken within an Animate document. This could be the creation of a shape, a selection change, color assignment, and much more.

Let's now go ahead and make use of the **History** panel to assist us in writing our scripts:

1. Create a new **HTML5 Canvas** or **ActionScript 3.0** document by selecting **File | New** from the application menu.

2. Open the **History** panel by choosing **Window | History** from the application menu.

3. Perform a number of actions within the document. Create shapes, change selections, and add layers until a handful of steps appear within the **History** panel.

4. Highlight the steps you want to copy within the **History** panel. Certain steps are not able to be copied – they are marked with a red **X** over the step icon.

5. With at least one valid step selected, open the panel options menu and choose **Copy Steps**:

Figure 13.9 – Copy Steps from the History panel

6. With the selected steps copied, switch to the JSFL document we created previously and paste in the steps using *Ctrl/Cmd + V*:

```
1  an.getDocumentDOM().addNewOval({
2      left:100, top:210, right:200, bottom:280
3  });
4
```

Figure 13.10 – The pasted code

The code to enact the step or steps is placed into the .jsfl file. In the previous figure, the code to create a new oval shape is added, along with the required location and size information, through an object defining the shape bounds across the left, top, right, and bottom values.

If you click the **Run Script** button at the top right of the script editor, the script will execute and your code will execute, performing the same steps that were copied within the .fla document.

We will want to make this more useful, of course. In my example, I'll automate and randomize the generation of many ovals in order to produce a cool splatter effect across the document.

> **Tip**
> Learn more about JSFL files and their capabilities by reading the Animate JavaScript API documentation: `https://www.adobe.io/apis/creativecloud/animate/docs.html`.

Let's walk through the creation of a Splatter command by modifying the JSFL scripts to produce something much more useful. Follow these steps:

1. Return to the `.jsfl` file and remove the initially pasted code to create the oval so that the file is completely empty. We'll add similar code later that does the same thing but in a smarter way.

2. Insert the following code at line 1 of the script editor:

```
function randomize(min, max) {
        return Math.round(Math.random() * max) + min;
}
```

Look familiar? This is the same randomization function we used when building the game in *Chapter 10, Developing Web-Based Games*. It accepts two numbers and returns a random one in between them.

3. We'll next define a set of variables to be used within the script. Add a few empty lines following the `randomize()` function and write the following beneath it:

```
var x;
var y;
var r;
var c;
var h = an.getDocumentDOM().height;
var w = an.getDocumentDOM().width;
var fill = an.getDocumentDOM().getCustomFill();
fill.style = "solid";
```

Here, we set variables to determine the x and y positions, the radius, and the color alpha percentage. These will all have elements that are somewhat random and are simply declared at this point with no values.

Then, we set variables to retain the width and height of the Animate document with the JSFL **JavaScript API**. Finally, we create a new variable named `fill` to act as a custom color to which we set its `style` attribute to `"solid"`.

The remainder of our script resides within a `for` loop similar to the loops created within our JavaScript game and AIR application development experiences in previous chapters.

4. Do you recall the initially pasted code to create the oval that we removed? It will make a re-appearance now! Add the following code block below the existing lines of code:

```
for (var i = 0; i < 500; i++) {
    x = randomize(-50, w);
    y = randomize(-50, h);
    r = randomize(10, 60);
    switch(randomize(0,2)){
        case 0:
            c = "E6" //90%
            break;
        case 1:
            c = "BF" //75%
            break;
        case 2:
            c = "FF" //100%
            break;
        default:
            c = "FF" //100%
    };
    fill.color = "#440000"+c;
    an.getDocumentDOM().setCustomFill(fill);
    an.getDocumentDOM().addNewOval({left:x, top:y,
right:x+r, bottom:y+r}, false, true);
}
```

Let's examine this loop as there is a lot going on here. The `for` loop itself runs 500 times to create 500 oval shapes in our document. Within the loop, we invoke `randomize()` to set the `x` and `y` position properties that were previously declared. When we request random position values, we make use of the stage width and height references through the `w` and `h` variables to ensure we cover the document stage with ovals. We also set a random radius size between `10` and `60` and set it to the `r` variable.

Following this is a `switch` statement, which determines the alpha transparency of the fill color, which is set directly following the `switch` block. To do this, we grab a random number between `0` and `2` and set the value of our `c` variable to a hexadecimal fragment alpha percentage based on the number returned. This is appended to the `color` attribute of our `fill` variable in order to create a color with varying opacity values, from 100% to 75%.

The last few lines of code set the custom fill color and then draw a new oval based on everything determined within the loop previous to this point. Note that the `addNewOval()` method is really the only remnant of our initial pasted code from the **History** panel.

5. Be sure to save your `.jsfl` file.

 In order to make this available as a command in the **Commands** menu, there is a special folder that the `.jsfl` file must be moved to. The location of this folder will vary depending upon your operating system. The locations for both Windows and macOS are as follows:

* The `Commands` folder on Windows:

    ```
    C:\Users\<USER>\AppData\Local\Adobe\Animate
    <VERSION>\<LOCALE>\Configuration\Commands\
    ```

* The `Commands` folder on macOS:

    ```
    /Users/<User>/Library/Application Support/Adobe/Animate
    <VERSION>/<LOCALE>/Configuration/Commands
    ```

> **Tip**
> The **Library** folder is hidden by default on macOS. In **Finder**, click the **Go** menu at the very top of your screen and hold down the *Option* key. **Library** will appear as a menu option. Alternatively, select the **Go to Folder...** option from the **Go** menu and use `~/Library` as your location.

In order to run the newly created command in Animate, perform the following steps:

1. Move or copy `Splatter.jsfl` into the `Commands` folder alongside the JSFL commands that are installed with Animate:

Figure 13.11 – Adding JSFL to the Commands folder

2. With the file in place within the Animate `Commands` folder, close the file explorer and launch Animate once more.

3. Create a new **HTML5 Canvas** or **ActionScript 3.0** document by selecting **Create New** or **More Presets** and generating a fresh document.

 Once the new document is created, choose **Commands** from the application menu. At the bottom of the **Commands** menu is our new **Splatter** command:

Figure 13.12 – The Commands menu and the Splatter command

4. Click **Splatter** and the command runs the associated JSFL script, generating a cool splatter pattern across the stage:

Figure 13.13 – The Splatter command results

Using JSFL scripts and the Animate JavaScript API is a highly versatile way of extending Animate for all sorts of different purposes.

Once you have a number of custom commands installed, you can choose to manage, rename, or delete them by choosing **Manage Saved Commands…** through the **Commands** menu:

Figure 13.14 – Managing commands

Custom commands appear alongside the default commands in this dialog, so be sure to only modify the ones you really want to!

In this section, we explored the use of JSFL scripts to create and execute commands within Animate. Coming up, we'll see how it is possible to extend Animate through the use of the CPSDK and add new publish targets to the software through the installation of plugins developed with this SDK.

Understanding the Animate Custom Platform SDK

In this section, we'll look at the **Animate CPSDK** and see how to install extensions from **Adobe Exchange** through the **Creative Cloud desktop application**.

Back before Adobe decided to re-brand *Flash Professional* to *Animate*, they were working under the hood to establish the software as a completely platform-agnostic solution for motion and interactivity. One team cannot target all platforms that exist in the world, and so they came up with the solution to allow anyone to add target platforms to Animate through the use of the CPSDK.

Visit the **adobe.io** website and go to the Animate section (`https://www.adobe.io/apis/creativecloud/animate.html`), and you'll be able to view all of the ways to extend Adobe Animate:

Figure 13.15 – adobe.io resources for Animate

You can find full documentation along with the actual CPSDK, which can be downloaded and put to use to implement a custom document type and publish workflow.

> **Note**
> Creating a new document type for Animate using the CPSDK is not trivial. If you ever decide to undertake such an effort, you should be intimately familiar with the platform you are targeting.

To make use of an extension that leverages the CPSDK, you will need to browse the plugins available for Animate within the Creative Cloud desktop application:

1. The first step in this process is to close Animate completely and open the Creative Cloud desktop application.

2. With the application open, locate the **Marketplace** tab along the top and choose the **All plugins** category.

3. We can filter the plugins displayed by selecting the Creative Cloud application we want to find plugins for. Choose **Animate** and only plugins compatible with Animate will be visible:

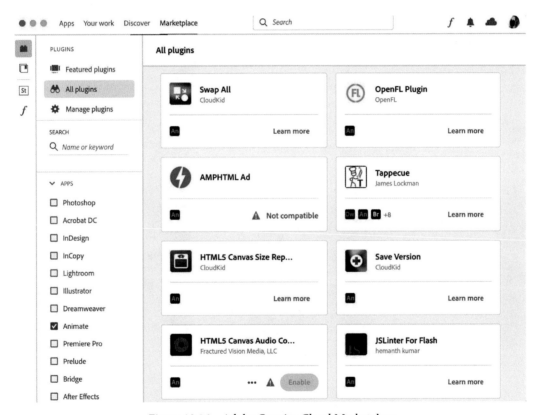

Figure 13.16 – Adobe Creative Cloud Marketplace

Not all plugins that you find here use the CPSDK. Some create new panels using JSFL and others may be components or other workflow tools.

4. Once you locate a plugin, all you need to do is click **Install** and the plugin will be installed onto your computer:

Figure 13.17 – Installing a plugin for Animate

You can also uninstall plugins that were previously installed using this same mechanism. Adobe is moving more and more functionality into the Creative Cloud desktop application from other sources.

Once you've installed a plugin, you'll want to use it. One of the reasons we closed Animate before installing a plugin is that Animate will only detect newly installed plugins on startup. If a plugin using the CPSDK is installed, we can now fire Animate back up and create a new document with it.

5. From the **Home** screen in Animate, click on **Create New** or **More Presets** and the **New Document** dialog will appear.

6. Click the **Advanced** category along the top of the dialog in order to choose a new document by document type.

7. Scroll down past the **PLATFORMS** and **BETA PLATFORMS** groupings and you will find a new header for **CUSTOM PLATFORMS**. The new document type using the CPSDK can be located there:

Figure 13.18 – Creating a custom platform document

8. Select the custom document type and click **Create** to generate a new document that targets the new platform.

Depending upon the platform, certain tools and features may not be supported. This is to be expected and is similar to what we've seen when comparing the native document types in Animate.

When it is time to publish your project, the CPSDK also includes the ability for developers to include their own platform-specific publish settings:

Figure 13.19 – Custom document publish settings

> **Note**
> Certain custom platform publish workflows may rely on additional processes to be installed and running to function correctly. Keep an eye on the **Output** panel when using a custom platform document type in case you are prompted to take additional action.

In this section, we had a look at the CPSDK for Animate and explored how to locate, install, and make use of custom platform plugins.

Summary

In this chapter, we looked at three ways to extend Animate beyond its default state through the creation of in-app tutorials, the writing of JSFL scripts and the configuring of associated commands, and the installation and management of plugins making use of the CPSDK to add new document types to Animate.

This concludes our journey for now. You should feel confident in using Adobe Animate to design an assortment of creative projects and I hope you continue to master all aspects of the software as your familiarity with these workflows and platforms continues to grow.

Other Books You May Enjoy

If you enjoyed this book, you may be interested in these other books by Packt:

Hands-On Motion Graphics with Adobe After Effects CC

David Dodds

ISBN: 978-1-78934-515-5

- Create a lower third project for a TV show with complex layers
- Work with shape layer animation to create an animated lyrics video
- Explore different tools to animate characters
- Apply text animation to create a dynamic film-opening title
- Use professional visual effects to create a VFX project
- Model, light, and composite your 3D project in After Effects

Mastering Adobe Photoshop Elements 2021 - Third Edition

Robin Nichols

ISBN: 978-1-80056-699-6

- Identify the five parts of Elements and set up your computer, camera, and monitor
- Import, organize, and keep track of your imported media library
- Develop advanced image retouching skills
- Discover how to add text and graphics to photographs
- Cultivate your understanding of multi-image, multi-layered editing techniques
- Develop illustrative skills with the many drawing tools available in Elements 2021
- Prepare images and projects for uploading to social media, print, and video
- Find out how to troubleshoot your work when things don't come out the way you hoped they would

Leave a review - let other readers know what you think

Please share your thoughts on this book with others by leaving a review on the site that you bought it from. If you purchased the book from Amazon, please leave us an honest review on this book's Amazon page. This is vital so that other potential readers can see and use your unbiased opinion to make purchasing decisions, we can understand what our customers think about our products, and our authors can see your feedback on the title that they have worked with Packt to create. It will only take a few minutes of your time, but is valuable to other potential customers, our authors, and Packt. Thank you!

Index

W

Z

Made in the USA
Las Vegas, NV
22 May 2021